MAKE COMICS LIKE THE PROS

THE INSIDE SCOOP ON HOW TO WRITE, DRAW, AND SELL YOUR COMIC BOOKS AND GRAPHIC NOVELS

Greg Pak and Fred Van Lente

WATSON-GUPTILL

Berkeley

Published in the United States by Watson-Guptill Publications,
an imprint of the Crown Publishing Group,
a division of Random House LLC,
a Penguin Random House Company, New York.
www.crownpublishing.com
www.watsonguptill.com

WATSON-GUPTILL and the WG and Horse designs are registered
trademarks of Random House LLC

Library of Congress Cataloging-in-Publication Data

Pak, Greg, author.
 Make comics like the pros : the inside scoop on how to write, draw,
and sell your own comic books and graphic novels / Greg Pak and
Fred Van Lente.
 pages cm
1. Comic books, strips, etc.—Marketing. 2. Comic books, strips,
etc.—Authorship. 3. Comic books, strips, etc.—Technique. I. Van
Lente, Fred, author. II. Title.
PN6714.P35 2014
741.5'1—dc23
 2014001711
ISBN: 978-0-385-34463-0
eISBN: 978-0-385-34451-7

Printed in China

Cover design by MacFadden & Thorpe and Katy Brown
Interior design by MacFadden & Thorpe

10 9 8 7 6 5 4 3 2 1

First Edition

TO ALL OF YOU WHO WON'T GIVE UP.
THIS BOOK IS FOR YOU.

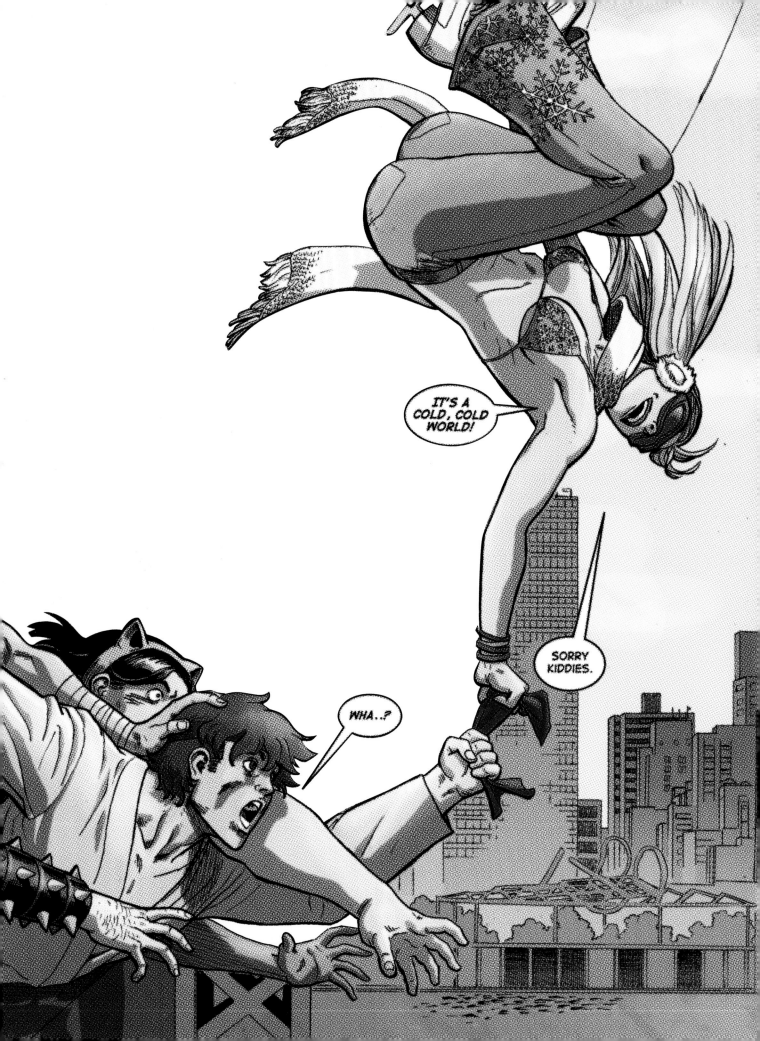

INTRODUCTION: THE BIG SECRET 1

CHAPTER 1
WRITING FOR PICTURES 13

CHAPTER 2
VISUAL STORYTELLING FOR ARTISTS & RELATED TRADESPEOPLE 43

CHAPTER 3
I LOVE IT WHEN A TEAM COMES TOGETHER 61

CHAPTER 4
PITCHING MAKES PERFECT 93

CHAPTER 5
D.I.Y IN PRINT AND ONLINE 109

CHAPTER 6
FINDING YOUR AUDIENCE—AND KEEPING IT! 129

AFTERWORD: THE PROBLEM WITH BREAKING IN . . . 143
INDEX 149

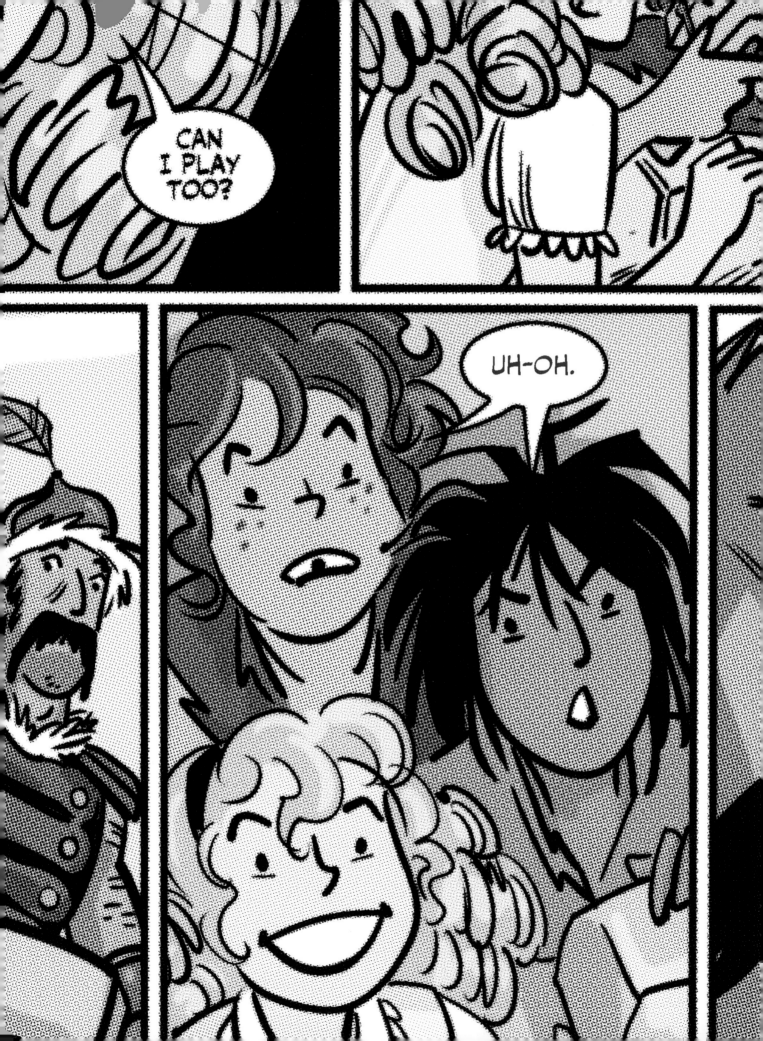

INTRODUCTION: THE BIG SECRET

Welcome to *Make Comics Like the Pros*, a practical compendium of everything that we—veteran comic book creators Greg Pak and Fred Van Lente—have learned while hammering out thousands of comic book script pages and working with hundreds of collaborators over the last decade. Here you'll find step-by-step strategies for how to drag your comic out of your brain, with invaluable advice on writing, drawing, coloring, and lettering. And we'll help you build your strategy for getting your book out into the world with from-the-front-lines tips on pitching, publishing, and promotion.

Throughout, we'll make our pointers as practical and hands-on as possible with play-by-play commentary on the creation of a brand-new comic book story written by us and drawn by the brilliant Colleen Coover. Whether you're a total beginner or an experienced pro, you're about to dive into a giant pool of awesome directly relevant to whatever your interests in comics creation may be.

But we're going to spill our biggest secret right up front: the big theme of this book—and the key to making comics like the pros—is *collaboration*.

At the minimum, the production of a typical comic book requires a writer, an editor, an artist, a letterer, a printer, a publicist, and a distributor. In theory, all of those jobs can be filled by one person, especially in the digital age. But most comics are created by a team, and the vast majority of comic book creators—and by "creators," we mean *everyone* who works on the book—need to learn how to talk to and work with everybody at every stage of the process.

And you guessed it: this book will help you do exactly those things.

The wrong way to frame all of this is that if you're making comics, you need to learn how to get all of your collaborators to see things the way you do and fricking *do* it already.

The reality is that great comics come from *true* collaboration, with genuine give-and-take through which smart creators learn from their colleagues and end up with a far better final product than they ever could have produced on their own.

Left: Greg Pak (left) and Fred Van Lente have written over sixty comics together, and have created hundreds of issues and graphic novels on their own.

Right: *Tranquility* was a story about a cop on a near-future moon base always one step ahead of the law she was supposedly trying to enforce. Though sales were poor, it was optioned by the movie company that hired Fred to write *Cowboys & Aliens*. You never know what leads to your next job. (Script by Fred Van Lente, art by Steve Ellis.)

We'd all like to pretend we're incandescent geniuses who drip perfection from every pen stroke or keyboard tap. But to reach our potential, we need a sounding board and honest critique. On a creative level, true collaboration means you have someone to call you on your cheap tricks, push you to improve, and surprise you with new ideas and possibilities.

We're going to explore every creative relationship in comics—unveiling how letterers, colorists, editors, writers, and artists all can work together for maximum impact. But to lay the groundwork for all of our conversations about collaboration, first we'll tell you a little bit about ourselves and how we started collaborating with each other, which should show you that while there's a way to make comics like the pros, there are as many paths to *becoming* a pro as there are pros themselves.

WHO WE ARE AND HOW WE CAME TO BE

Ever since he was very young, Fred knew he wanted to be a writer; he just wasn't sure what kind. His dad was a casual comics fan and a lot of his funny books fell into Fred's hands at an early age—by the time Fred entered kindergarten, he could read thanks to all the old comics he devoured! But he was also into prose writing and interested in screen-writing, and went to Syracuse University to study film.

Greg knew he wanted to be a writer by the time he was nine years old and Ray Bradbury had become his patron saint. Greg wrote short stories throughout middle school, high school, and college. He also grew up drawing all the time—his mother bought her kids crayons and blank paper instead of coloring books. But at some point, Greg stopped thinking of creative work as a career. He kept cartooning and writing through high school and college and beyond, but he studied political science as an undergrad at Yale University and then went home to Texas to work on the first gubernatorial campaign of the great Ann Richards.

Fred enjoyed moviemaking but had even more fun hanging out with the students studying to be comics artists in the Illustration Department down the hall. He really loved the way they brought his ideas to life, so after school, he moved to New York City to try to break into the comics industry with them. It took many long years, because it required juggling several (usually pretty terrible) temp jobs at a time, but he and two fellow Syracuse University alums, artists Steve Ellis and Ryan Dunlavey, managed to create small-press titles like *Stuperpowers!*, *Tranquility*, *Action Philosophers*, and *The Silencers*. Though none of these titles was a huge seller, people in charge read them and liked them and gave Fred work. Platinum Studios, the film

"One of the most moving pieces I've seen all year."
- John Petrakis, Chicago Tribune

Robot Stories

WINNER
OVER 23 AWARDS
including

SPECIAL JURY AWARD
FOR EMOTIONAL TRUTH
Florida Film Festival

BEST SCREENPLAY
Hamptons Int'l
Film Festival

GRAND PRIZE
Rhode Island Int'l
Film Festival

BEST DIRECTOR
BEST ACTRESS
Fuchon Fantastic
Film Festival

BEST SCREENPLAY
BEST ACTRESS
St. Louis
Film Festival

AUDIENCE AWARD
Boston Fantastic
Film Festival

BEST FEATURE FILM
Sci Fi London
Film Festival

Everything is changing...

... except the human heart

PAK FILM AND SHOTWELL MEDIA PRESENT

A ROBOT STORIES PRODUCTIONS FILM "ROBOT STORIES" TAMLYN TOMITA SAB SHIMONO WAI CHING HO GREG PAK co-starring JOHN CARIANI CINDY CHEUNG BILL COELIUS EISA DAVIS RON DOMINGO
TIM KANG JULIENNE HANZELKA KIM JAMES SAITO casting by KIM IMA animation by DANIEL A. KANEMOTO sound design by NELSON NUDO hair/makeup by LEO WON costume design by KITTY BOOTS
production design by SHANE P. KLEIN music by RICK KNUTSEN edited by STEPHANIE STERNER cinematography by PETER OLSEN
co-produced by KARIN CHIEN produced by KIM IMA and GREG PAK written and directed by GREG PAK

 PAK FILM
www.pakfilm.com
 SHOTWELL www.robotstories.net

Above: *Robot Stories* was an anthology film, four stories about love, death, and robots. It had tremendous success on the festival circuit but was a terrible calling card for more feature projects—since no one makes anthology films. But the script unexpectedly turned out to be a perfect writing sample for making the transition to comics.

Left: *The Silencers* was "The Sopranos with Superpowers," a crime saga featuring superpowered mob enforcers who have to become independent operators when the mob family they work for gets rubbed out. (Art and design by Steve Ellis.)

company that optioned *Tranquility*, a near-future sci-fi thriller, gave Fred the job to write *Cowboys & Aliens*, the comic that the 2011 movie was based on.

After working in Texas politics for a year, Greg snagged a Rhodes scholarship to study history at Oxford University, ostensibly in order to become a better politician. But at Oxford, Greg had the chance for the first time to get involved with a student filmmaking group, and all the lights came on. After Oxford, Greg moved to New York City to attend NYU's graduate film program. After years of making shorts, he directed the independent sci-fi feature film *Robot Stories*. Then one day his agent called up to say Marvel was looking for new comic book writers and would he be interested?

Meanwhile, it was Fred's super-noir crime series he created with artist Steve Ellis, *The Silencers*, that attracted the eye of editor Mark Paniccia at Marvel, and he invited Fred to pitch for the company's *Amazing Fantasy* anthology title. Fred's pitch was initially rejected, but he got a call when the original writer had to be let go (the classic understudy-makes-good story isn't limited to Broadway). From there, Fred got steady offers to write for the company's kids' line, with books like *Marvel Adventures Iron Man* and *Wolverine: First Class*, as well as off-beat titles like the supervillain heist *MODOK's 11* and short stories here and there.

Greg's first Marvel project was the 2004 *Warlock* miniseries illustrated by Charlie Adlard. Then Greg got tapped for the *X-Men: Phoenix—Endsong* miniseries, illustrated by Greg Land, which hit the top ten in sales the month it debuted. After writing a slew of miniseries, Greg finally got a shot at an ongoing with the "Planet Hulk" story that began in *Incredible Hulk* #92 and eventually led to *World War Hulk*, Marvel's big 2007 summer comics event.

Before we met, neither of us had cowritten any comics. But in 2007, as Greg was finishing up *World War Hulk*, he pitched the idea of an ongoing series starring the Renegades, a group of Marvel heroes who were crazy enough to side with the Hulk during his recent war in New York. Greg's writing schedule was pretty packed, and Marvel editor Nate Cosby suggested he consider cowriting the new project with this dude named Fred.

So we met in a Tex-Mex restaurant during a New York City snowstorm and, as Nate had anticipated, immediately hit it off. We had a blast working on the Renegades pitch, which ended up getting rejected because of a glut of new team books at Marvel at the time. But a few weeks later, we got a call asking if we'd be interested in reworking the pitch as a buddy book starring just two of the Renegades: Hercules and Amadeus Cho, the most incorrigible

Greek demigod and the craziest kid genius in the Marvel Universe.

We said sure, and ended up writing over fifty issues of Hercules and Amadeus stories over the next five years.

Some cowriting teams divide their work according to task—with Writer A plotting and Writer B fleshing the stories out into complete scripts with dialogue, for example. But we never even tried that route; both of us immediately and instinctively knew that to reap the real creative rewards and fun of collaboration, we needed to be equally involved in every step of the process. Here's how we went about it:

We'd usually start each new story arc by tossing around ideas over burgers in a dive somewhere in New York. From the beginning, one clear virtue of collaboration was that it prevented us from deep-sixing our own best ideas.

Every great, world-changing story idea probably sounded really stupid the first time someone articulated it: "An *alien* in *tights* and a *cape* who jumps around and punches bad guys? Come on." Sure, sometimes we need to let our dumb ideas quietly die. But when we were mulling over a Hercules story to tie into Marvel's 2008 *Secret Invasion* (an event featuring the alien Skrulls), Fred allowed himself to mention what he thought was one of his dumber ideas: that Hercules should go on a quest to kill the Skrull gods. And Greg said, "That's perfect!" The story became one of the most lauded of our *Incredible Hercules* run.

A big part of what made our collaboration work was that we shared a shameless willingness to jump on the best idea in the room. We'd fight passionately for what we thought was the most effective angle for a story or scene. But the minute the other guy came up with something better, we'd turn on a dime and embrace it. There's a strange and wonderful kind of selflessness that collaboration can encourage. If you're working with a good partner (and if you don't have a cowriter, this could be your editor or your artist), you don't have to fear anything—you know you're both just trying to figure out the best way to tell the best story possible, and you're both going to get equal credit for the success and failure of your work.

When it came to the practical task of putting words on pages, one of us would write up a first draft of a story outline after our face-to-face story meeting. Then the other would edit it and send it back to the first guy, who would edit it and send it back to the second guy, and so on until we were both satisfied. Then we'd repeat the process for the page-by-page outline for the individual script. And then we'd divide up the script, each of us taking an equal number of pages to write. Sometimes, we'd split it right down the middle, with one of us writing the first half and the other guy writing the second. Other times, if one of us had a special affinity for or understanding of a certain section of the script, we might divide things a little differently, with Greg writing the opening and closing, for example, and Fred writing the middle.

But as always, we'd trade those script pages back and forth, editing each other until we were both happy.

Editing each other might be the scariest words for new writers in the paragraph above. But give and you shall receive. When you give your cowriter permission to dig into your precious words without restraint, you end up looking much, much smarter, funnier, and wiser. Greg readily admits that he'd often cram in three too many jokes on certain pages or panels, leaving it to Fred to do the dirty work of cutting one or two. (Or all of them.) But knowing he had backup meant that each guy could run a bit wild and try things out. So in every issue, we'd streamline each other's dialogue, clarify panel descriptions, and correct dumb typos. And in true *Jerry Maguire* fashion, we'd regularly complete each other, paying off setups the other guy only semiconsciously created.

Panel 1: Angle up - Gudrid's POV down her crosshairs - Suddenly an even younger girl named SOPHIE shoves her face into view. She's carrying a comically large wooden toy sword. Sophie's clearly a child of privilege -- pretty, colorful clothes, maybe some kind of headpiece.

1. SOPHIE: Hey, Gudrid! Hey, Khu! Whatcha playing?

2. SOPHIE: Can I play too?

Panel 2: Gudrid fires wildly, raising the crossbow to avoid hitting Sophie!

3. GUDRID: *GAAHHHHH!*

4. GUDRID: *Sophie! WATCH IT!*

Panel 3: The bolt sails up to the top of the tower where it lands loudly (though bloodlessly) in the SHIELD carried by the uppermost SENTRY, startling him! (Maybe this is a blunt bolt rather than sharp-tipped bolt, and it bounces off the shield. Like this, but more hand-forged. More ref.)

5. SFX: *tunk*

6. SENTRY: Wha-?!?

Panel 4: High angle looking down from the Sentry's POV. The three girls look up (the two older ones out of the haystack) caught red-handed.

7. KHU & GUDRID (1 balloon, 2 pointers):Uh-oh.

Panel 5: Smash zoom into Sentry as he points down, screaming.

8. SENTRY: *TO ARMS! BROTHERS, TO ARMS!*

9. SENTRY: *WE ARE UNDER ATTACK!*

Panel 6: As they scramble, starting to run, Gudrid wags a furious finger in Sophie's face; she just giggles.

10. GUDRID: How many times do we have to *tell* you, Sophie? This *isn't* a game!

11. GUDRID: We're not pampered little *princesses* like you -- we're trying to *eat!*

12. SOPHIE: *Hee-hee!* You *orphans* are *funny!*

Fred Van Lente 4/2/13 2:06 PM
Deleted: and both were always *hungry.*

Fred Van Lente 4/2/13 2:46 PM
Deleted: 5…As Khu and … stand up, step forward, eyes sharp, … little …approaches …them from the side ... [1]

Fred Van Lente 4/2/13 2:48 PM
Deleted: 7…Who wants to play ... [2]

Greg Pak 4/7/13 10:57 AM
Deleted: '

Fred Van Lente 4/2/13 2:49 PM
Deleted: 8. KHU: . Scram, kid.

Fred Van Lente 4/2/13 2:50 PM
Deleted: 9. SOPHIE: . Come on. I'll let *you* be the *princess.* . 10. KHU: . Pft. Princesses are *losers.* .

Fred Van Lente 4/2/13 2:50 PM
Deleted: 6…Khu lunges forward, kicking the plank the pies are sitting on. The pies fly through the air -- Gudrid is grinning, catching them. ... [3]

Fred Van Lente 4/2/13 9:49 AM
Formatted: Font:Italic

Fred Van Lente 4/2/13 2:51 PM
Deleted: 11. SFX: . THWAAANG

Fred Van Lente 4/2/13 2:51 PM
Deleted: 12. KHU: *Thieves* have all the fun!

Greg Pak 4/5/13 1:02 PM
Deleted: Aerial shot - Angle down -

Fred Van Lente 4/2/13 3:01 PM
Formatted: Font:Bold, Italic

Greg Pak 4/7/13 10:48 AM
Deleted: G

Fred Van Lente 4/2/13 3:04 PM
Formatted ... [4]

Fred Van Lente 4/2/13 3:04 PM
Formatted ... [5]

Greg Pak 4/5/13 1:03 PM
Deleted: T

Fred Van Lente 4/2/13 3:04 PM
Formatted: Font:Bold, Italic

Greg Pak 4/7/13 10:48 AM
Deleted: .

Collaboration: rarely pretty, but always colorful.

Swordmaids

From Idea to Concept

There's no better kind of learning than doing. We thought we'd put that maxim into practice in *Make Comics Like the Pros* by guiding you through the comics creation process from Nothing to Something, and we've enlisted our pal Colleen Coover to help us. One of America's best designers, cartoonists, and illustrators, Colleen has drawn a bazillion comics, both creator-owned (*Bandette*, *Gingerbread Girl*, *Small Favors*) and mainstream superhero (*X-Men First Class*, *Power Pack*) and has been nominated multiple times for the industry's highest honor, the Eisner. She has agreed to be our cocreator on this little story in exchange for, you know, money. (Golden Rule of Comics Creation: Make sure everyone, and we do mean *everyone*, gets *paid*. Or at least do your damnedest to try.)

Now we swear to you, this isn't some old pitch we had lying around in a drawer somewhere that we dusted off once we were contracted to write this book. No, we were quite literally making this comic up and writing the manuscript for this book simultaneously.

That's not to say we didn't have an *idea*, of course. Everything starts with an idea. In fact, that's the common cliché interview question all writers get: "Where do you get your ideas?" We like Neil Gaiman's response (paraphrased): "Why, Ideas R Us, down on Main and Second." Harlan Ellison likes to joke about a mail-order joint in Poughkeepsie that sends him a new idea every month.

The truth is that ideas come literally from *everywhere*. From your life experiences. From conversations you have with friends, family, or strangers. From things you read in the news. From things you saw in a television show, movie, or book that you thought you could

do better. From random images or ideas that pop into your head at different times and suddenly seem to form an interesting pattern. When you're a professional creative person, the world itself is—*must be*—your inspiration. It's the only way to ensure that your ideas will be fresh and different—and that you're not ripping off the same popular stuff lesser talents are. Even more important, it will make sure your work speaks *to* the world, and to people's real lives and struggles, even if filtered through a prism of fantasy.

In this instance, our inspiration came from, well, ourselves. When we initially started this process, we had an idea for a teenage heist series called *Crime Girl* but realized it was remarkably similar to *Bandette*, the great digital comic Colleen was about to start with her frequent collaborator (and husband), Paul Tobin. (Tangential Wisdom: The response that will kill a prospective project faster than any other isn't "This won't sell" or "This isn't any good," but *"We're already doing that."*)

Then we remembered an idea we had for a miniseries while we were doing *Incredible Hercules*. The interplay between fun-loving, empathic Herc and his dour, berserker brother Ares, the god of war, was huge fun, and Greg had the idea of visiting the immortal half-brothers' rivalry at various times across history: battling Thor as Vikings, getting wrapped up in the Napoleonic Wars, romancing Jane Austen.

A lot of people ask us how to break into Marvel or DC Comics, and talk about the story ideas they have for Batman or Spider-Man. Those are great characters, and we love them. We mean really. *Love* them. But they're also toys that are owned by someone else. These days the Big Two generally won't hire you unless you've written some comics of your own first, so whenever you come up with a story idea that involves a hero with

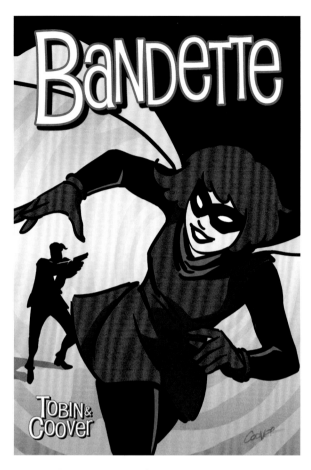

Bandette was nominated for four Eisner Awards in 2013, including a much-deserved artist nod for Colleen herself, and was named the Best Digital Comic of the year. (Art and design by Colleen Coover.)

characters, make them women? Colleen can draw pretty much anything, but it's her women for which she's best known. (Tangential Wisdom: *Write to your artist's strengths*.) And it put a spin on an old, familiar formula.

At this point we started to move away from the mythical and historical aspects into a more fantastical sword-and-sorcery setting, as that's a genre we both love but haven't done much professional work in. Perhaps the greatest duo in American fantasy are Fritz Leiber's creations, Fafhrd and the Gray Mouser, the oversized barbarian and diminutive thief who brawl and steal their way through his *Swords* series of novels and short stories, and we couldn't help but be reminded of how much we loved those tales as kids.

We know, we know: you're thinking, *Wait, you're just tweaking somebody else's idea by combining it with your idea, which was based on the ancient Greeks' mythological ideas?* But it's even worse than that! Leiber, as it turns out, got his inspiration for Fafhrd and the Gray Mouser from another friend of his, sci-fi fan Harry Otto Fischer. Fischer came up with the characters and Leiber wrote the stories. But where did Fischer get *his* idea from? Thor and Loki, perhaps? The reality is that virtually every storytelling trope is thousands of years old and has been mined countless times. The challenge is to find your own take, that version so personal and specific that only *you* could write it.

Again, to keep it fresh, we decided to switch up some familiar clichés: our pair would be mismatched in size, like Leiber's duo (and like Hercules and his buddy Amadeus Cho, come to think of it), but our plus-sized girl would be the nimble thief, and the wiry petite girl would be the accomplished warrior.

We also made the decision to tweak the traditional swords-and-sorcery setting a bit, moving it farther east from mythical England or Norway, which would enable us to have a more multicultural cast and draw on a greater variety of real-world histories and traditions. So our world is near a coast or river somewhere along the border between a mythical Eastern Europe and a mythical Central Asia.

As we chatted about our characters' first adventure, a third character emerged—a childhood playmate, the bratty kid who always wants to play in their games while growing up, someone we all knew as kids, but with one important difference: sent to play with the servant kids when she was a youth, this third girl is a princess and heir to the throne. So the seeds of

the "®" symbol and a corporation's name attached to it, always, *always* keep in the back of your mind a version that doesn't require you to be one of the few dozen people currently being paid by Disney or Warner Brothers to write for Marvel or DC Comics . . . even if that *is* your end goal! Those are fantastic companies, and we've worked for both of them. But if you're a freelance writer, you want to be able to tell your stories regardless of which specific company might be interested in publishing them.

So once we had to replace *Crime Girl*, we gravitated back to what was so fun about the Hercules/Ares relationship and landed once more on the buddy-adventure genre. Over burgers one day, the idea just struck us: to change things up a bit, why not gender-swap our main

conflict are sown in childhood, and a jealousy/rivalry forms that lasts to early adulthood. From character, a rudimentary plot forms.

At this point Fred's notebook is filled with options jotted down quickly and just as quickly crossed out:

General Setting? 18th century? Rustic? *Braveheart*? Boonie-shire? Versailles (as an isolated location, not as a palace design)

The princess—is she bastard/illegitimate? Does she need an escort to go to the capital to get married? Does she spring our heroes from the dungeon to bring her there?

The interplay became too fast and furious to re-create here (or, for that matter, capture in hand-written notes), but suffice it to say we swiftly found a direction and a twist that pleased us. Keeping in mind we only had about eight pages to work from within the confines (and budget) of this book, we jotted down a superfast outline that may not make any sense to you now but, trust us, will get a lot clearer as we move along—or, as often happens, it might change entirely! (Remember, we were doing this in "real time," folks!)

1. Childhood
2. Revisit as adults
3. Inside thieves' guild
4. Caught—fight!
5. Fight! II
6. Mad escape!
7. Captured! Dungeon!
8. Stay of execution, princess reveal—
 "To be continued"

They call these kinds of things *"rough outlines"* for a reason. But it's enough to work out a script from—and enough to send character descriptions to Colleen. This is the point at which true collaboration begins: she'll get inspiration from the notes we send her at the early stages, and then we'll get inspiration from her designs to write the final script.

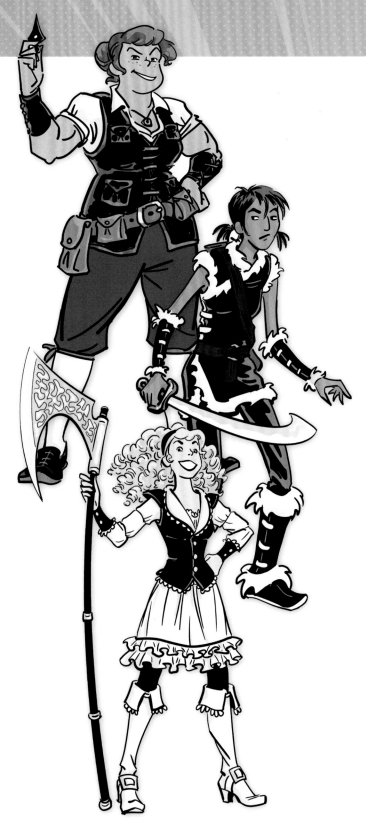

Top: Gudrid character design by Colleen Coover.

Middle: Khu character design by Colleen Coover.

Bottom: Sophie character design by Colleen Coover.

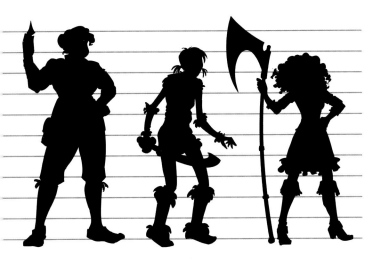

Any of our three *Swordmaids* leads can be quickly identified by the reader from her outline alone—a frequent component of cartooning success.

Here are the broad descriptions of our characters that we sent to Colleen:

GUDRID (actual Norse woman's name Fred looked up in a Viking role-playing game book): The thief of our roguish duo, she is, shall we say, "plus-sized" but in full possession of her self-esteem and in the modern era would be described as, for lack of a better word, sassy: "Screw you, I'm sexy and I know it." She has exceptionally nimble and graceful hands and prefers long-ranged weapons like throwing daggers, as she can't move all that fast to close distance between attackers. But she's good at carrying loot! Squeezing into small places isn't her strong suit, but hey, that's what she has Khu for.

KHU (Short for "Khutulun," which is the actual name of a Mongolian warrior princess, niece of Kublai Khan (or so Wikipedia tells us)): Tall and wiry. Goth Mongol warrior chick—dark-minded, cranky, cynical, but, like all cynics, is really a wounded idealist at heart. Gets "Hey, honey, why don't you smile more?" catcalls from would-be wiseguys in the street . . . until she stabs them in the face, that is. Her preferred weapon is a long blade with an axe-shaped extension on one

side. Unlike Gudrid, gets up close and personal in combat. Very agile—she's the second-story specialist of the duo, climbing into high tower windows, stealthily taking out the guards (lethally or non-), then making her way to the ground floor to let Gudrid inside.

These two are about nineteen or twenty years old, friends since birth, and have been adventuring for a couple of years now. The perfect team, making their way through ruins, wizards' lairs, and teeming cities alike in search of gold and glory!

Then, into, or rather back into their lives, comes . . .

SOPHIE, sixteen, who used to pester to join in the fun when they were kids and drove Gudrid and Khu crazy. But now she's the all-grown-up-and-spoiled heir to the kingdom. Betrothed to some faceless princeling in a faraway land to solidify an alliance of her father's, Sophie wants to go on a big adventure before she's married off, and when Khu and Gudrid wind up in her dungeon, she thinks she has found the perfect patsies to "kidnap her" and lead her off in a grand quest.

If this plan sounds crazy, that's because it is, and because Sophie is—she's a little bundle of psychoses (she should be shorter than both Khu and Gudrid) and has had her father's smiths forge her a grand gold weapon bigger than she is. She has no impulse control, is used to getting her way in every little thing. In other words: World's Worst Adventuring Companion, but since she's the only thing standing between our heroes and the gallows, what else are they supposed to do?

We think Colleen's completed designs (on the opposite page) are pretty awesome. Take special note of the characters' relative sizes and silhouettes—surprisingly crucial when creating memorable comic book characters. Think of Mickey Mouse's ears and Batman's cowl—these are recognized around the world just by their basic shapes.

So we've got our idea. We've got our team. Now how the heck do we actually *create* a comic book?

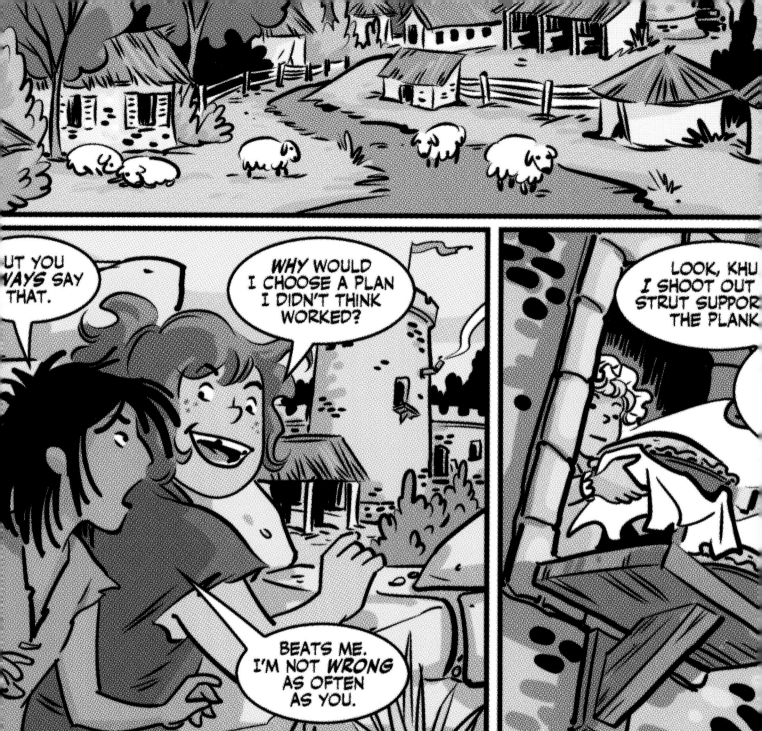

UT YOU
WAYS SAY
THAT.

WHY WOULD
I CHOOSE A PLAN
I DIDN'T THINK
WORKED?

BEATS ME.
I'M NOT *WRONG*
AS OFTEN
AS YOU.

LOOK, KHU
I SHOOT OUT
STRUT SUPPOR
THE PLANK

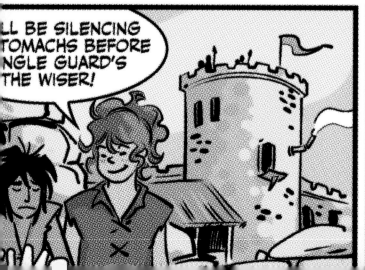

LL BE SILENCING
TOMACHS BEFORE
NGLE GUARD'S
THE WISER!

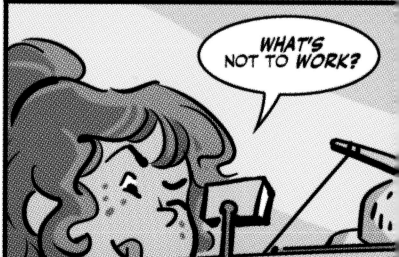

WHAT'S
NOT TO *WORK?*

WRITING FOR PICTURES

KNOW YOUR PREMISE

One of the biggest challenges of telling a longer dramatic story is figuring out just what your story's really about.

Some people talk about a story's *theme*. We like legendary playwriting teacher Lajos Egri's use of the term *premise*. As we interpret Egri, the premise of a story can be stated in a sentence with an action verb and boils down to a massive cosmic truth that describes the journey your characters are taking.

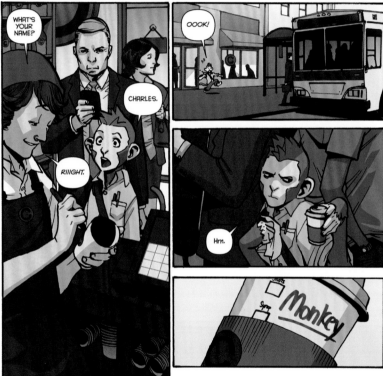

Code Monkey Save World, page 1. Pencils and inks by Takeshi Miyazawa, colors by Jessica Kholinne, letters by Simon Bowland. For more on this comics page, see page 16.

So the premise of *Macbeth* might be: untrammeled ambition will consume your soul. If you go back and look at the way Shakespeare tells his tale, every scene, in one way or another, pushes the story toward the fulfillment of that premise. So knowing your premise becomes critical for helping you decide what scenes stay and what scenes go, for figuring out what's really essential to your story.

When Greg was outlining his "Planet Hulk" saga, which followed the exiled Hulk on an alien planet going from slave to gladiator to rebel to emperor, he wrote "monster to hero" on a piece of paper and stuck it on his bulletin board. That was the key journey for the Hulk, and it

was hugely helpful to keep in mind throughout the many months Greg wrote the story.

But the actual premise of the story was a little deeper and more specific: unbound anger, no matter how justified, leads to tragedy.

When a premise is this specific, it can help you find an answer to every question you encounter while writing. "Planet Hulk" was a sprawling epic for which Greg created an entire world with its own cultures, religions, zoology, and history, along with a big supporting cast of new allies and enemies for the Hulk. With a canvas that huge, it could be easy to get overwhelmed with the endless

The final page of the "Rio Chino" story written by Greg Pak and illustrated by Ian Kim from the *Outlaw Territory* anthology. Sometimes the classics just work.

possibilities. But Greg could look at every new idea he might have and ask himself, "How does it further the premise?"

KNOW YOUR ENDING

Another way to think about all of this is to know your ending. If you know in your bones how your story ends, you probably know your premise, even if you haven't fully articulated it. And by building toward that ending, you're choosing the settings and situations and conflicts and characters that best serve it.

This is how we worked together on *Incredible Hercules*. We can't recall ever sitting down to formally define our premise. But we knew we had two buddies alternately supporting each other and driving each other crazy. We also knew that we were telling an epic heroes' journey that would end with both of our leads growing up and truly becoming the heroes they were meant to become through tremendous sacrifice.

There's not a huge amount of specific detail in that ending. But what really mattered for us at that point was knowing the core of the emotional climax—not necessarily every specific detail of the plot. In monthly comics, things

can change at the drop of a hat as new ideas ferment in the shared universe. During the course of *Incredible Hercules*, we were offered multiple opportunities to build small events of our own or tie in to bigger Marvel Universe events. Because we knew our ending but were flexible with the precise path we needed to take to get there, we could jump on all those opportunities while still serving our bigger story.

SHOWING VS. TELLING

Comic books are a hybrid art form, using both prose and pictures to tell a story. So it's possible to use descriptive and didactic storytelling methods the way a novelist might, taking many pages to describe a character's inner thoughts, for example. But most of the comics we write are similar to movies and plays in that they rely primarily on *dramatic* storytelling, which involves creating scenes in which characters interact and conflict while striving to achieve their objectives.

This is a huge topic, worthy of everyone's further study. (We highly recommend Egri's *The Art of Dramatic Writing* and Syd Field's *Screenplay* and *Four Screenplays*.) But in a nutshell, the key principle boils down to showing versus telling.

The old writing cliché "show, don't tell" in prose means using active verbs instead of flat descriptors. In all forms of writing, it means don't tell us "the landlord was a meanie," have the landlord doing something or saying something mean.

On the first page of his graphic novel *Code Monkey Save World* (page 14), Greg could have just *told* readers that our hero is an outsider, treated like a second-class citizen by all those he meets. But delivered in that kind of flat description, it's just a *concept*. It doesn't live and breathe until and unless we actually *show* it. So on the last panel of that first page, Code Monkey sees that the coffee shop barista has written "Monkey" on his cup, and we totally feel his pain.

Our medium deals in images and action. Whenever we can move our story forward by showing the characters actually *doing* things rather than just having someone describing or explaining things, we're winning.

INNER VOICE

So now that we've told you all about showing versus telling, let's contradict ourselves for one brief moment. As we mentioned before, comics are a hybrid art form; they use both pictures and the written word to tell stories. We both were trained in film school, so when we came into comics, we had a screenwriter's suspicion of voiceover. In film, relying on spoken internal voice to carry the story can feel like cheating. But the longer we've worked in comics, the more we've come to appreciate the use of captions to present the characters' thoughts. We *watch* movies, but we *read* comics. And sometimes embracing the written word can be the most efficient and effective way to convey character and emotion.

Your narration should never simply restate in words what the artist is already conveying in pictures. If you're writing a Batman comic, and you're calling for the shot of a city at night, there's no reason to add a caption "Night falls over Gotham City." Fred's artist friends at Syracuse kept an old *Avengers* comic around with a similar example: a hero was fighting a villain and the floor got blown out underneath him and as he plummeted through the hole he yelled out, "Oh no I am falling downward!" (As opposed to upward?) Fred's friends thought this was the funniest, cheesiest thing they'd ever seen. (Well, they *were* in college.)

Narration should always enhance the art—or, at times, elucidate more abstract concepts difficult to convey in pictures, such as the in-the-head psionic powers of the psychic Secret Service agent Brain Boy on page 17. Even better, you can use narration to contradict the images or provide a dissonant counterexample, something *Understanding Comics* author Scott McCloud calls a "parallel" word/combination—i.e., where the words and pictures don't intersect.

In all cases, the writer can never forget that he or she is trying to create a comic book—a storytelling medium in which art is king. You can share the spotlight with the artist, but you should never try to hog it.

Opposite: Fred Van Lente's inner monologue plus Freddie Williams III's artwork together show how a psychic Secret Service agent scans a hotel for potential threats to the US president in *Brain Boy*. Neither the art nor the words would make much sense separated from the other. Letters by Nate Piekos. Colors by Ego.

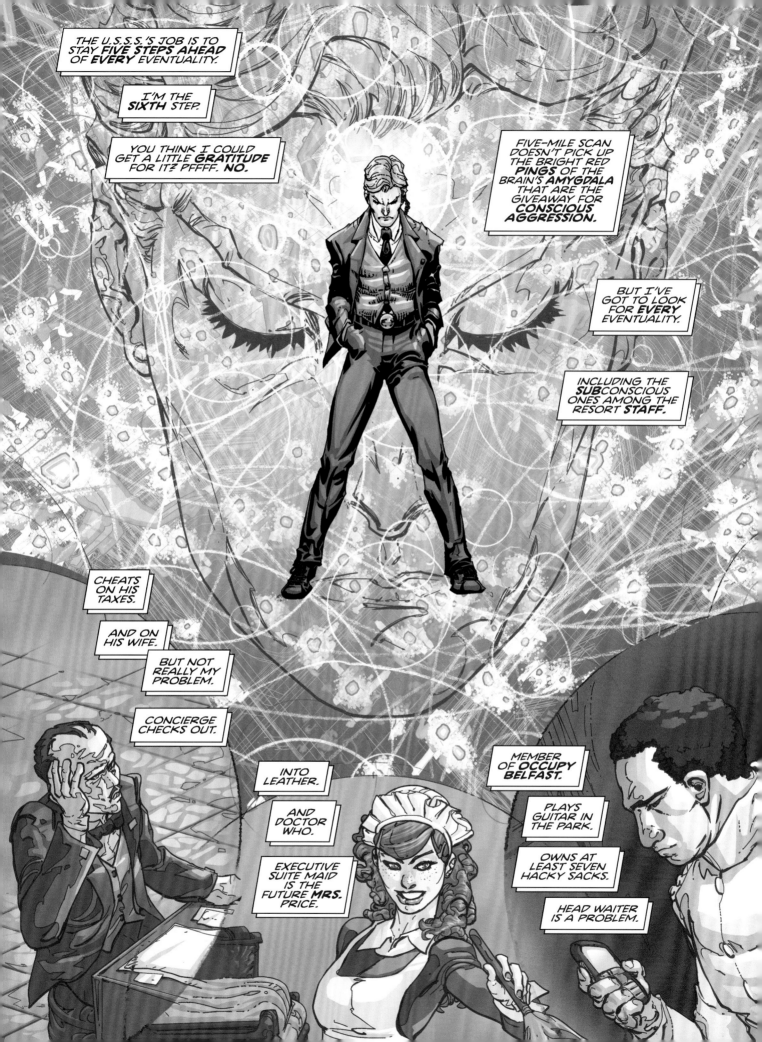

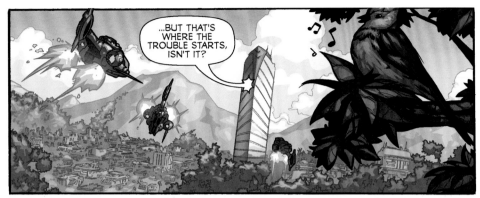

...BUT THAT'S WHERE THE TROUBLE STARTS, ISN'T IT?

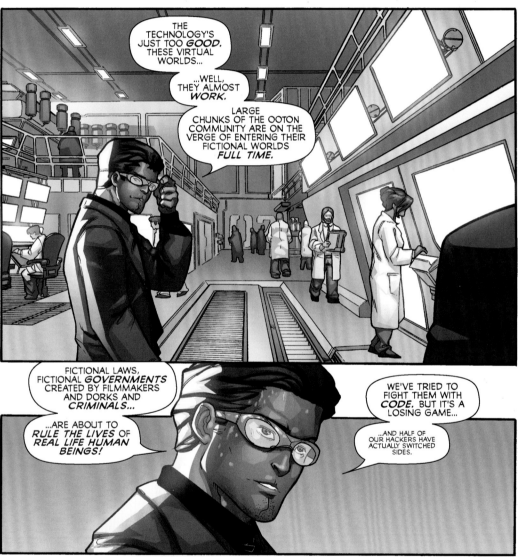

THE TECHNOLOGY'S JUST TOO *GOOD.* THESE VIRTUAL WORLDS...

...WELL, THEY ALMOST *WORK.*

LARGE CHUNKS OF THE OOTON COMMUNITY ARE ON THE VERGE OF ENTERING THEIR FICTIONAL WORLDS *FULL TIME.*

FICTIONAL LAWS, FICTIONAL *GOVERNMENTS* CREATED BY FILMMAKERS AND DORKS AND *CRIMINALS...*

...ARE ABOUT TO *RULE THE LIVES* OF *REAL LIFE HUMAN BEINGS!*

WE'VE TRIED TO FIGHT THEM WITH *CODE.* BUT IT'S A LOSING GAME...

...AND HALF OF OUR HACKERS HAVE ACTUALLY SWITCHED SIDES.

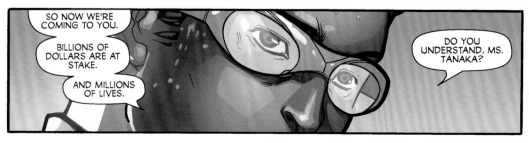

SO NOW WE'RE COMING TO YOU.

BILLIONS OF DOLLARS ARE AT STAKE.

AND MILLIONS OF LIVES.

DO YOU UNDERSTAND, MS. TANAKA?

Vision Machine page 21

BUILDING HOOKS

In a good movie, something intriguing or shocking almost always happens in the first two minutes. There's another point about five minutes in when the plot thickens and a new little twist keeps us watching. Another surprise hits around the fifteen minute mark, and then after a half hour or so, we reach the end of the first act with a key turnaround that hooks us for good.

Screenwriters and filmmakers work with *time*; all these hooks are designed to keep the viewer watching another few minutes.

Comics have a similar pattern, but since comic book readers determine the pace of their reading, the hooks are based on physical *pages* rather than time. A filmmaker has to give viewers a reason to keep watching every second and every minute. A comic book writer needs to give readers a reason to move to the next panel and turn to the next page—and with monthly comics, to buy the next issue.

So every panel in a comic book ideally should have its own tiny cliffhanger. The last panel of a page needs a bigger cliffhanger. And even bigger turning points need to hit around page five and especially on the last page of the book. Let's look at a couple of pages from Greg's graphic novel *Vision Machine* (pages 18 and 20) for some examples.

Page 21, panel 1: We're in an exterior location with funky-looking flying ships heading toward an interesting-looking building. Penciller RB Silva's layout focuses our attention on that building and makes us want to find out what's inside. And the text in the balloon pointing to that building ends with a question mark. If we want to find out who's talking and what the answer to that question is, we better keep reading!

Page 21, panel 2: Now we're inside the building, in a big, cool control room or lab of some kind. Again, RB has drawn the image invitingly, with one-point perspective that draws us into the image with converging lines. Subconsciously, we want to get closer. So we have to keep reading. Also, Chavez, one of the story's antagonists, addresses us directly and describes the dangers caused by Buddy, the real hero of the book. If we want to find out what's at stake for Buddy, we have to keep reading.

Page 21, panel 3: Now we're closer on Chavez—and we see sweat on his face. Up until this point, we've never seen Chavez lose his cool. Suspense increases—there's something really dangerous afoot.

Page 21, panel 4: And now we have an extreme close-up on a sweating, scared Chavez—who says millions of lives are at stake. To top it off, we end with the reveal that he's talking with someone named Tanaka, and we already know that one of Buddy's best friends has that last name! The plot just thickened big-time. And the last balloon ends with a question mark. We'd better turn the page!

Page 22, panel 1: Now we're on the last page of the issue. We open with the reveal that Chavez is indeed talking with Jane Tanaka, Buddy's friend (and unrequited love interest). She has a sharp expression on her face. Is that anger at Chavez . . . or Buddy? Gotta keep reading!

Page 22, panel 2: Now we're closer on Jane—and, shockingly, she's changing, turning crimson, and the background is transforming, turning dark and cloudy. If we want to find out where this transformation is going, we had best keep reading. And once again, the panel ends with a question mark, nudging us subconsciously to jump to the next panel for the answer.

Page 22, panel 3: We pull back to see a transformed Jane in dark-angel form with a flaming sword. And we get an inset close-up of Jane saying, "Don't you mean *destroy*?" Which is both a question and the final reveal that she's ready to go into battle against Buddy. That's how our issue ends, with the most important romantic relationship in the book turned upside down, a death threat issued, and the promise of insane virtual world warfare.

Clearly, not every comic book will end with the promise of imminent death and sci-fi action. But the idea of the hook applies regardless of genre. Maybe the hook in your story will turn on something as gentle and subtle as waiting for a leaf to fall to the ground. But every panel and every page wants that hook.

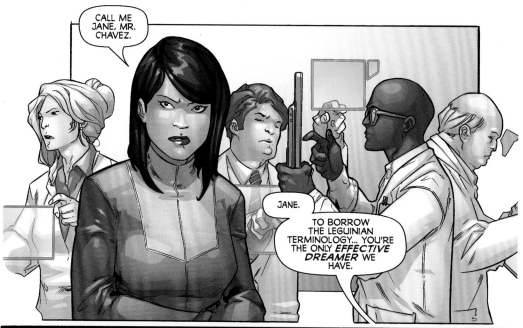

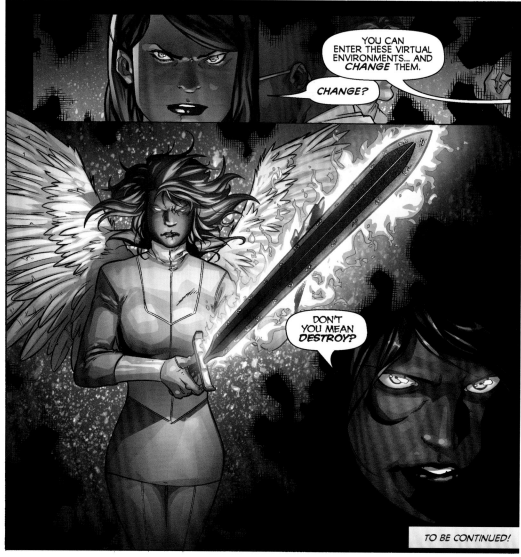

Vision Machine
page 22

SCRIPT FORMAT

And now perhaps the most practical of all of our bits of extremely practical advice: We answer the perennial question, "How the heck do you actually format one of these scripts?"

Unlike a prose short story or novel that's a complete work unto itself, a comic book script is an internal document, a blueprint for the creative team to use in creating another work. So a simple rule of thumb for a comic book writer is this: How can you expect to get what you want if you don't ask for it?

A lot of neophytes hesitate to be specific for fear of offending artists or seeming "pushy." But experience has taught us that nothing frustrates a penciller more than having us writers dither or be vague in direction. Or, worse, to ask for changes to finished artwork later on because we weren't clear on what we wanted in the first place.

The key is to provide not too much or too little direction for an artist, but the exact right amount. Obviously, that's easier said than done, more of an art than an exact science. Alan Moore, perhaps the most lauded modern comics writer, is (in)famous for the detail he lavishes on each script; his description of the first *panel* of *Watchmen*, one of the most celebrated opening sequences in comics, runs over a page long!

As much as we'd recommend emulating Alan Moore in many other things, this is not necessarily one of them. We can only imagine how today's pencillers would react to a newbie writer turning in a script with a few pages *per panel*, which could lead to a 100-page script for a 20- or 22-page comic. Unless you actually happen to be Alan Moore, it seems likely that the artists would run screaming for the hills.

Succinctness in panel descriptions encourages clarity, the single most important feature of a panel description. Fred hews to the maxim that *one sentence per panel* is the desirable goal. A rarely achieved, but worthy, goal.

FORMATTING IN MICROSOFT WORD

Unlike screenwriting, comics scripting has no standardized format, although many comics scripts are written *in* screenplay format, thanks to the popularity of the Final Draft word processing program over the past few decades. Both Greg and Fred went to film school, and those experiences informed the development of their individual format styles, though in quite different ways.

Fred's format is modeled after the scripts to an unpublished *Howard the Duck* miniseries uploaded to the old pre-Internet network CompuServe back in the 1980s by the late, great Steve Gerber, the writer who created

(continued on page 24)

CREATING A COMICS SCRIPT TEMPLATE IN MICROSOFT WORD

✕ Choose New Blank Document in the File pull-down menu.

✕ Go to Format > Style and click New.

✕ In the Name field, type "Comics Page Number."

✕ In the Font window, choose your font: Bold, Underline, and 16-point size.

✕ From the pop-up menu in the lower left-hand corner, select Paragraph. In Spacing type 12pt after and 3pt before.

✕ Click OK.

✕ Go to Format > Style and click New.

✕ In the Name field, type "Comics Dialogue."

✕ Leave the Font and Size for this one the same as Normal.

✕ From the pop-up menu in the lower left-hand corner, select Paragraph. Under Indentation, choose Hanging, and give it a 2" drop. In Spacing, type 6pt before and 3pt after.

✕ Click OK.

✕ For Panel Descriptions, just leave the Style as Normal.

✕ Save your still-blank document as a Template by choosing File > Save As and then Word Template from the pop-up menu. Name it "My Comics Script Format" or something like that. This way, whenever you open the Project Gallery and click the My Templates button, you'll have it readily available.

✕ Write your script toggling between the different Styles as necessary, selecting Format > Style > Apply Style.

✕ Fred also maintains free downloadable script templates at fredvanlente.com/comix.html.

ARCHER & ARMSTRONG #12: "500 SHADES OF GREYS"
Written by Fred Van Lente / © 2013 Valiant

<u>ONE</u>

<u>PERE</u> - All these panels should be PAGE WIDTH, WIDESCREEN style, stacked on top of each other, with panel 1 being the biggest.

Panel 1: BIG PANEL: LONG SHOT: Per the opening of *Patton*, GENERAL REDACTED walks out in front of a ridiculously huge U.S. flag: http://www.liveleak.com/view?i=5cb_1178900597

1. LOCATOR:	FARAWAY. OTHERWHEN.	
2. SFX (FOOTSTEPS):	*tek tek tek tek*	

Panel 2: Zoom in: Redacted turns to us, hands folded behind his back, holding riding crop.

3. REDACTED:	Boys.	
4. REDACTED:	As many of you know, I came here looking for *lost pilots*.	
5. REDACTED:	*Flight 19.*	
6. REDACTED:	I sent them out, in the early days of *Rising Spirit*, to research the military possibilities of the *Bermuda Triangle*.	
7. REDACTED:	And they flew off, into *nothingness*, never to return.	

Panel 3: Tighter in on Redacted.

8. REDACTED:	*Most* said, "*give up* on them boys. They just plum *vanished*."	
9. REDACTED:	But not *me*. I tracked their signal for *years*. 'Til it finally popped up again. Four thousand xxxx klicks *away*.	

Panel 4: Tighter in on Redacted. A single tear rolls down his single, working eye.

10. REDACTED:	While that signal led me here, I never *did* find them.	
11. REDACTED:	I *did* find *you*.	
12. REDACTED:	And let me just say . . .	
13. REDACTED:	...you are the *finest* fliers it has ever been this broken-down bomber jockey's *privilege* to command.	

<u>TWO</u>

Panel 1: HUGE PANEL - NEAR-SPLASH - REVERSE ANGLE - WIDE ANGLE - Of DOZENS upon DOZENS of ALIEN GREYS wearing leather aviator helmets and goggles pushed on their foreheads, gloves and white scarves, standing erect at attention, listening to Redacted's speech. I want to see lots of Greys here, Pere-feel free to Photoshop as many in as you want!

1. TITLE: ***500 SHADES OF GREYS***

2. CREDITS: By Fred, Pere, and Friends.

3. REDACTED (OFF): I'd fight with you ***wrinkly sons of*** xxxxxxx anywhere, ***any***time, any***place***.

4. REDACTED (OFF): Today we go ***out*** and ***finish*** the mission Flight 19 ***started***.

5. REDACTED (OFF): We will bring the heathen collectivist Bolsheviks of ***New Roanoke*** to ***heel***.

6. REDACTED (OFF): And use the Faraway as our ***beachhead***-to return to the outside world-

Panel 2: Shoot over Greys' shoulders-they shoot their fists high as Redacted raises his crop over his head.

7. REDACTED (BIG): -and ***save*** it from ***itself!***

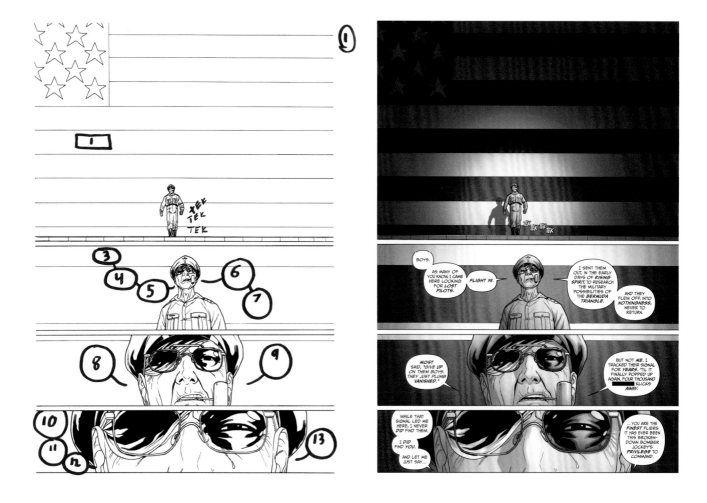

Howard and who had defining runs on Marvel's *Defenders*, *Man-Thing*, *Daredevil*, and *Guardians of the Galaxy*. The template's distinguishing characteristic is the numbers beside the speaker of dialogue. This is something of an archaic holdover from the days in which all lettering was done by hand, but the practice still helps the editor "balloon out" the dialogue on a photocopy of the artwork to show placement to the letterer to save time and confusion. As you can see in the example from Fred's Valiant series *Archer & Armstrong* on pages 22–23, numbers of the lines on the script correspond to the numbers in the balloon guide for the letterer.

Fred started writing scripts in this style for his artist buddies in college. When he landed his first professional gig at Platinum Studios, where he wrote the graphic novel *Cowboys & Aliens*, his editor, Lee Nordling, requested a few format changes. First, Lee asked that if a finished comic page required multiple script pages to describe, the bottom of the script pages should include a "More" or "Continued" tag. This prevents the unpleasant pencilling disaster of an artist laying out a four-panel *comics* page only to turn the *script* page and discover two more panels she was supposed to add!

Did the discussion of comics page versus script page get a little confusing in that last paragraph? There's a good reason for that: it *is* confusing. After too many misunderstandings in conversations with artists or editors over whether they were talking about "comics page 12" or "script page 12," Fred just eliminated page numbers for the comic script, leaving only the markers for the correct comics page.

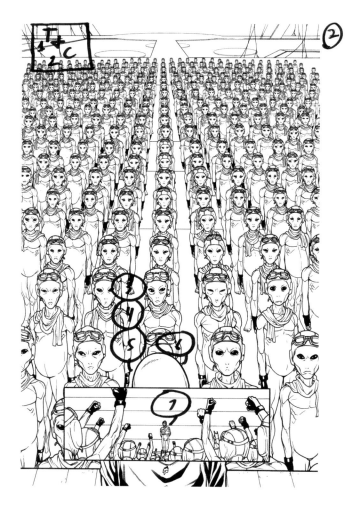

In fact, the entire point of this script format is to make things as clear as possible for the artist and facilitate easy collaboration. In this template, the description of a new comics page always begins at the top of a new script page, even if the description of the page is only a few sentences long (sorry, trees). The dialogue is indented in a clearly different way from the panel descriptions so that the artist can tell the difference between the two at an instant's glance. To extrapolate further from the one-sentence-per-panel ideal, the ideal for scriptwriting for Fred is to fit one page of comic book onto one page of comics script; but if the ideal fails and the description of the comics page continues on the next script page, that fact is clearly indicated.

Archer & Armstrong editor Josh Johns uses the numbers on Fred's script to draw out a rough guide for letterer Simon Bowland, which informs the final arrangement of the text. (Note that not every line makes the final cut!) Line art by Pere Perez, colors by David Baron, letters by Simon Bowland.

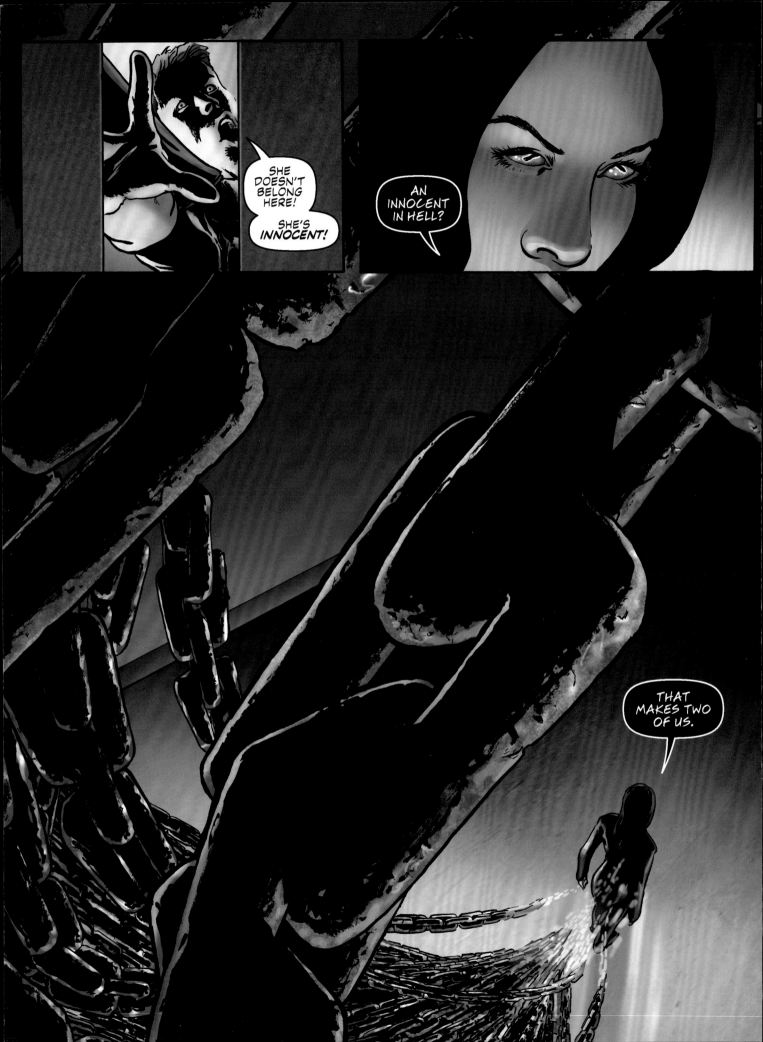

FORMATTING IN FINAL DRAFT

These days, Greg writes most of his comic scripts in Microsoft Word, using the format you'll see later for the *Swordmaids* script, mainly because Word's "Track Changes" feature allows you to see to the previous version of any particular tweak. This can be handy when collaborating. Final Draft allows for clear labeling of edits with customized colors but doesn't retain information about what has been cut or tweaked.

But when Greg started in comics, his word processor of choice was Final Draft, the software he first used to write screenplays two decades ago as a film student. The advantages of Final Draft include keystroke commands for quick format transitions, autocompletion for frequently used character names, and the general non-bugginess and crash-resistance of the software.

For those of you who prefer Final Draft, here's how Greg tweaks the format for comic book scripting, as you can see in this excerpt from the *Dead Man's Run* series Greg wrote for Aspen Comics and Gale Anne Hurd's Valhalla.

First, get rid of the standard INT. LOCATION - DAY headers, and label scenes by page and panel number instead. As in Fred's format, each new comics page gets a new page break in the comic script. And the PAGE ONE and Panel 1: headings are bolded to make the distinct panels crystal clear.

Second, for each individual panel, write out all of the action first and then the dialogue. This goes against typical screenwriter instincts for seamlessly mixing action and dialogue for a fast, snappy read, but it takes into account the static nature of the comics medium—we're seeing one image at a time, not moving images, so describing the panel in one block of text makes sense. A lot of people like to think of comics as "movies on paper," but to us, that's an inadequate analogy. Motion pictures, you know, *move*; so they can do things comics can't. The subtle variations of expression on an actor's face in a single take can show as much meaning as multiple comics panels. Likewise, because comics is a literary medium, single individual moments can be savored by creators and readers in ways that would be difficult (or worse, boring) in film—but much more on that in the next chapter.

29.

PAGE EIGHTEEN

Panel 1: Sam, dragged away. The door is closing before him -- he's reaching towards us.

 SAM
 She doesn't belong here!
 (link)
 She's *innocent*!

Panel 2: Extreme close on the Warden. She's quietly, dangerously amused.

 WARDEN
 An innocent in Hell?

Panel 3: BIG panel -- two thirds of the page, at least. The Warden turns, walking across her office, and we see chains binding the Warden herself -- long trailing chains that descend from above and connect to her back like wings, a la the #0 cover -- she's a prisoner herself. The chains are translucent at their highest ends, helping create the sense that they're always there but only sometimes visible.

 WARDEN
 That makes two of us.

The Warden of Hell reveals her own chains in *Dead Man's Run* #1, written by Greg Pak with art by Tony Parker, colors by Peter Steigerwald, and letters by Josh Reed.

FULL SCRIPT VS. MARVEL METHOD

We've been focusing on formatting for full scripts, in which all the plot and dialogue are described in detail. But another form of comics scripting that once dominated our field is the "plot first" style or "Marvel Method."

After the comics field all but collapsed in the mid-1950s, the owner of Atlas Comics (which would later become Marvel) had editor-in-chief Stan Lee fire almost his entire staff. But Lee still had to produce sixteen bimonthly books every eight weeks with himself as sole writer. Blessed with such legendary talents as Jack Kirby and Steve Ditko, who in addition to being definitively brilliant pencillers were formidable all-around storytelling geniuses in their own right, Lee developed a time-saving method for comics scripting.

If a comics script is a blueprint, Lee wrote a blueprint for the blueprint, with just a few sentences describing each page. Sometimes he just gave his artists a simple verbal description of the story over the phone. Then the penciller would work out the panel-by-panel story beats himself. Once the finished boards were turned in, Lee would dictate the dialogue to be added to the artwork.

Given Marvel's popularity after the publication of *Fantastic Four* #1 in 1961, Lee's method was quickly adopted as one of the primary means of writing comics in America. On the plus side, the Marvel Method makes the working relationship between writer and penciller both looser and closer at the same time. *Looser* because the writer cedes huge storytelling decisions to the artist, who chooses the shots (literally and figuratively) and the overall pace of the tale on the page as the visuals come to life. When laboring over neurotically overdetailed full scripts, artists sometimes complain of feeling no better than hired hands (a popular term is "art monkey"). With the Marvel Method, artists are unequivocally collaborative equals, as well they should be.

Under the Marvel Method, the relationship between artist and writer also becomes much *closer* because the writer then has to tailor his or her dialogue to suit the expressions of the characters on the finished art, which can lead to a much more organic storytelling experience for the reader. Nothing is more cringe-worthy than a finished comic in which it is clear the artist and writer have been working at cross-purposes!

That said, many writers simply aren't comfortable with the Marvel Method. Recent comics writers coming out of film school probably have a stronger interest in picking camera angles and influencing the look of the comics they write (and yes, we're blushing, toe in dirt). And as comics have become more "writerly" and superhero tales in general more sophisticated, story beats land more often on a single line, an expression of a character's face, or other similarly subtle factors. More traditional stories focused on the unbridled action of Hero A foiling Villain B's dastardly crime probably allow for a wider variety of visual interpretation of plots and might seem like a better match for the Marvel Method.

But we've recently had a breakthrough with our own use of the Marvel Method. We've even begun to *prefer* it for some projects. The trick for us was to simply treat it as a normal script—but with no dialogue. So we break down everything page by page and panel by panel as usual. But instead of writing out fully polished dialogue, we write short sentences describing what the characters say—and the intended emotional impact.

This took a bit of practice. In the past, we felt we needed to hammer out every line of dialogue in order to figure out the pacing and panels. And sometimes for particularly tricky pages, we'll still include the finished dialogue in one of our Marvel Method scripts. But as we've done more and more scripts using the Marvel Method, we've gotten better at figuring out the rhythm of a scene without writing every word the characters say. In fact, not fretting over dialogue at this stage often gives us the time to focus more sharply on the right images to nail the emotional point of a given scene.

The other key for Greg in making plot-first scripting work was to simply get on the phone with his collaborators. At the recommendation of editor Eddie Berganza, Greg started writing plot-first for his current Action Comics run. Artist Aaron Kuder does a first pass at layouts. Then Greg, Aaron, and the editors get on the phone for an hour to talk through every page and panel. It's an intense, hugely fun collaboration that's enabled the team to discover great moments in every issue that Greg never would have figured out completely on his own.

Maybe the biggest practical challenge with the Marvel Method is staying on top of the schedule in order to give yourself enough time to write and polish the dialogue when the art comes in. In other words, don't wait until the last bit of finished art arrives, or you'll end up having to dialogue the whole thing in a single night before it's rushed to the printer. And while you may feel sorry for yourself that evening, the real victim in this scenario is your letterer, who you really want to be your best friend. (More on that later!)

THE *SAINT GEORGE* EXPERIMENT

Here's a fun experiment to demonstrate the fluidity of the collaboration between writer and artist in the Marvel Method. It's an excerpt from the plot of Fred's retelling of the Saint George myth with artist (and *Incredible Hercules* veteran) Reilly Brown. Read it and try to visualize the images as the artist sees them. Then turn the page and see what Reilly actually drew! How much did your conceptualization differ from the final version?

```
                    "SAINT GEORGE,"
             Part Two, Pages One and Two
```

As we discussed, George—who perhaps was wounded with an arrow in his back in the previous sequence?—wanders the Libyan Desert and gets extremely lost. He runs out of water, sun burning down, etc.

George's horse approaches an OASIS in the distance. Kneeling on a rock athwart the KYRE SPRING is a Greek princess, CLEODOLINDA ("CLEO"), dressed as a bride. Cleo is a wannabe Oracle, or Greek Goth girl.

Cleo turns toward George, having heard the horse's approach. She calls out, trying to warn the rider away. She has chosen to die this way honorably, and needs no rescue! And he should leave now, for she does not want him to share her fate!

But George, who among his many other issues, is also unconscious, slides sideways off his saddle . . .

. . . and flops on his back in a cloud of sand by the bank of the spring!

Cleo looks down at the unconscious George for a panel. Then:

"Great," she says.

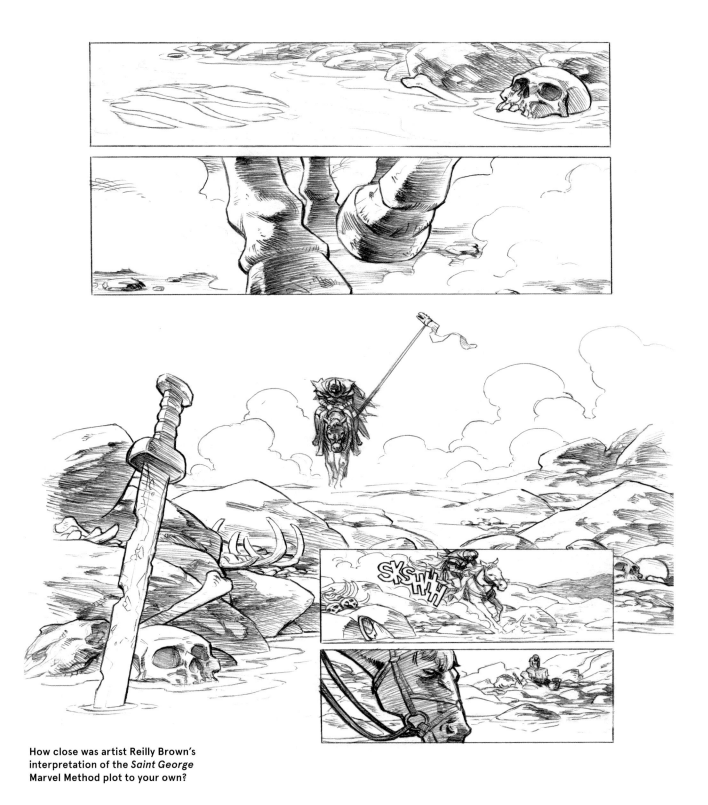

How close was artist Reilly Brown's interpretation of the *Saint George* Marvel Method plot to your own?

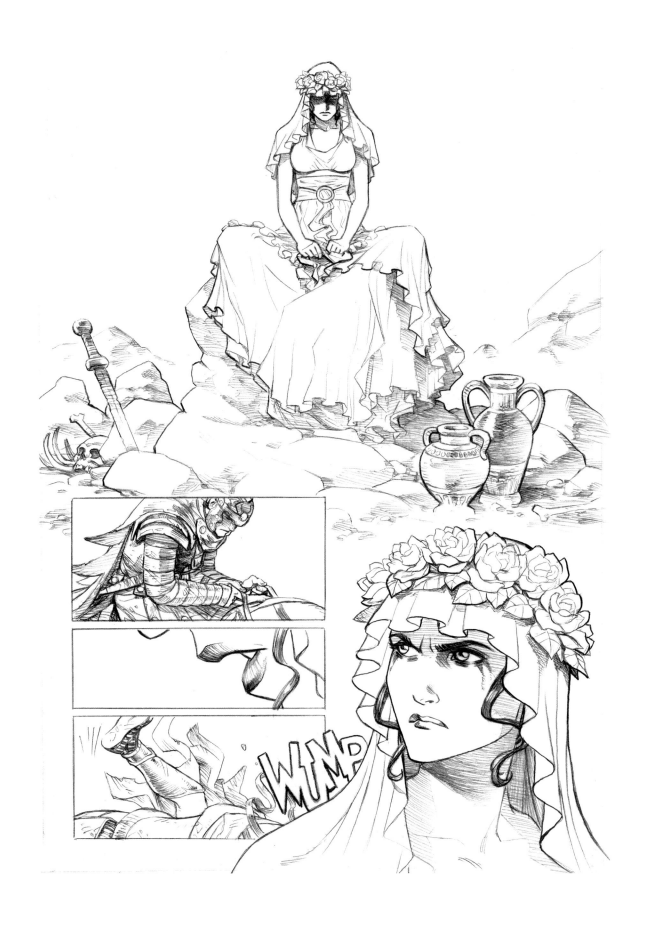

Swordmaids
The Script

All righty, in the introduction we told you how we came up with the idea for *Swordmaids* and brought Colleen on board to realize it visually. Here's our script for the first 8-page installment of the first storyline. Note how we bring a lot of what we discussed earlier to bear here.

Additionally, here are a few helpful explanations for some of the jargon and formatting conventions you'll see in the script:

ITALIC OR BOLD-ITALICIZED WORDS in dialogue are meant to be bolded by the letterer, indicating the speaker's emphasis. Many people weaned on prose fiction can find all this a bit excessive and a lot of writers never bold any words at all, but we believe that because comics is primarily a visual medium, the visual emphasis on the words results in a more natural cadence of speech.

LOCATOR: Special blurbs at the opening of the scenes showing where the action takes place, like *Law & Order* and *X-Files* always used to do—fairly standard in American comics these days.

PARENTHETICALS: Special instructions beside the character names, frequently denoting where the tail is supposed to go:

OFF: The character is off-panel, so the tail should trail off in that direction.

Here we have an example of a tail of a balloon trailing off-panel (as well as SFX and bold/italics).

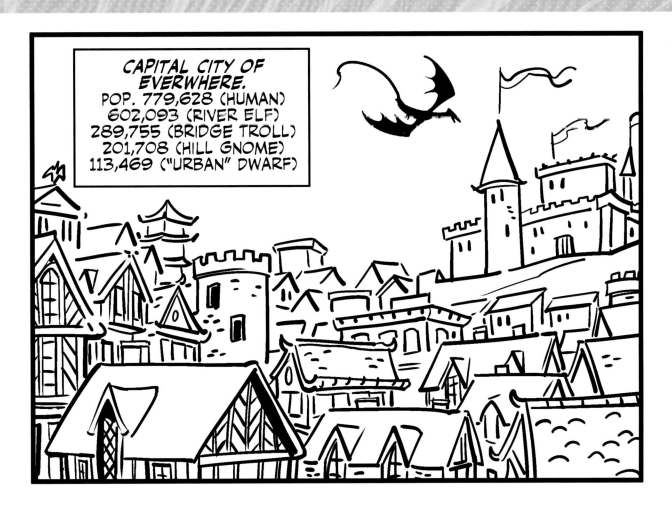

A locator also often provides additional details, such as the time frame in which a story takes place, to orient the reader in the story.

DOWN/UP: Indicating where the character *is* off-panel by the direction the balloon tail is pointing.

SMALL: This requests the letterer to drop the font size of the line a few points, to indicate a character is whispering or speaking under her breath.

BIG: Shockingly . . . the opposite of small! You're asking the letterer to pump up the font a few sizes to indicate a character yelling. ALSO OFTEN INDICATED BY WRITING IN ALL CAPS, YOU KNOW, JUST LIKE YOUR UNCLE DOES IN EMAIL.

SFX: Meaning *sound effects*, which a letterer typically does in a different font than the dialogue, without balloons.

[CHARACTER NAME]'S VOICE: This is a very cinematic way of describing captions with lines indicated by quotation marks that contain dialogue by a character not even physically present in the scene (as opposed to "off," which is just characters not physically present in the panel). The comics equivalent to movie voice-overs.

. . . : Ellipsis points, a conceit ripped off from manga, indicate a character is hesitating before speaking. Probably overused in today's comics, but they bear demonstrating here.

SWORDMAIDS: Chapter One

Written by Greg Pak and Fred Van Lente / 2013.04.08

<u>ONE</u>

Panel 1: Establishing shot of a sleepy little medieval village. Small, thatched-roof cottages around a small, one-towered castle. Sheep pastures surrounding the area. Rustic. Rather than a purely European style, though, feel free to work in some central-Asian elements—maybe yurts on the edges of town. Our fantasy world here is off somewhere along the border between Eastern Europe and Central Asia, so there's lots of cultural mixing going on here.

 1. LOCATOR: Hamlet of Muntz. Pop. 215 (Human) 4,950 (Sheep)

 2. KHU (DOWN): You're *sure* this is going to work.

 3. GUDRID (DOWN): *Sure*, I'm sure!

Panel 2: Medium shot—GUDRID and KHU as kids. They're poor and scruffy and hungry. They're peering around the edge of a partially-toppled wall surrounding the keep.

 4. KHU: But you *always* say that.

 5. GUDRID: *Why* would I choose a plan I didn't think worked?

 6. KHU: Beats me. I'm not *wrong* as often as you.

Panel 3: Reverse angle—we see what Gudrid and Khu are staring at: the castle COOK placing out PIES to cool on a plank in the window of the castle kitchen, about a story off the ground.

 7. GUDRID (OFF): Look. Khu. *I* shoot out the strut supporting the plank.

 8. GUDRID (OFF): *You* dash over there with your unearthly *speed* and catch the pies as they fall.

Panel 4: Khu rubs her belly. Gudrid gives her a wry smile.

 9. GUDRID (UP): They'll be silencing our stomachs before a single guard's the wiser!

 10. SFX: *GGRRRMBBBBLLLLL*

Panel 5: Close on Gudrid as she puts a CROSSBOW with a reticular sight to one eye, tongue sticking out, lining up her shot.

 11. GUDRID: *What's* not to *work?*

<u>TWO</u>

Panel 1: Angle up: Gudrid's POV down her crosshairs. Suddenly an even younger girl named SOPHIE shoves her face into view. She's carrying a comically large wooden toy sword. Sophie's clearly a child of privilege: pretty, colorful clothes, maybe some kind of headpiece.

 1. SOPHIE: Hey, Gudrid! Hey, Khu! Whatcha playing?

 2. SOPHIE: Can I play too?

Panel 2: Gudrid fires wildly, raising the crossbow to avoid hitting Sophie!

 3. GUDRID: *GAAHHHHH!*

 4. GUDRID: *Sophie! WATCH IT!*

Panel 3: The bolt sails up to the top of the tower where it lands loudly (though bloodlessly) in the SHIELD carried by the uppermost SENTRY, startling him!

 5. SFX: *tunk*

 6. SENTRY: Wha-?!?

Panel 4: Aerial shot. High angle looking down from the Sentry's POV. The three girls look up, caught red-handed.

 7. KHU & GUDRID (1 balloon, 2 pointers): Uh-oh.

Panel 5: Smash zoom into Sentry as he points down, screaming.

 8. SENTRY: TO ARMS! BROTHERS, TO ARMS!

 9. SENTRY: WE ARE UNDER ATTACK!

Panel 6: As they scramble, starting to run, Gudrid wags a furious finger in Sophie's face; she just giggles.

 10. GUDRID: How many times do we have to **tell** you, Sophie? This **isn't** a game!

 11. GUDRID: We're not pampered little **princesses** like you—we're trying to **eat!**

 12. SOPHIE: *Hee-hee!* You *orphans* are *funny!*

<u>THREE</u>

Panel 1: Khu grabs the crossbow from Gudrid and fires in one, single motion!

 1. GUDRID: Khu—what are you—

 2. KHU: Just a second!

 3. KHU: If I'm gonna be running for my life—

Panel 2: Reverse angle—The bolt hits the strut on the plank, knocking it off and causing the pies to slide off . . .

 4. SFX: *kunch*

 5. KHU (OFF): —it ***won't*** be on an ***empty stomach!***

Panel 3: BIG PANEL—NEAR SPLASH—Khu and Gudrid run away eating pies down the road away from town and castle followed by polearm-wielding guards with Sophie between the two groups, still lugging her comically large sword, still trying to catch up!

 6. SOPHIE: Aw, c'mon guys!

 7. SOPHIE: ***WAIT FOR ME!!***

 8. LOGO: **SWORDMAIDS**

 9. STORY TITLE: **Part One: Legends in Their Own Minds**

FOUR

Panel 1: Establishing shot of a bigger city, a teeming metropolis with a much bigger castle. Years later. To tip off that this is a fantasy world, we could maybe put a small dragon lazily winging through the air overhead.

 1. LOCATOR: *Capital City of Everwhere.*

 Pop. 779,628 (Human) 602,093 (River Elf) 289,755 (Bridge Troll) 201,708 (Hill Gnome) 113,469 ("Urban" Dwarf)

Panel 2: Closer. Exterior of a big, windowless, stone mausoleum-style building in the heart of the city, like a Yale secret society building.

 2. LOCATOR: TEN YEARS LATER.

 3. KHU (OFF): Are you sure this is going to work?

Panel 3: Khu and Gudrid are walking up to the front door, carrying pies, dressed as cooks in aprons and white babushka-style hair wraps. (Let's put a hay cart loaded with some pumpkins in the street here. Not that we put much emphasis on it, but it'll play later.)

 4. GUDRID: If I ever said "no," would that make you feel better?

 5. KHU: . . .

 6. KHU (SMALL): Touché.

Panel 4: A snooty BUTLER opens the door of the mysterious building. Gudrid and Khu affect bored, deadpan looks.

 7. GUDRID: Delivery.

 8. BUTLER: You're early.

 9. KHU: Want it or not?

10. BUTLER: Hmp. Main table.

Panel 5: Gudrid and Khu enter the grand hall, walking along the big main table. A group of shifty-looking male THIEVES of various shapes, species, races, and sizes are hunched over the table, counting their loot-piles of gold and jewelry. These are Dungeons & Dragons-style thieves: leather jerkins, short swords and knives rather than big blades. Nimble fingers, shifty eyes. Let's have some fun and give them all black bandit masks, like Robin. One of the thieves is giving Khu and Gudrid a dirty look.

11. THIEF: Hey. No girls allowed.

12. KHU: Relax, jackass. We're just delivering the pies.

13. BUTLER: They're not labeled. Girl, where'd you get these? The meat shop or the fruit shop?

14. GUDRID: Neither . . .

<u>FIVE</u>

Panel 1: But when one of the thieves reaches toward the pies, they EXPLODE into a cloud of blackbirds!

 1. GUDRID: . . . the *magic* shop.

 2. BIRDS: KAW KAW KWAK BWAK KAW KWAK!

 3. THIEF: GAAAAH!

Panel 2: In the confusion, our heroines whip off their aprons—thereby revealing their on-model Coover-designed costumes! Drawing her sword, Khu outduels several thieves rushing her! Blackbirds still flapping all around!

 4. THIEF: What the devil—*get them!*

 5. ROGUE: Wait! I know you—

Panel 3: Two thieves, one with a nasty-looking mace, charge the gold-burdened Gudrid from either side!

 6. ROGUE: —you two applied for membership!

 7. GUDRID: And *you* told us you don't accept *women!*

Panel 4: Gudrid does a perfect cheerleader SPLIT, causing the one to swing the mace over her head and smash his comrade in the face!

 8. SFX: WHAMMMM

Panel 5: Our heroines dodge the other thieves and, using their re-moved aprons as sacks, load up the gold and jewels from the table! The butler is shocked.

 9. BUTLER: You-you can't *steal* here!

 10. BUTLER: This is the *Thieves' Guild!*

 11. KHU: Yeah, well . . .

<u>SIX</u>

Panel 1: SPLASHEROO! Our heroines burst out of the front of the building, knocking aside thieves, making good their escape! Black-birds flying all around! Mayhem! Awesome! We love these crazy kids!

1. KHU: girls will be girls!

2. GUDRID: *Hahahahaha!*

Panel 1: Exterior. Thieves round the corner of the Thieves' Guild building and chase after a hay wagon (the one we set up on Page Four) that's trundling away. On the back of which we can just see a couple of heads wearing white babushkas, as if Khu and Gudrid are trying to hide, but peering back toward the thieves.

 1. THIEF: There they are! Get 'em!

Panel 2: As the thieves run after the wagon, Khu and Gudrid peer after them from behind the door of the Thieves' Guild building. Babushka-less. Grinning.

 2. GUDRID: See, Khu?

Panel 3: From the back of the wagon, we see the babushkas are wrapped around a couple of pumpkins sitting on the hay. Thieves running after it in the background, still thinking they're chasing G&K.

 3. GUDRID'S VOICE: "*Told* you it'd work."

Panel 4: Angle down—Khu and Gudrid, wide-eyed, turn to see the business ends of SPEARS pointing down on them.

 4. KHU: Guess even *you* get it right once in a—

 5. GUARD (UP): Now, ladies.

 6. GUARD (UP): I'm *sure* you can show us your *notarized permits* from the Guild.

 7. GUDRID (small): Aw, man. Jinxed it.

Panel 5: Reverse angle—ANGLE UP—The guards, dressed the same as they were in the opener, are pointing their spears down at us.

 8. GUARD: Otherwise we have a *dungeon* with your *name* on it.

<u>EIGHT</u>

Panel 1: Long shot of a lavish Cinderella-ish CARRIAGE held up by the guards clamping a glum Khu and Gudrid in chains.

 1. SOPHIE (in carriage): Here, here—what's the hold-up?

 2. GUARD: A thousand pardons, Your Grace!

 3. GUARD: Just enforcing your father's **crackdown** on **unlicensed thievery**.

Panel 2: The carriage door opens and an elegant slipper steps out.

 4. SOPHIE (UP): You don't say?

 5. SOPHIE (UP): The King's Guard has put **dozens** of street scum away over the past few weeks.

Panel 3: BIG PANEL reveal of the older Sophie in her princess's finery.

 6. SOPHIE: So he won't miss these two.

 7. SOPHIE: Release them into my custody, Captain.

 8. SOPHIE: Khu. Gudrid. It's been a long time.

Panel 4: Two-shot: Khu & Gudrid look at each other like "Uh-oh, we've stepped in it now . . . "

 9. SOPHIE (OFF): You **won't** find it so easy to **ditch** me this time . . . **Hee-hee!**

 10. BLURB: *To be continued!*

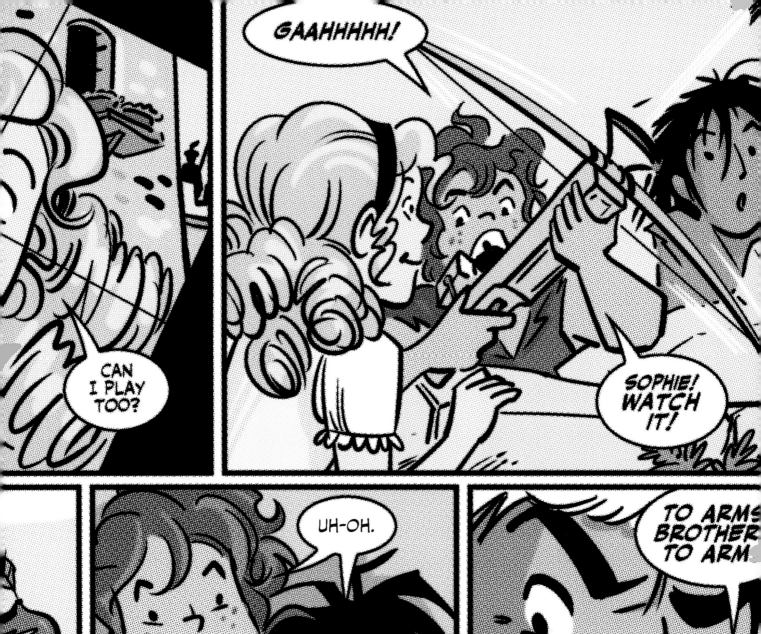
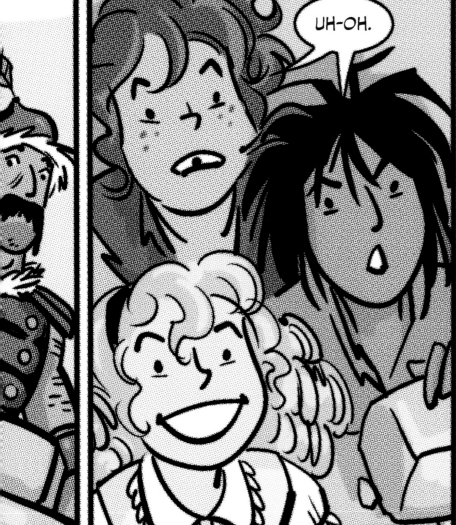
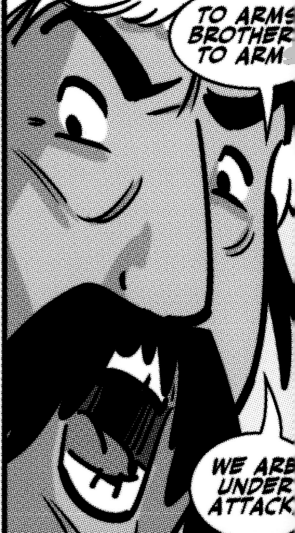

VISUAL STORYTELLING

FOR ARTISTS & RELATED TRADESPEOPLE

ARE COMICS DRAWN MOVIES?

"Comics are not drawn movies," says Gabriel Hardman, and he would know. Before becoming the penciller of such comics as *Hulk*, *Secret Avengers*, *Agents of Atlas*, *Planet of the Apes*, *Heathentown*, and *Kinski*, Hardman made his name as one of Hollywood's top storyboard artists, providing visual guidance to films such as *Austin Powers: International Man of Mystery*, *The X-Files*, *X2: X-Men United*, *Superman Returns*, *Tropic Thunder*, *Spider-Man 3*, *The Dark Knight*, *The Dark Knight Rises*, and *Inception*.

The first page of *Kinski*, written and drawn by Gabriel Hardman. He told us he plans on making this dark tale of a man and his dog into a movie, so in a sense, this particular comic *is* a kind of a proto-storyboard.

The more movies that are made from comics, and the more movie adaptations that become a viable (or at least a highly desired) revenue stream for creators, the more comic book creators themselves begin talking about comics simply as the precursor to some other medium. And though there are a lot of similarities between the visually based storytelling mediums of comics and movies, we find it important to knock down this straw man and draw important distinctions between the two.

"The forms are totally different," Hardman goes on to explain. "The obvious problem with that is that it's condescending towards comics and dismissing the unique and interesting forms about comics, and the kinds of stories that comics can tell and the way that they can tell them. It's just a lazy observation. I feel like a lot of it is down to the idea that comics are basically like a storyboard for a movie, yet they don't even have that much in common."

Now, *storyboards*—they're *literally* drawn movies. Prior to shooting, filmmakers often have much or all of a movie drawn out by an artist in "panels" that represent a motion picture screen. "Storyboards are a production tool," Hardman says. "The ideal way that it works is that you're using the storyboards to communicate what the director wants to all the other people in the crew—the cameraman, the special effects guy, the physical effects people—so they all have a sense of where the director is going with something. And on the day [of shooting], so the crew knows what stuff to bring, what kind of shots they're going to be shooting."

Unlike comics, then, storyboards are not a final product—they are a blueprint to get you to that final product. "The most important thing about doing storyboards is understanding filmmaking," Hardman says. "It has nothing to do with drawing them, as long as you can get the idea across in the drawings, that's the most important thing. . . . I always try to have a high level of quality in the storyboards, but the drawings do not need to be pretty to indicate the ideas behind them. The most important thing is just that it's this document to communicate with. If you don't understand how lenses work, if you don't understand how all the elements of filmmaking work, you can't translate that into these shots in a way that's going to be something workable for everybody.

"There are no structural limitations on that, as far as how many drawings you need to do in order to convey the idea of a single shot. You can have a stack of storyboards that's the size of a phone book that represents a very small chunk of a film. But comics are rigid in the form that you're expressing something in these units of a page. You have this incredibly limited space. It's basically a haiku when compared to making a film where you essentially can use however many shots you want. You can express that idea no matter how long it takes you to do it, no matter how much real estate it takes up.

"In comics you are encumbered by the space, but that makes a unique kind of storytelling that has different opportunities to it. There's just a completely different set of dynamics that go into the design of a comics page, the way your eye flows across the page, and what makes something an exciting image, and you're trying to suggest movement, as opposed to something that's a moving, changing image."

SIMPLE AND DYNAMIC: COMMANDMENTS FOR PENCILLERS

In comics, the penciller is the person who, shockingly enough, uses a pencil (physical or digital) to draw the initial images. Later, an inker and colorist (sometimes the same person as the penciller) finish the art. But at that initial stage, the penciller serves the roles of costume designer and dresser; matte painter and cinematographer; key grip, gaffer, and lighting expert all at once; animal handler and trainer; special effects coordinator; director; and production designer. Yes, these roles and more—most important—the penciller is the cast.

Perhaps it's too much stating the obvious to say that the penciller is the most important member of the comics-making team; yes, without the penciller, you wouldn't have any drawings or panel borders, just an unrealized idea in the form of the script.

But that's not *why* the penciller is the most important person on the team.

The most important skill any penciller can bring to her work is empathy. What are the characters feeling at this exact moment, and how can you make sure the reader knows that? Much of the time, that's made clear in the script. But often it isn't. The penciller has to see the story through the reader's eyes and make sure that vision is clear on the page. Confused people are rarely excited, or moved, or thrilled. They're just confused. Clear beats are key to any story, tragedy or comedy, action or romance.

"The broad way to say it is, 'Be clear, yet be dynamic,'" Hardman explains.

Notice we have not made a single mention of *style* in this entire discussion—we'll get to that in a bit. But when it comes to the basics of storytelling, *how* you draw is irrelevant. People read stories to read about other people, even if those people are dogs, mice, cats, aliens, gods, or machines. Every panel on every page of a comic is somehow related to those characters' struggles—or it

better be, if the writer has done the job correctly—and this is what the penciller must always keep in mind. You can draw in whatever style you want—cartoony or photo-realistic—in a fixed-grid layout or with self-guided digital panels or with the images multiplying fractally across the page like shattered glass—as long as you're answering the three most important questions in every panel:

WHAT is happening?
WHOM is it happening to?
And HOW do they FEEL about it?

Here are some good basic guidelines to follow in story-telling, regardless of genre, tone, or drawing style:

1. Put the important thing in front. "Is that suitcase going to be important later?" Hardman asks. "Well, then put it somewhere people can see it!" Is there a bomb in it? Make sure we know it's there. Is somebody's dirty laundry in it? Feel free to hide it in the background. This goes double for characters.

2. Action progresses from left to right. People read from left to right in most languages around the world, and no matter how much you might want to emulate the Japanese style, making your readers read right to left, like "unflipped" manga, is maybe not the smart-est way to go about it. In other words, stuff you want the reader to see first should be on the left side of the panel, and stuff you want the reader to see next should be on the right side of the panel. It is especially important, when drawing, to not drive your letterer crazy by making sure that whoever speaks first is on the left half of the page. Otherwise, you get into weirdly placed balloons, crossing balloon tails, and all sorts of related nastiness.

3. You really only need to establish spatial relations once. People aren't stupid. If Chickadee Lad is staring through the skyline at the thugs pointing their guns at Eagle-Man when he leaps heroically through the window to the rescue and we see the bad guys' shocked reactions, we don't need to see Eagle-Man in the shot, we'll remem-ber where he is.

That said, though:

4. Always show everything at least once. Introducing elements—like props—in a scene out of nowhere, par-ticularly when they're supposed to be there all along, can confuse the heck out of people. Do not ever forget the importance of *close-ups* so that the reader can see your characters' faces. Particularly as emotions change within a scene, keep cutting back so that the reader doesn't miss a beat.

5. Dynamic pages require varying shot types. It's hard to walk through artists' studios and not see cartoonist Wally Wood's legendary "22 Comics Panels That Always Work." Assembled by his former assistant, legendary writer/artist Larry Hama, they provide a nice catalogue of varying shots that make a dialogue-heavy scene more than a painfully dull slog of headshots. We've assembled our own list of such shots on pages 49–51, and yes, they work just as well for showing people talking as showing people getting shot at.

6. Small panels for small moments, big panels for big moments. This has nothing to do with shots and everything to do with using the layout of a page as a narrative tool. Winsor McCay first pioneered this technique in the early part of the twentieth century in his justly legendary Sunday comic strip *Little Nemo in Slumberland*. As the dreamscape Nemo enters is stretched to unimaginable heights and shrunk to infinitesimally tiny microcosms, McCay shrank and expanded the size of his panels accordingly. Then in the 1940s, the artistic team of Joe Simon and Jack Kirby imported this technique into comic books, pioneering the one-panel-page (commonly called a splash page) in *Captain America Comics* to open every story with a bang; and then, when Simon and Kirby moved over to DC, they perfected the tech-nique with *double-page spreads* to open every issue of their *Boy Commandoes* as dynamically as possible.

Ironically, as we move into the digital comics era, in which panel-to-panel transitions may be happening automatically on a phone or tablet, double-page spreads and splash pages may have the opposite effect—by shrinking to conform to your device's screen, it's actually minimizing the moment! This is a development McCay, Simon, and Kirby could never have anticipated—but digital comics creators have an even more specialized toolset with which to wow readers, as we'll show in later chapters.

Now these broad guidelines are just that, of course. "Do I break the rule of putting the important thing in front?" Hardman asks. "Yeah, of course I do. Do I break the rule of things going left to right? Of course I do. But that still should be the first thing you should think about and if you're doing it, you're doing it for a reason."

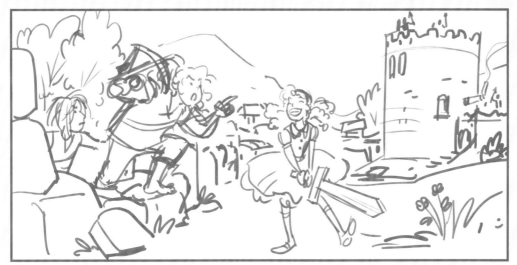

As Colleen roughs out *Swordmaids*, note how she is already following the put-the-important-thing-in-front rule.

We asked Colleen to do one panel "wrong" to demonstrate the importance of the left-speaker-is-first-speaker rule. The right one is right. Er, correct. You know what we mean.

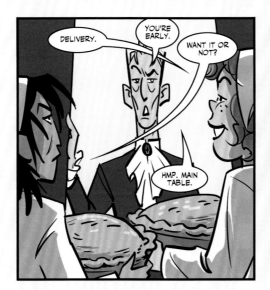

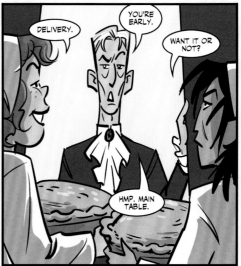

Action sequences require the simplest and most fluid depiction of spatial relationships. Note how Colleen uses Gudrid's eyes to direct the reader's attention to the bandit preparing to attack, and how his swing with the mace follows through into the next panel.

Double-page splashes are often used at the beginning of a story to get the reader as pumped as soon as possible, as this massive battle scene between Romans and Egyptians that opens *Saint George* shows. (Script by Fred Van Lente, pencils by Reilly Brown, colors by Jordie Bellaire.)

MY FIRST SHOT LIST: PANELS YOU'LL ALWAYS NEED

Using these simple guidelines, we can make up a *shot list* of the most basic, useful panels—these are not the only ones, but they are the most common and most useful building blocks of any comics tale. The comics-as-drawn-movies comparison is superannoying, but many of the terms in pencilling and cinematography can be used interchangeably, as it's the same concept of *mise-en-scène*: figures arranged across a defined space. The most common "shots" in both and why you use them are spotlighted on pages 49 to 51:

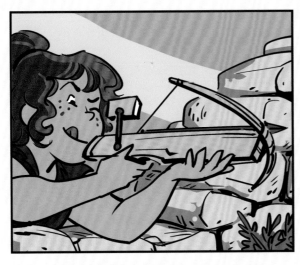

CLOSE-UP (CU): Somewhat self-explanatory, you are focusing in on one character (usually it's a character); perfect for reaction shots and moments of intense expression. Almost always just a head shot.

EXTREME CLOSE-UP (ECU): Less common, but a CU on steroids: shots of just a character's eyes or mouth, for instance. Really good for people yelling.

INSERT or DETAIL: An ECU that focuses in on a noncharacter subject, usually an object to which you want to draw the reader's attention.

TWO SHOT: A tighter close-up on (shocking, we know) two characters.

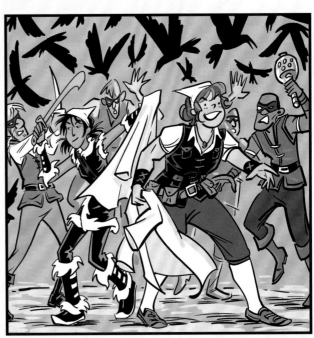

MEDIUM SHOT: If shots were ice cream, this would be vanilla. But vanilla is super-useful; most shots in any comic, particularly action shots, will be medium.

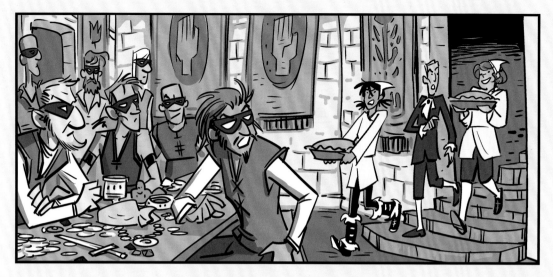

LONG SHOT or WIDE SHOT: In an extended scene, the wide shot can play the critical role of showing where everything is in relation to everything else. Wide shots can also have huge emotional impact—sometimes it's much more affecting to see a sad character small in the frame in a wide shot than to show an extreme close up of tears.

ESTABLISHING SHOT: A specialized long shot at the top of a scene (usually the first panel) that establishes the setting for the coming action. Usually, but not always, the characters themselves are not actually in the shot. Frequently, an establishing shot is the exterior of a space and then the next shot is in the interior of that space.

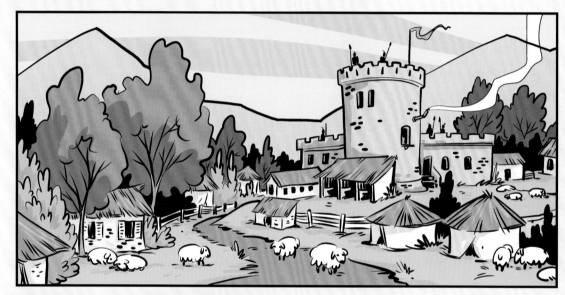

POV (POINT-OF-VIEW): You are literally seeing out of a character's eyes, showing us what she sees. Any shot, really, can be a point-of-view shot: if you're looking into a lover's eyes, it's a close-up; if you've spotted a sniper on the rooftop across the street, it's a long shot.

ANGLE UP or WORM'S EYE SHOT: The camera is down at ground level tilted up to the dominant figure. Gives added power to the figure and, when used as a POV shot, makes the viewpoint character weaker and in jeopardy. Of course, in many genres, a lot of figures are just way bigger than human-size, so this is less "manipulating the emotions through fancy camerawork" and more "what is actually happening," as in *OMG that giant robot is really freaking huge!!!*

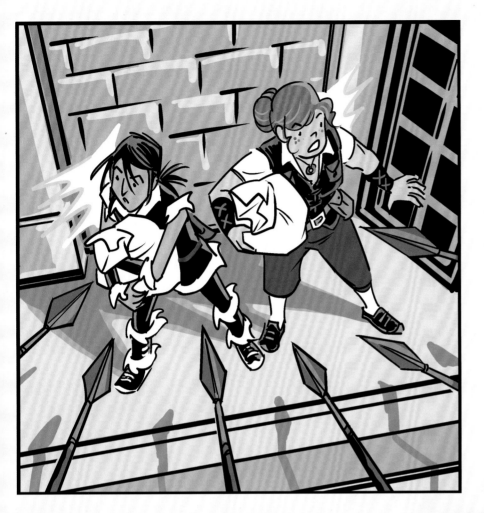

ANGLE DOWN or BIRD'S EYE SHOT
(left): The reverse shot (see below) of the worm's eye shot: the camera is positioned above the figures and angled down at the figures below. When used as a POV shot, it makes the dominant figures appear weaker and in jeopardy, and emphasizes the power of the viewpoint character. Of course, in lots of genres—like those with flying people—this is also less "manipulating the emotions through fancy camerawork" and more "what is actually happening," as in *Cheeze it, boys! Eagle-Man is swooping down on us!* (Bird's eye is not to be confused with an aerial shot, which is just the view of the action from the position of something in the sky; a bird's eye shot tends to exaggerate perspective for a storytelling effect.)

REVERSE SHOT/ANGLE (below, left and right): This is useful when characters are facing one another or some other thing. Assuming the figures in the scene are positioned in space like the players in a tennis or ping-pong match, if Angle A situates the camera on the side of the court with player A, then the REVERSE of that shot or angle will put the camera on the opposite side with player B. Reverse shots are frequently, but not always, pairs of matched POV shots.

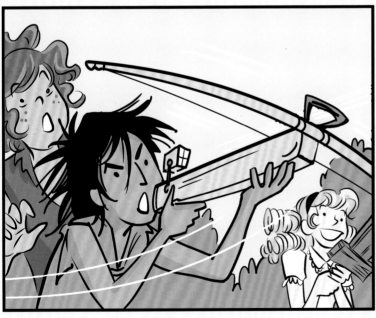

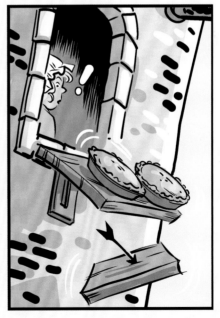

YOU'VE GOT TO HAVE STYLE

Jack Kirby, Jim Lee, Amanda Conner, Bill Watterson, Gilbert Hernandez, Lynda Barry, Naoki Urasawa, and hundreds of other spectacularly successful artists all have radically different styles, from Sunday funnies cartoony to modern photorealistic to deceptively primitive to lush and painterly.

So how do you decide what style works for you and for your project?

The honest answer? Only you can determine that.

If you're a writer or an editor looking for an artist, you need to think about how different kinds of art will support your story's feel and tone. This is an intensely personal and subjective part of the process. Sometimes the choices seem obvious—clean lines and simple figures for a children's book, for example. But maybe your particular kids' story delves into darker corners, and a more nightmarish look just feels right. Sometimes only you will be the person who can see how all of this will work. And that's exactly why you're the one making this particular comic. Search until you find the right collaborators who speak your language, understand what you're going for, and excite you with their own ideas.

But often, particularly on work-for-hire projects (wherein you're a hired gun working for the person or corporation that actually owns the intellectual property), you may be paired with collaborators you didn't personally choose. As an artist, you may end up working in a genre you're not accustomed to. As a writer, you may end up with an artist whose style is very different from what you had in mind when you came on board. We've always embraced these situations, thinking hard about what our artists do best and writing to their strengths. Very often, we're pleasantly surprised by how brilliantly the collaboration proceeds.

The legendary Jack Kirby defined the iconography of the superhero genre by striking a perfect balance between cartoony energy and classical illustration realism. In modern American comics, the trend has typically been toward greater photorealism—think of the painted art of Alex Ross—to ground the science fiction and fantasy of these characters firmly in visual verisimilitude. There is room for a wide range of expression within that idiom, of course, as can be seen in Jae Lee's stylized compositions and layouts for Greg's *Batman/Superman* series. On the other end of the spectrum, *Action Philosophers* (see page 54) tells irreverent-but-accurate comics stories about the lives and thoughts of history's A-list brain trust. Depicting the high concepts of notoriously difficult writers like Kierkegaard, Sartre, and Derrida in a cartoony fashion may strike some as odd, but Ryan Dunlavey's expressive style has the effect of making these big ideas much less intimidating to the average reader, and that's why Ryan and Fred's book has been used in philosophy courses all around the world and has been translated into a half-dozen languages.

Steve Kurth's photorealistic art brings the fantastical near-future preapocalyptic New York City of *Octane* to life. (Script by Fred Van Lente. Colors by Kito Young.)

WHEN DASEIN CONTEMPLATES HIS *OWN* EXISTENCE, HE CANNOT HELP BUT PROJECT ONTO IT *TIME*---

UH-OH.

--*I.E, MORTALITY*-- THE REALIZATION HE WILL ONE DAY *END!*

WE DO NOT *"FEAR"* DEATH -- FEAR IS A RESPONSE TO AN *OBJECT*, A TEMPORAL THREAT AGAINST WHICH WE CAN *FIGHT* OR *FLEE!*

DEATH, AFTER ALL, IS *INEVITABLE* AND *INDEFENSIBLE*.

NO, HEIDEGGER SAYS, WHAT WE FEEL TOWARDS DEATH IS *ANXIETY*--FOR, UNLIKE FEAR, ANXIETY HAS *NO OBJECT!* IT IS A CONSTANT NAGGING DREAD OF, LITERALLY, *"NO-THING"!*

HMMM... *ANOTHER* WAY OF FORMULATING THE DILEMMA IS: DASEIN IS ANXIOUS BECAUSE HE IS CONSCIOUS OF *BEING HIS OWN FUTURE!*

"CONSCIOUSNESS IS A BEING, THE NATURE OF WHICH IS TO BE CONSCIOUS OF THE NOTHINGNESS OF ITS BEING!"

IN THE FACE OF DEATH, ONLY *MAN* CAN MAKE *HIMSELF!*

ONLY HE, USING HIS *INTENTIONAL CONSCIOUSNESS*, CAN *CHOOSE ACTS* THAT LEAD HIM TO HIS *IDEAL SELF!*

What's less wacky than our impending mortality? Somehow Ryan Dunlavey's open, cartoony style softens the blow in the "Jean-Paul Sartre" episode of *Action Philosophers*.

Swordmaids
The Roughs

They're called layouts, thumbnails (because of their small size), or roughs, but these are, if you will, the penciller's own "storyboards" for sketching out a comics page before she executes it. It's a guide to share with collaborators and publishers to make sure you're all on the same page about the direction the pages will take.

Even though you've seen bits and pieces of the final art throughout this chapter, here are Colleen's initial roughs for the final *Swordmaids* pages. As you'll see, the roughs are sketchy enough that Colleen can bang them out very quickly. But they're detailed enough to allow us to make out all the different angles she's choosing, how she's staging the action, and even a basic sense of the expressions she's giving the characters. And in every page and every panel, you'll see Colleen running a clinic on the basic guidelines for good storytelling that we outlined in this chapter.

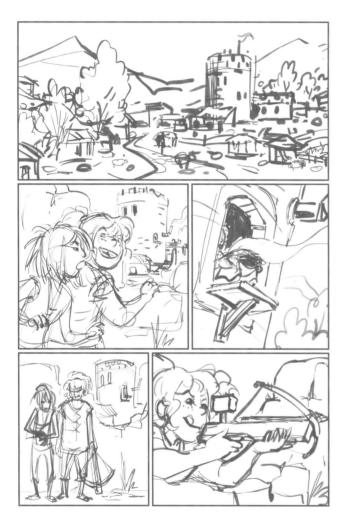

PAGE 1

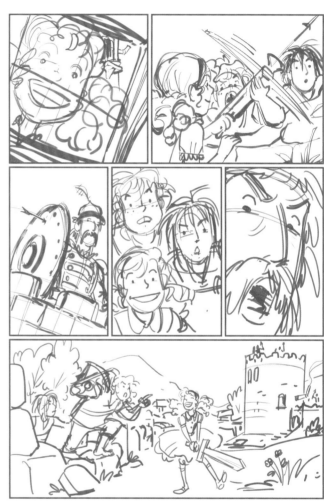

PAGE 2

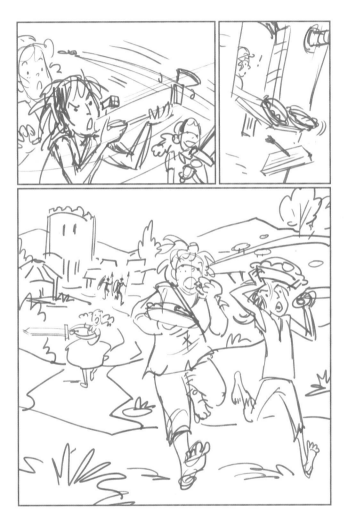

PAGE 3

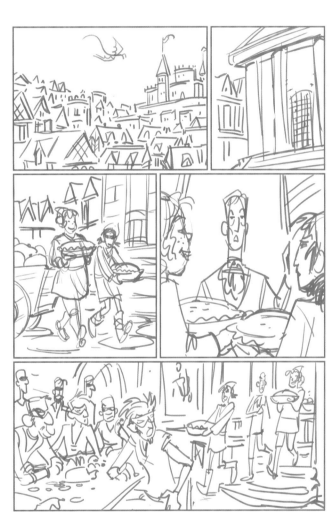

PAGE 4

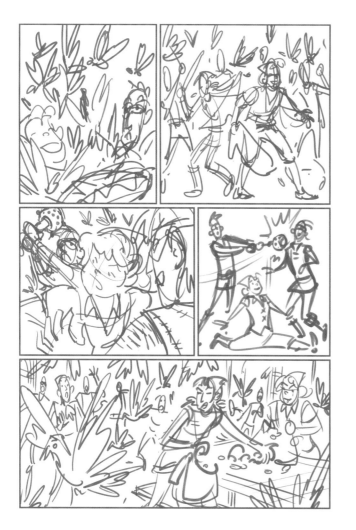

PAGE 5

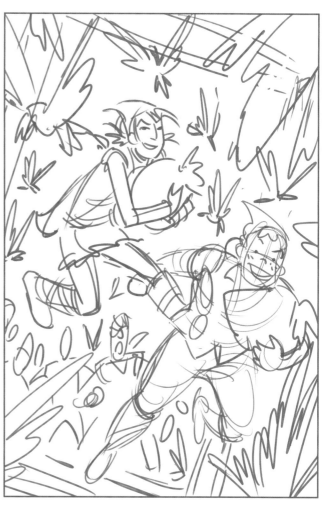

PAGE 6

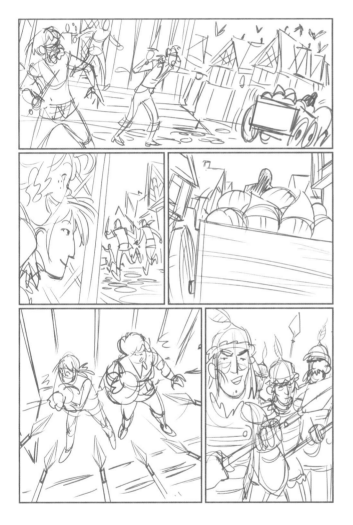

PAGE 7

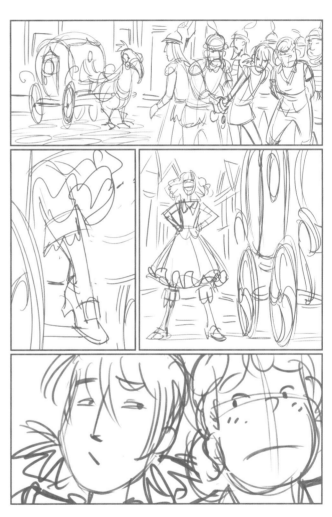

PAGE 8

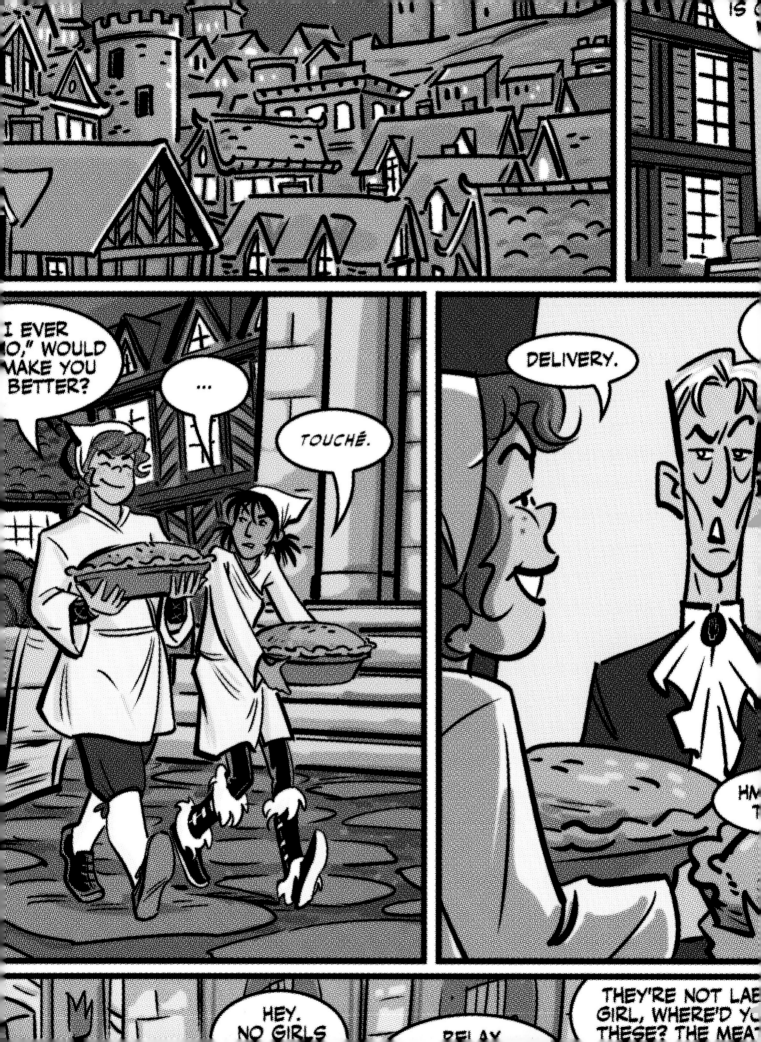

I LOVE IT WHEN A TEAM COMES TOGETHER

IT TAKES A VILLAGE
(A REALLY, REALLY, REALLY SMALL VILLAGE)

So far we've concentrated on the relationship between writers and artists, which is appropriate, because words and pictures are the basic building blocks of comics. But stopping the conversation there would be like only discussing directors and cinematographers in a book about moviemaking. Just as great movies rely on great producers, gaffers, sound designers, production designers, and composers, great comics rely on phenomenal inkers, colorists, letterers, and editors. And for the final product to reach its full potential, every member of the team needs to learn how to communicate with the others. We'll explore each specialty in turn.

THE INKER: CREATING A THREE-DIMENSIONAL WORLD

The inker may be the comics pro least appreciated by the general public, who might just equate his work to tracing (as in the classic scene with the inker played by Jason Lee in Kevin Smith's *Chasing Amy*). Even writers (like us!) who have worked in the industry for years can have difficulty articulating just what makes great inking so great. So for a little help, we spoke with industry legend Klaus Janson, who has been inking for decades on such titles as Frank Miller's legendary *Dark Knight Returns* and Greg's *World War Hulk*. Janson describes three major components to the inker's job.

First, Janson strives for "clarity in storytelling, making sure the reader's eye looks at what they're supposed to look at within the page." By controlling degrees of black and white in an image, the inker can help make sure the reader picks up on the elements she has to see for the storytelling to work.

Second, Janson stresses the inker's contribution to creating a "credible and believable world." Specifically, Janson is talking about the inker's ability to create the illusion of depth in a two-dimensional image. All comic book images are technically flat. But Janson says, "You have to fool the reader. Depth is an illusion in comics, but it's essential in order to have the reader join you in this adventure."

"What you are trying to establish is a world with three dimensions," he explains. "So in terms of inking, I always try to emphasize depth, not only through perspective or putting blacks in the foreground, and grays in the middle ground, and then whites in the background. But also in terms of volume."

Janson also uses a weighted line, meaning he uses different widths for different effects, which can also help create that critical sense of depth. "That allows me to, for instance, make sure that the bicep is in front of the shoulder muscle. So I'm always conscious of the volume of the figure."

Finally, Janson talks about the power of the inking to help convey emotion. "I'm not a slick inker," says Janson. "I can be, and I've certainly done jobs that are slick. But what I really like to do is try to convey emotion [which is] part of the reason I'll sometimes use spatter or a very powerful, thick line."

We're used to crediting the emotional impact of a story to the writer and penciller. But strong inks can help convey everything from anger to excitement to sadness to elation, and a strong inker knows how to wield those tools to serve the story.

"If a reader cries during a story, I love that," says Janson. "I feel like I've really connected with a reader."

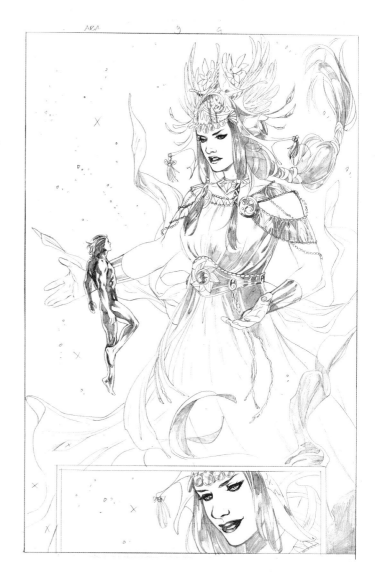

COMMANDMENTS FOR INKING

1. Editors, let your artist help choose your inker. Certain pencillers always work with certain inkers because they love the look those inkers provide and they know the inkers will flesh out certain elements in just the right way. If you keep that kind of a team together, your penciller may work a bit more quickly, knowing that the inker knows how to handle certain things just right.

2. Editors, writers, and artists, when picking your inker, think about style and the kind of story you're telling. Maybe a penciller has a very clean line, but your book really wants a stark or gritty feel. Casting the right inker can help bring out those elements. A huge amount of what we call "style" in art depends on the inker.

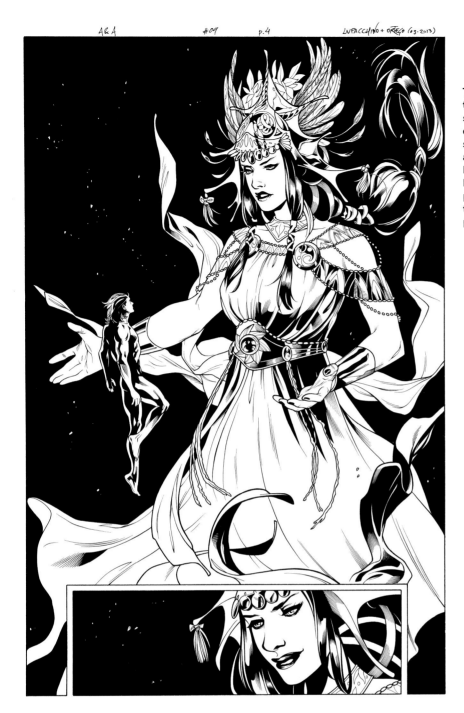

The inker adds realism and three dimensions even in strange worlds without such dimension. In this dreamlike section of *Archer & Armstrong*, a hero has a vision of meeting his long-dead mother. Note how Guillermo Ortego's inks provide a weight and realism to Emanuela Lupacchino's pencils (page 62).

3. Inkers, use your subtle skills to improve the drawing when you can. Janson says, "When I find that a penciller needs help with anatomy and I'm better at anatomy, I'll subtly help that. If a penciller needs help creating depth in a panel, you go in there and you help with that. But you do it in a way where you don't change a penciller's goal and style." Which leads us to:

4. Inkers, strive to work in a style that works with the pencils. "It's not your job to change the penciller's style," says Janson. "Your job is to help the penciller achieve what the penciller wants to achieve."

5. Writers and artists, make your deadlines so that the inker doesn't have to rush. As we've noted before, if the writer and penciller are late, the time has to be made up somewhere, and that usually means a mad rush for everyone else. The inkers are making those pencils truly come to life. Don't force the inker to do all of that life-giving work in a single marathon session.

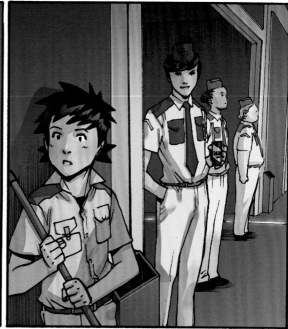

THE COLORIST:
ADDING THE FOURTH DIMENSION

The modern colorist typically uses Photoshop (the industry standard software) to digitally color the inked pages of the comic book. We like to compare coloring in comics to a movie's musical score. Like different musical cues, different colors can evoke completely different moods and emotions. A great colorist knows how to enhance every aspect of a story—from character to theme to plot—through color.

The images (pages 64-67) from Greg's "Los Robos" short story illustrates the point. Drawn by Takeshi Miyazawa with colors by Jessica Kholinne, the story follows Stanford, a boy who works as a janitor at an elite military academy. The cadets have slick blue uniforms. But Stanford is stuck in a dorky yellow jumpsuit. Through color alone, we immediately see that he's different—and of lower status. As an added bonus, when Stanford ends up bonding with a giant robot that was actually destined for one of the students, his yellow uniform provides contrast and helps him pop out against the darker gray and blue of the robot. So the color choices not only define Stanford's character and status but also help with the very basic task of making readable comics in which different elements make visual sense.

Jordie Bellaire is one of modern comics' most accomplished colorists, having worked for Marvel, Dark Horse, and Image on such diverse titles as *Deadpool*, *The Manhattan Projects*, *The Massive*, *Nowhere Men*, and *Hulk: Season One* with Fred and *Dr. Strange: Season One* with

Greg. We asked her to walk us step by step through her process:

Once Bellaire receives the line art file from the inker in high resolution (anywhere between 400 and 600 dpi is industry standard), she sends it to her assistants for "flatting." They use the eyedropper tool in Photoshop to "color-pick" colors from a previous issue—to make sure the series has a consistent palette from issue to issue—and add broad, basic colors to each shape on the page. Usually, these are darker colors, the "shadow colors" from the parts of figures downcast from light.

"It's weird I work this way, because a lot of other professionals all paint light to dark," Bellaire says, "but I like to go dark to light. I like to have the light shine on the character and then show where the light is. I like to start with the darkest forms.

"So my assistants color-pick from older issues for me. And if there is no older issue to work off of, they just read the script and then take their best shot. Usually I end up changing everything they do, about 98 percent. The flatters' main job is to separate shapes on a page so that shirts are separated from faces and hands from arms."

Once Bellaire receives a "flat" from her assistant, she locks the basic layer in Photoshop and uses that as a foundation to create a more sophisticated look for each page—or, more accurately, each sequence. She often goes through and creates "color holds" for an entire issue first—which is replacing black lines on art with colors to generate

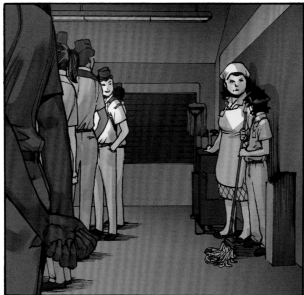
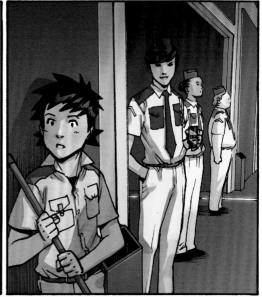
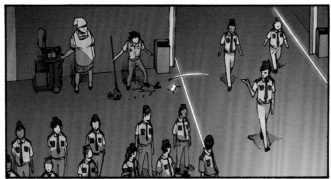

Jessica Kholinne's colors beautifully complement Takeshi Miyazawa's line art in Greg's "Los Robos" short story.

(continued)

Note colorist Jessica Kholinne's use of "color holds" in the backgrounds of these panels. By coloring the lines of the clouds and rocks another color, she creates depth and makes the figure in the front pop out more.

a special effect, such on ocean waves or an explosion—as those can get tedious to do on an individual basis.

"Then I'll go back and do all the characters, over [individual] sequences," she says, "so if they're all going to be in an igloo for ten pages, I'll color all the characters for ten pages, and then I'll color all the last ten pages when they're next to a fire so I don't have to switch gears." She does this even if the actual story cuts back and forth in between the two sequences. "I do like to work in sequences or in scenes, even if they're not always chronological, I prefer to get my mind set into a groove and work that groove."

If the inker's job is to create a three-dimensional world, then the colorist's task is to add a fourth dimension: time. The colorist is the most important person in the process for fleshing out the setting provided by the penciller. Is it night or day? Early morning or late afternoon? Is it cold or hot? Bellaire's lifelong interest in film helps her answer those questions.

Bellaire describes one project in which "the script called for noon and then the artist said he wanted it in the morning, and again, it was one of these setting things. I wrote to (the other creators) saying, 'I'm thinking of Steven Spielberg, *Close Encounters of the Third Kind* desert sequence.' If I ever get to start a sentence to a

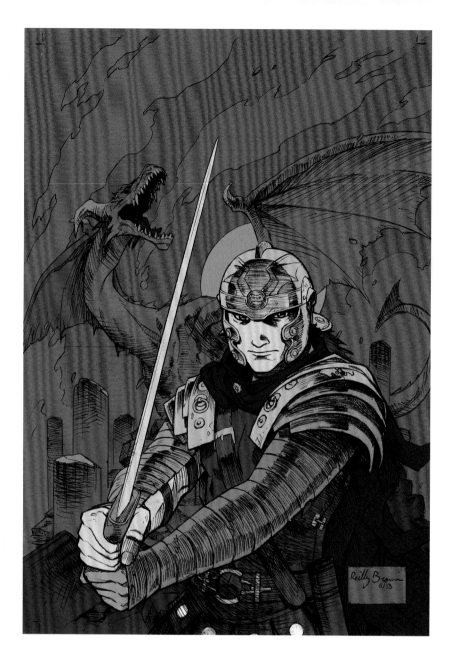

At right is the "flat," shadow-color version of Reilly Brown's cover for *Dark Horse Presents* #30 created by Bellaire's assistant; on page 69 is her final version. As she says, you can see she retained little of the assistant's original colors. But that's okay, as the purpose of the flat file is "so can I always have those objects available to me. If I end up really hating the way that I've colored a dragon, I don't have to do like painters or old school colorists and basically change everything all over again. I can just very quickly grab that shape of the dragon [in Photoshop] and then change the color in seconds."

collaborator, 'Steven Spielberg,' I'm really happy; I'm getting to cash in on my film love and trying basically to do a color homage to it. And when I sent it over, they were like, 'Oh my God, this is exactly what we pictured.'"

This is why it is so crucial for the writer—or, failing that, the penciller—to indicate the time of day at the beginning of every scene. Bellaire explains, "If it's not specified in the script or even if you ask and they make up their mind and then they change their mind and they say, 'Oh, but instead of blue flame, can it be orange flame, or instead of night, can it be dusk' and they think that that's an easy change but it's not just a filter, it's not just an overlay. You have to go back in and think about the difference of light and day and shadows. It's very annoying."

Once the page looks right to Bellaire, she "traps" the file, "which is basically securing the black line art on top of the colors so that if there's any kind of plate shifting when it prints, there's no disgusting 'halo effect' around it," which is to say, a white line around figures on a page—a surprisingly common flaw in many books today (not naming any names, of course).

"After the trapping's done, I send it over to the publisher, as small-res[olution file] for approval, so the writer and the artists and the editors can all sign off. And if everybody's happy, I put them all up on the FTP [folder], and then the letterer grabs them. And that's basically it."

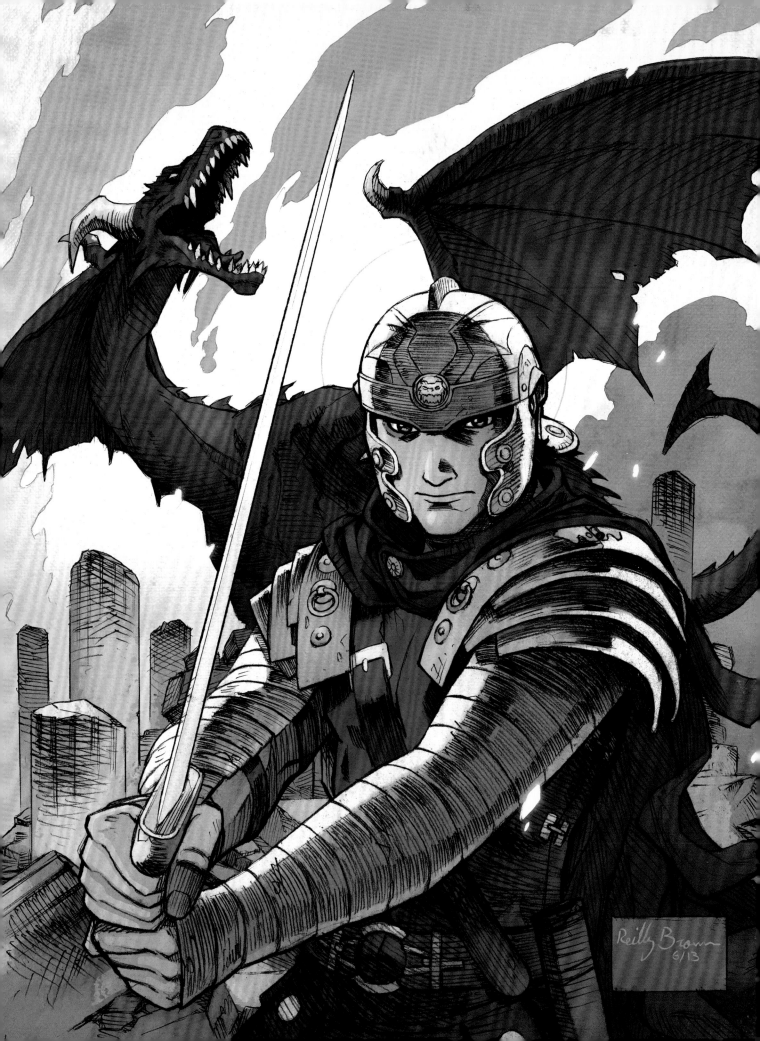

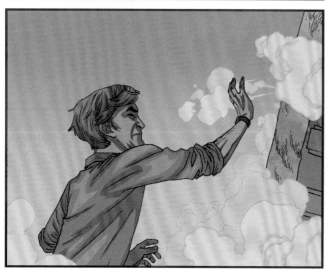

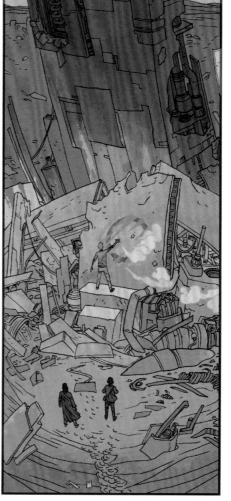

Color as setting: two Jordie Bellaire–colored pages from *Nowhere Men* demonstrate the different palettes she uses to establish different settings, one a daytime desert scene and the other an arctic night. (Script by Eric Stephenson, art by Nate Bellegarde.)

COMMANDMENTS FOR COLORING

1. Writers, tell the colorist whether it's night or day in the script. And feel free to make any specific color suggestions in the script as well. And the corollary: colorists, read the scripts. When you understand and care about the story, you can really use color to make it sing on every level.

2. Colorists, don't be shy about asking questions and suggesting things to writers, artists, and editors. You understand how color can help shape story and emotion better than anyone else working on the book—share those big ideas!

3. Writers and artists, make your deadlines (starting to sense a theme here?). If you're late, it's the colorist who gets screwed. Not only do late pages lead to terrible all-nighters for colorists and compromise the quality of the work, they can actually cause colorists to lose work and money as the pages get distributed to other people in order to make the final deadline. "I really hate to rush," Bellaire says. "You are going to have to be on time, because a colorist's job takes time. Less than you think, maybe, but more than you think as well. A colorist should not have to color your book inside of five days if it's a project you've had three months to work on."

4. Editors, give colorists finished inks as soon as they're approved. Let's keep this train moving!

5. As some of the last creative people to put their hands on a comic book page, colorists are also often called on to fix mistakes that were made at other points in the process. Colorists might be called on to remove a character or element from an image, switch the panel order or reverse panels, or enlarge or shrink certain elements within an image. Colorists, be ready to tackle these challenges. Everyone else, please don't take too much advantage of these bonus services.

6. Say, did we mention you should always indicate the time of day in a scene? Or, as Bellaire puts it, "Write the (**bleep**) time of day in your (**bleep**) script because if you don't, you've got to (**bleep**) deal with what I show you." We couldn't have said it better ourselves!

THE LETTERER: LEADING THE READER'S EYE

The letterer's job is to create the word balloons, captions, sound effects, and title cards that contain all the text in a comic book. The most basic aspect of the job is to provide a seamless reading experience. As Simon Bowland, the letterer for our *Incredible Hercules* and *Valiant* projects, puts it, "The letterer has to make sure that the dialogue flows correctly across the page so that the reader's eye naturally skips from one balloon to the next in the correct order. If the reader has to stop and think about which balloon to read next, then you've not done a good enough job."

But the letterer is also using visual clues to create the diverse, imaginary voices and sounds in the reader's head through the choice of fonts, font sizes, and styles. And there are a thousand aesthetic choices to be made when it comes to sound effect size, color, style, and placement.

In the first page of *Vision Machine* (page 74), which depicts a promotional event by a technology company that uses an old-time superhero comic, you can see a dozen great creative decisions made by letterer Charles Pritchett, who chose an era-appropriate font for the faux-superhero Visionary logo, worked in a fun arrow caption, offset the colors behind the captions to create a sense of old-school printing, differentiated between the balloon styles for the old-school panels and corporate guru Liz Evers's voice, and designed a nice fat look for the SFX.

We've heard some letterers say their job is to be invisible. Sometimes the greatest compliment can be when readers never consciously think about the lettering—they're just reading the book, enthralled by the art and the story. Ironically, achieving that ideal can result in letterers getting less credit than they deserve. As Bowland notes, letterers "rarely receive cover credits, rarely receive royalties (even though the rest of the creative team does), rarely even get mentioned in press releases and publicity interviews. Trouble is, good lettering should almost be invisible to the reader—if they notice the lettering, if your work actually leaps off the page and stands out like a flashing beacon, then you've done a poor job. So it's Catch-22, really."

But sometimes the vibe of a book really benefits from aggressive lettering. *Incredible Hercules*, for example, became known for its goofy sound effects, which were provided by none other than the multitalented Simon Bowland (whom we frequently mentioned in interviews,

for the record, we note with a wink). Nate Piekos, a terrific letterer who sells (and gives away for free!) his custom fonts on Blambot.com, went above and beyond the call of duty in Fred's *Brain Boy* series (page 75), visually depicting the thoughts of the drivers around the hero while he's stuck in a traffic jam (it doesn't hurt Nate is a terrific artist in his own right).

COMMANDMENTS FOR LETTERING

1. Artists, leave enough room at the top of the panels for letters. And put the person who speaks first on the left and the person who speaks last on the right.

2. Writers, pay attention to how many balloons you're squeezing into a panel and how many words you're squeezing into a balloon. Less is more.

3. Editors, get your writers to do a dialogue polish while looking at the art before sending the script to the letterer for ballooning. Many problems can be cleaned up easily at this stage without wasting the letterer's time. And not doing so does not make for happy letterers. As Bowland notes, "If dialogue is being rewritten after the letterer has done their work, then the letterer will have to do that work a second time in order to accommodate the revisions—and they won't be paid for that extra effort, so they're effectively doing work for no remuneration."

4. A round of corrections after the first ballooned pages come back is normal. But writers and editors, try to get all of your corrections in at once, if possible. Letterers might not mind getting one or two last-minute corrections an hour before the book goes to the printer. But they won't appreciate getting fifty. (Of course, we know from embarrassing personal experience that writers will on occasion come up with far too many critical corrections at the eleventh hour. So we highly advise writers to make friends with letterers, because your letterer is the person whose sleep and timc you're stealing on those terrible nights. Probably every comics writer on the planet owes every letterer he has worked with at least four free drinks at the convention bar.)

5. Writers, always ask to look at lettered pages before they go to the printer. You know the script the best—you'll be able to tell if balloons are covering up critical information or if edits have goofed up the flow of the dialogue.

6. Letterers, don't vary the size of fonts unless you're going for a specific effect.

7. Letterers, if you have to choose, readability is more important than design.

8. Letterers, try not to put balloons in places where they block the eye line between characters.

9. Letterers, don't go too small with fonts. Today, traditional comics are slightly shrunken to fit on tablet screens. And sometimes full-size comics are reprinted in smaller digest sizes. Check out your work on a typical iPad or Android tablet screen to see if it's readable.

Vision Machine, page 1, lettered by
Charles Pritchett. (Art by RB Silva.)

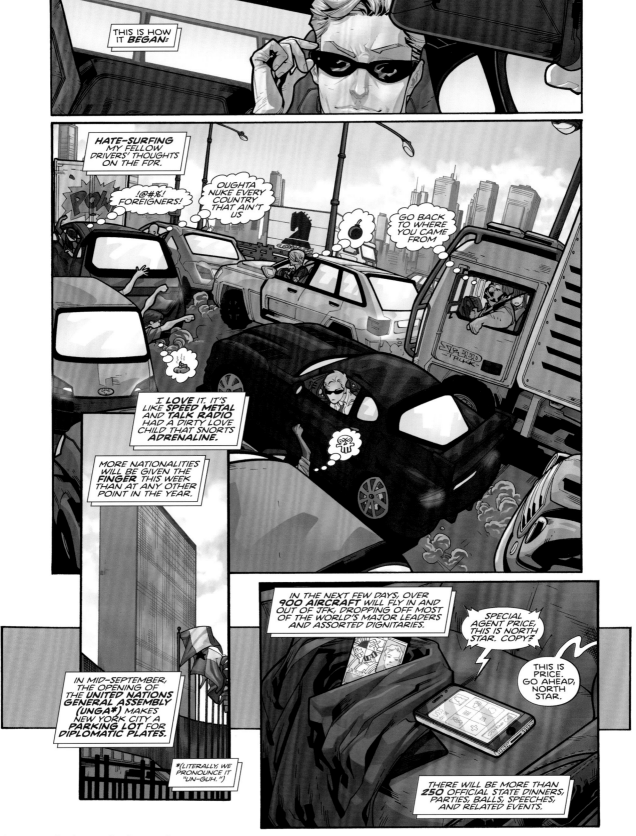

Pictures can also be words when you're communicating via thought, as letterer Nate Piekos proves in this page from *Brain Boy*. Note also how the arrangement of captions leads the reader's eye through a fairly complex panel layout. (Script by Fred Van Lente, pencils by RB Silva, inks by Rob Dean, colors by Ego.)

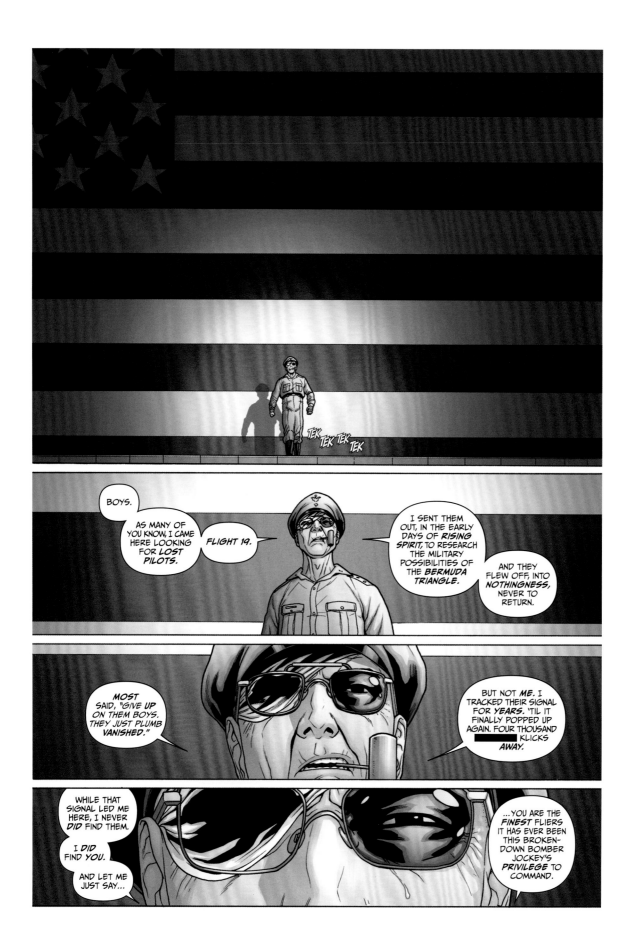

Simon Bowland shows off his chops in the opening speech of the villainous General Redacted in *Archer & Armstrong* #12, whose dialogue is, of course, itself "redacted" from time to time. (Script by Fred Van Lente, line art by Pere Perez, colors by David Baron.)

THE EDITOR: PUSHING TIN

In the mainstream comics world, editors and writers work hand in hand through every stage of the process. We liken this dynamic to the Old Hollywood creative producer/director relationship. Like David O. Selznick picking out new properties to turn into movies, an editor may develop the original idea for the direction of a comic book. Then the editor seeks out a creative team to bring that idea to fruition. Usually the writer is the first person brought on board.

When Greg was first tapped for the "Planet Hulk" gig at Marvel, editor-in-chief Joe Quesada gave him the basic pitch: the Hulk gets exiled to an alien planet where he becomes a slave and a gladiator. Greg was then set loose with editor Mark Paniccia to develop the million different elements of the story that became "Planet Hulk." Brilliant artists like Carlo Pagulayan and Aaron Lopresti brought all of those crazy characters and ideas to life. But week after week and month after month, Mark was the person Greg spent the most time with talking about the project.

Under this system, the editor is ultimately the boss. He represents the company and hired the talent; he has the power, if push comes to shove, to let the talent go. And from time to time, editors do indeed exercise that option. But great editors strive to work collaboratively with the creative team to solve rather than impose solutions.

In creator-owned comics where there is no corporate parent driving the project and the creators of the comic own the intellectual property they create, this relationship can be inverted. Very often the writer serves as the default editor of her creator-owned project. Or if there's a separate editor, she is generally working for hire. The writer (or writer and artist) are the owners of the property and the final boss(es).

But whether a project is work-for-hire or creator-owned, we recommend making the most of the opportunity to work with editors. Greg came out of independent film, where he would subject every new project to multiple test screenings and seek out critiques from trusted mentors and colleagues. When he made the transition to mainstream comics, he missed that chance to test-screen. But he very quickly realized that his editors were providing invaluable feedback at every step of the process.

Yes, very often in mainstream comics, writers have to deal with seemingly silly requests that have nothing to do with the characters or story. When you're working in a shared universe, different books have to coexist in the same world, and sometimes you can't use the characters you want or you have to incorporate elements that at first glance don't make much sense. And yes, if you work in

this business long enough, you will eventually suffer that sinking feeling as a book starts to fall apart due to too much editorial interference. On occasion, writers and editors develop different ideas for the character or story that simply can't be reconciled. We've never gotten to the point of resigning or being fired from a book as a result. But on occasion, we've looked back on books as lost opportunities, as projects on which we just couldn't put together conflicting mandates to come up with something for the ages.

But the vast majority of the time, editors are just trying to figure out the best ways to tell the best stories possible. And every time we get notes, we're given another golden opportunity to make the book better. Here's just one small example:

When working on *Magneto Testament*, the definitive origin story of the classic X-Men antagonist, Greg wrote an outline that showed Max, the book's young hero, gradually discovering his mutant powers while imprisoned in a Nazi concentration camp. The more editor Warren Simons thought about those moments, the more he began to question whether they worked. Greg didn't understand at first—he had built certain moments to culminate spectacularly in the revelation of Max's powers. But the more Warren and Greg worked together on the book, the clearer it became that explicitly working superhero elements into the story fatally detracted from the historically accurate world they were trying to create. Warren was absolutely right.

So that's the glorious, creative side of editing. But what about the practical, day-to-day reality of the job?

In monthly comics, the editor is the person most responsible for keeping the train on the track and running on time. It's probably the hardest and most underappreciated job in the industry.

Nate Cosby has been an editor for Marvel, Archaia, and Dynamite, as well as a writer of comics himself, including the Eisner-nominated *Cow Boy*. (He also happens to be the editor who put Fred and Greg together on *Incredible Hercules*.) He likens the job of an editor to "pushing tin"—i.e., being an air traffic controller: "You've got to land the planes. The planes are *going* to run out of gas. You've got to land these planes! But why get to the point where they're all out of gas? Why not get it done ahead of time? And the answer is people are generally lazy; they generally don't want to work that far ahead. And that's fine. They don't have to. But they're going to have to deal with me."

Nate Cosby is a writer as well as an editor. He penned the Eisner- and Harvey Award-nominated YA western *Cow Boy*, illustrated by Chris Eliopoulos.

"MY HERO"

SO HERE'S WHAT I'M THINKING - A ROLLOUT ALONG WITH YOUR NEXT BIG CROSS-OVER EVENT-

AN EIGHT-ISSUE MINI-SERIES, WRITTEN BY THE CREATORS OF "HEROES", PENCILLED BY JOHNNY JUNIOR, WITH VARIANT COVERS BY THE BEST IN THE BIZ!

A FORGOTTEN HERO REDISCOVERED! LOOK OUT, MODERN-DAY CRIMINALS, HERE COMES--

--"THE BOMBADEER!"

"THE BOMBADEER?" BUT I THOUGHT YOU SAID THIS GUY USED TO BE A FAMOUS GOLDEN-AGE HERO.

OUR FOCUS GROUPS SHOW THAT TO BRING IN THE "LEGACY" FANS WE NEED A RECOGNIZ-ABLE, ESTABLISHED NAME.

ONE MORE TIME, POPS...

...WHAT WAS YOUR OLD SUPER HERO NAME?

COULD THIS BE THE END OF JAP-SMASHER?!

The WWII-era hero, the unfortunately-named Jap-Smasher, tries to reinvent himself in a pitch meeting with an editor in this short from the Harvey Award–nominated *Awesome* anthology . . . with mixed results. Hey, doesn't that writer look familiar? (Script by Fred Van Lente, art by Ryan Dunlavey.)

That may sound a tad harsh, but much of an editor's job is to get very talented, very opinionated, and often very successful and willful people to obey the calendar and the looming deadline, no matter how inconvenient that may be.

"[The editor has] got to get ahead of the game as much as possible," Cosby says. "That means annoying people. That means, 'Hey, I know you know when this book comes out. I know you know when it has to be solicited. I am telling you, I'm not looking at when the first book comes out, I'm looking at the fifth issue.'

"And it's diminishing returns. If you take a week and a half to write a script, if an artist takes six to seven weeks to draw, then you gotta ink, then you gotta color it, then you gotta rewrite it and if it's a big book, a high-circ[ulating] book, then a lot of other fingers are gonna get stuck in the pie. If it's something that's going to sell over a hundred thousand copies, then you can bet that the editor-in-chief, the chief creative officer, all the senior editors get to read it. There can be eight drafts of the script, there can be all those kinds of things. You can have a high-end artist, someone really big you're paying a lot of money . . . that doesn't mean they're fast, that means they're high quality and they cannot be replaced. And if you know that that high-end, cannot-be-replaced artist is going to take eight to nine weeks on a book no matter what, that means you've got to get that script to them as soon as possible. Emailing and bugging and running numbers and looking at calendars over and over.

"Guilt is a magical device. 'You got to do this. I told somebody you were gonna do this, and if you don't do it . . .' I tell people a lot of times, editing is a faith-based initiative: 'I believe that you will turn this in by this time. And if you make me a nonbeliever, then I need to find someone else to believe in.'"

Given how intense the whole thing seems to be, how can editors work better with the creative team and vice versa? Funny you should ask!

COMMANDMENTS FOR EDITING

1. Writers, if an editor suggests something, try it. We know it hurts. We know you've built a whole story that depends on a specific element that your editor wants you to change. But there's an excellent chance that you might actually be wrong—or that in making the tweak your editor suggests, you might find another angle on the story that's even more interesting. (This is a pretty good rule for you artists, too, although in your case, it's a lot more time consuming just to "try something out.")

2. Editors, give notes as soon as you can. Writers and artists are *much* happier making changes when things are at the outline/layout stage rather than when everything is nearly done.

3. Editors, remind your creative team that you might be providing suggestions, but what you really want is for your collaborators to come up with solutions that work for them. Similarly, writers and artists, if you don't understand what your editor is really asking for, keep asking questions. If you can identify the real issue that's bothering him, you have an excellent chance of finding a solution that works for everyone.

4. Get on the phone or meet face-to-face if possible. Sometimes we can miss nuances in one another's work and end up giving notes that don't make sense. Email chains can get long and complicated, with each party getting confused, second-guessing the other side, and spending way too much time on detailed, point-by-point replies. Getting on the phone can sometimes allow for fast clarifications and quick solutions. But meeting in person is the best. We're still creatures of flesh and blood, and something about literally getting into the same room allows for the best communication and creative sparks.

5. Editors, always, always, always give your writers the chance to make any needed dialogue tweaks. Nothing is as disillusioning to a writer as seeing a published book with different words from what she wrote. We're not kidding. It's the absolute worst.

6. Everyone, when an editor sends you layouts or art or colors or proofs or letters, get your comments back as soon as you possibly can. If you get stuff at 3 p.m. on a Friday, make the time to review it before the end of the day. You might catch a mistake that the colorist might otherwise have reproduced in another six pages over the weekend. When everyone responds quickly, everyone wastes less time.

7. Editors, give proofs to your whole creative team before going to press. The more eyeballs on the work at that stage, the better. Each member of the team has deep knowledge about a different aspect of the book, and you'll have your best chance of catching any mistakes if everyone gets a peek. Plus, you never know when someone unexpected will catch a mistake everyone else missed.

Maybe this is stating the obvious, but collaboration is a personal as well as a business relationship, and it's always good to be friends. Fred Van Lente with two of his supertalented *Archer & Armstrong* artists, Clayton Henry (left) and Emanuela Lupacchino (right), at New York Comic Con.

GOLDEN RULES FOR COMICS COLLABORATION

Now that we've talked to everyone on the comics creation totem pole, we think we can distill a few good, basic rules that apply to pretty much everyone:

1. Let creators create. Everyone on the team is a creative collaborator and will work best when truly brought into the process. Editors and writers, share the pitch and the script with the whole team early enough for everyone to make real creative contributions. Artists, inkers, colorists, and letterers, step up and share the big ideas you might have about how to make the story shine.

2. Share credit with everyone. Writers, mention and praise your creative team in interviews. Editors, give everyone credit on the cover. When people are appreciated, they're more committed, and the project gets better.

3. Always think about the other person's time (i.e., give notes as soon as you can). Many of the biggest frustrations in the comics creation process can be avoided if everyone gives their notes as soon as possible. Editors, try to catch story problems at the outline stage, not the script stage. Writers and editors, give your blocking notes at the layout stage, not the pencil stage.

4. If you see something, say something. Everyone in comics makes mistakes all the time—that's just the reality when you're constantly moving so fast to make deadlines. But when a team is working well, everyone is catching everyone else's mistakes all the time, so we can correct things as we go.

5. Suggest solutions but ask questions. If you're in a position to give notes to someone on the team, remember that you may not have the best idea of how to fix a problem. Sometimes writers and editors don't feel that they know enough about their partners' creative processes to speak coherently about them. But if something feels off to you about the colors, for example, something's probably off. If you don't know how to articulate it, just start a discussion with your colorist. Sure, suggest solutions. But make it clear that you'd love for your creative collaborator to come up with solutions that make sense to him.

6. Work the kinks out on the first pages. The first few pages of a new project are usually the toughest. Everyone's getting his or her footing and feeling out everyone else. But this is the perfect time to knuckle down and work out the kinks. These pages might take longer to nail down than you might want. But if you get them right, you'll have worked out a bunch of questions regarding aesthetics and style that will help the rest of the book go much more smoothly.

7. Pick your battles. Jack Kirby famously said, "Comics will break your heart." And he's right. Monthly comics in particular are produced so quickly and intensely that it's almost impossible to fix every tiny thing that might plague you. The trick is to stay focused on the big picture, to concentrate on the elements that are essential for the emotional story to work and the plot to make sense. If ten things are wrong but you only have time to fix three, pick the three that really matter. If you pick right, 98 percent of readers will never notice the other seven.

Swordmaids
The Finished Pages

Congratulations! You've made it halfway through this book, and we will reward you with the glory that is Colleen Coover's finished *Swordmaids* art—pencilled, inked, colored, and lettered.

"Wait a minute!" we hear you cry. "We're halfway through and we're seeing the pages? The book's about making comics—and now you've made a comic! Aren't you done?"

Oh, no, young grasshopper. Not by a long shot. This is what makes our how-to book different than all those Grade-Z how-tos cluttering the shelves. You have chosen wisely in selecting this one.

Because after the fun of creation, the *real* work begins . . .

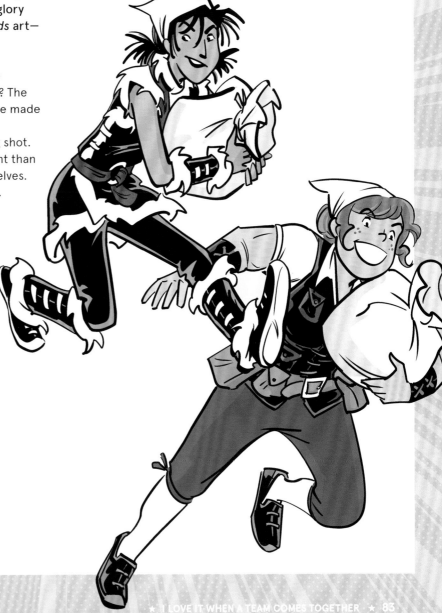

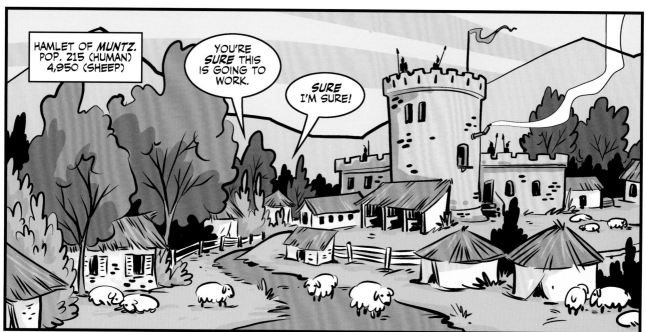

HAMLET OF *MUNTZ*.
POP. 215 (HUMAN)
4,950 (SHEEP)

YOU'RE *SURE* THIS IS GOING TO WORK.

SURE I'M SURE!

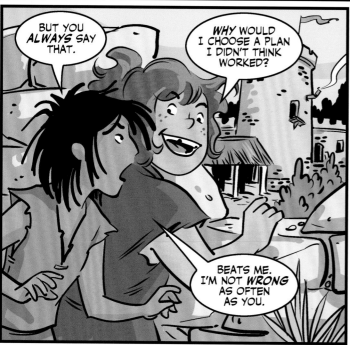

BUT YOU *ALWAYS* SAY THAT.

WHY WOULD I CHOOSE A PLAN I DIDN'T THINK WORKED?

BEATS ME. I'M NOT *WRONG* AS OFTEN AS YOU.

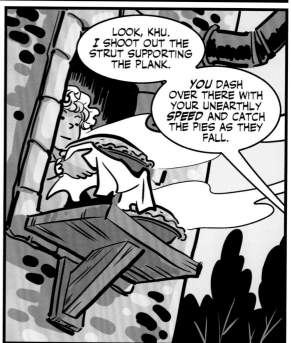

LOOK, KHU. I SHOOT OUT THE STRUT SUPPORTING THE PLANK.

YOU DASH OVER THERE WITH YOUR UNEARTHLY *SPEED* AND CATCH THE PIES AS THEY FALL.

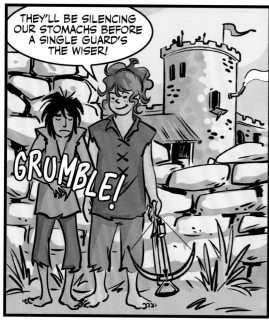

THEY'LL BE SILENCING OUR STOMACHS BEFORE A SINGLE GUARD'S THE WISER!

GRUMBLE!

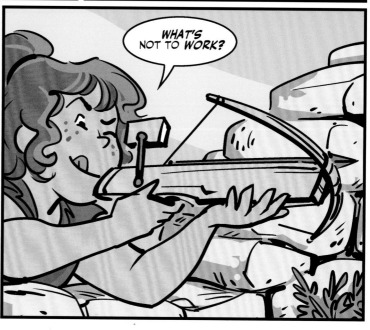

WHAT'S NOT TO *WORK?*

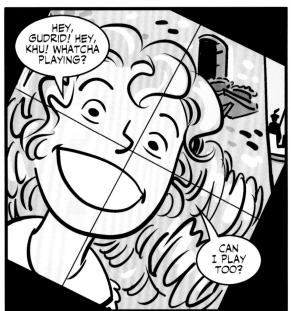

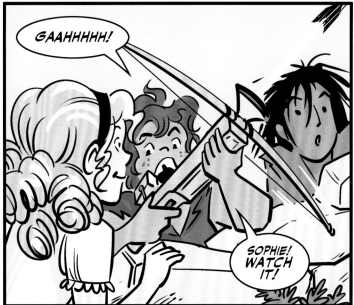

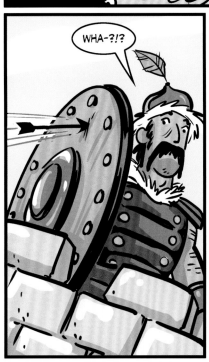

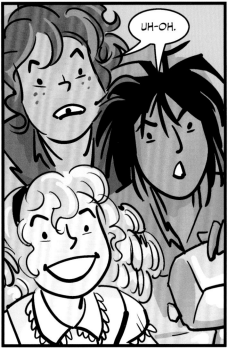

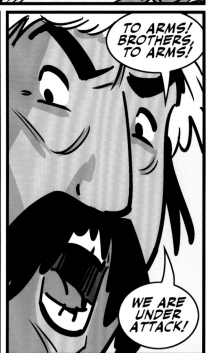

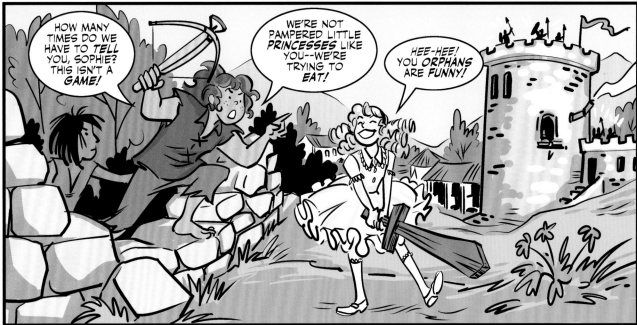

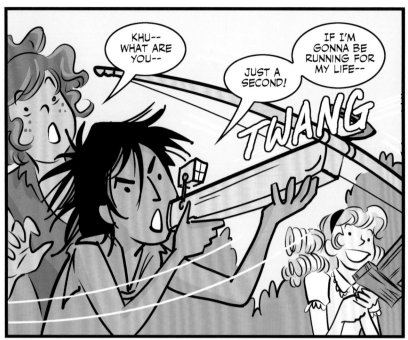
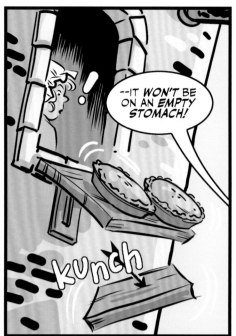
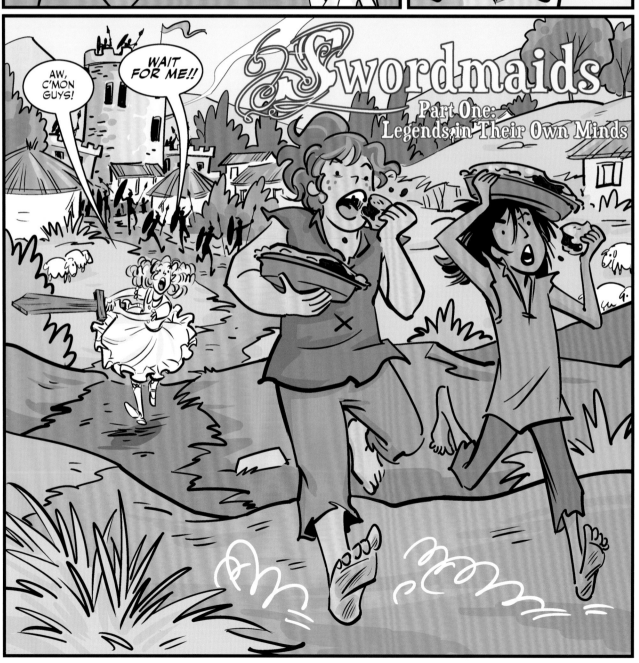

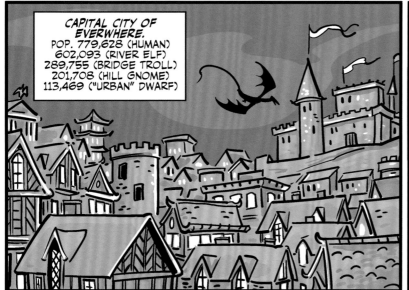

CAPITAL CITY OF EVERWHERE.
POP. 779,628 (HUMAN)
602,093 (RIVER ELF)
289,755 (BRIDGE TROLL)
201,708 (HILL GNOME)
113,469 ("URBAN" DWARF)

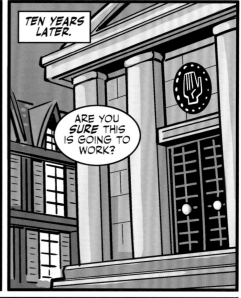

TEN YEARS LATER.

ARE YOU *SURE* THIS IS GOING TO WORK?

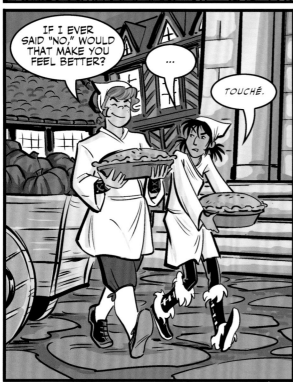

IF I EVER SAID "NO," WOULD THAT MAKE YOU FEEL BETTER?

...

TOUCHÉ.

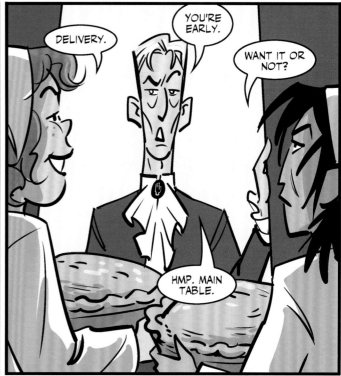

DELIVERY.

YOU'RE EARLY.

WANT IT OR NOT?

HMP. MAIN TABLE.

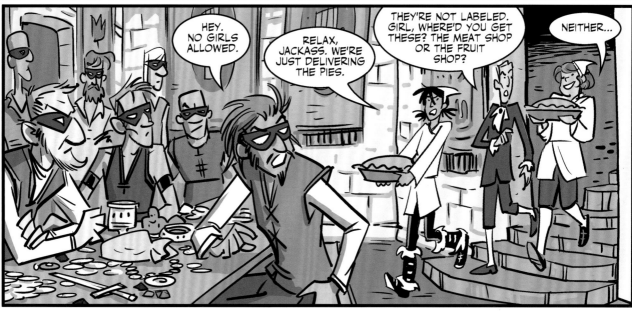

HEY. NO GIRLS ALLOWED.

RELAX, JACKASS. WE'RE JUST DELIVERING THE PIES.

THEY'RE NOT LABELED. GIRL, WHERE'D YOU GET THESE? THE MEAT SHOP OR THE FRUIT SHOP?

NEITHER...

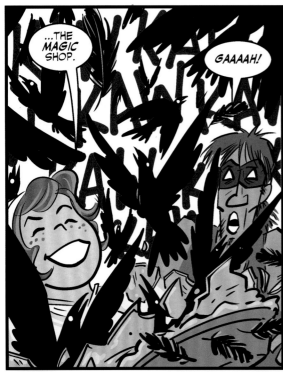

...THE MAGIC SHOP.

GAAAAH!

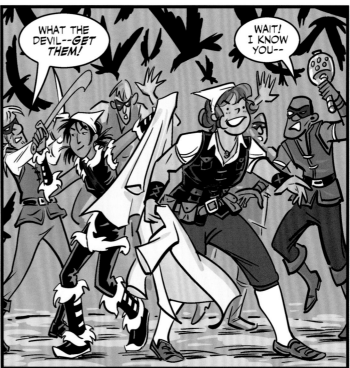

WHAT THE DEVIL--GET THEM!

WAIT! I KNOW YOU--

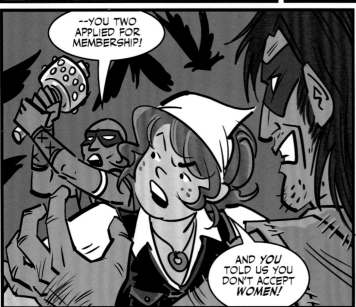

--YOU TWO APPLIED FOR MEMBERSHIP!

AND YOU TOLD US YOU DON'T ACCEPT WOMEN!

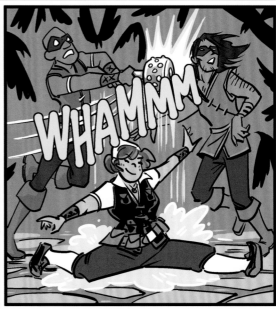

WHAMMM

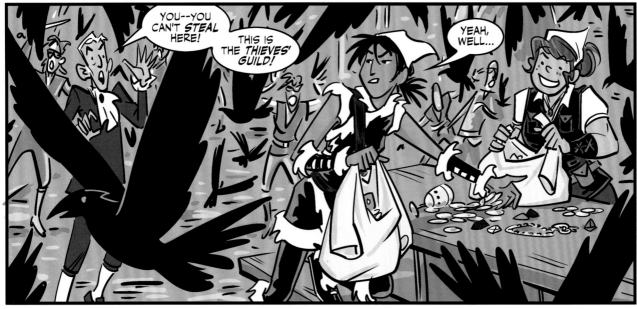

YOU--YOU CAN'T STEAL HERE! THIS IS THE THIEVES' GUILD!

YEAH, WELL...

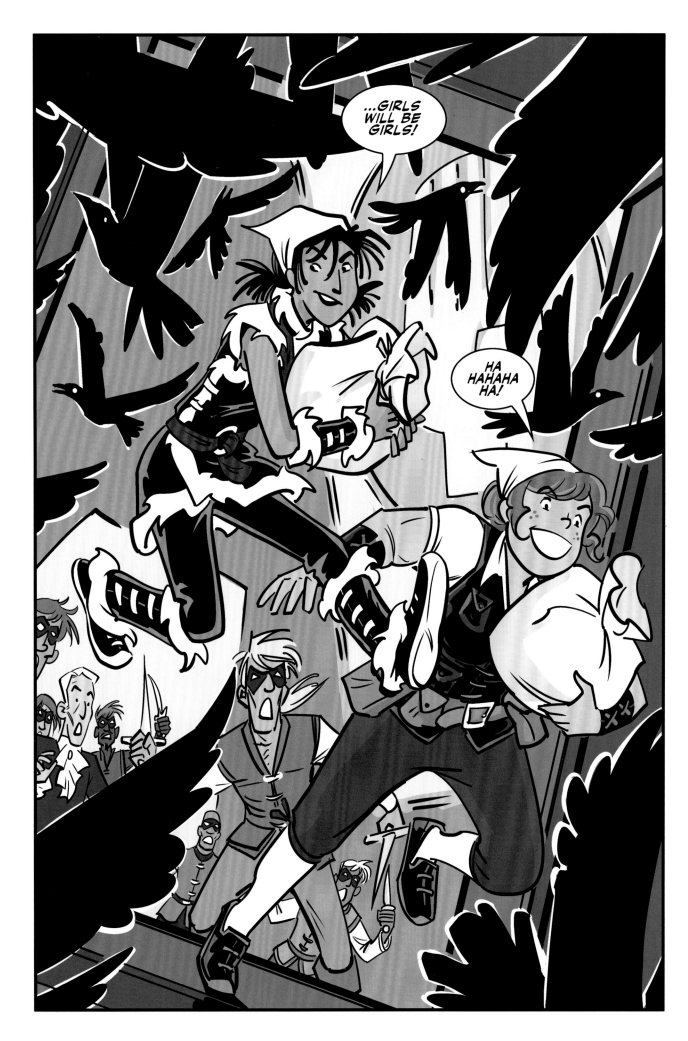

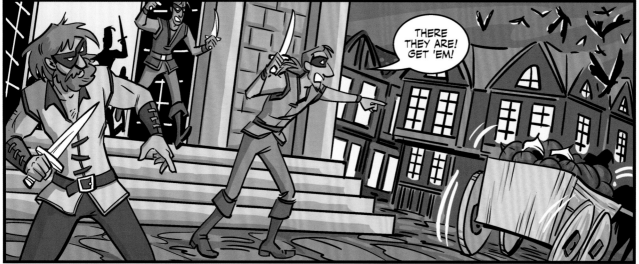

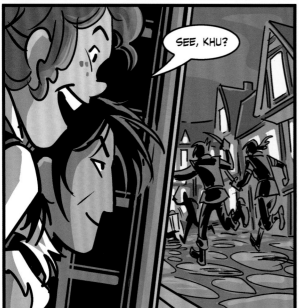

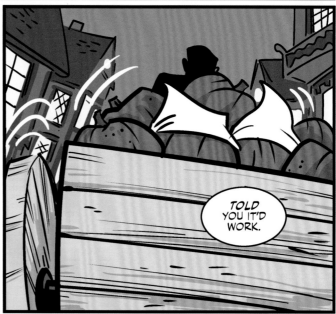

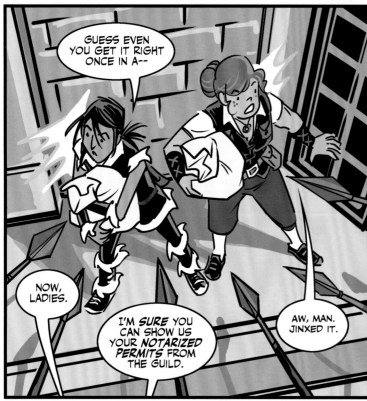

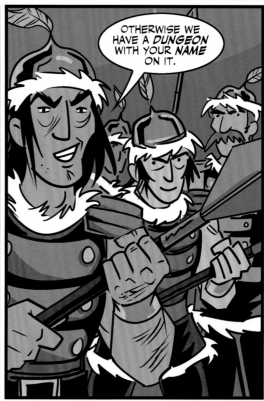

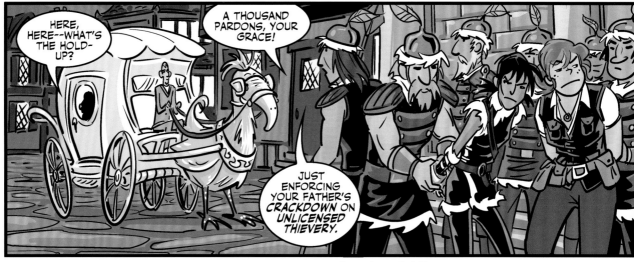

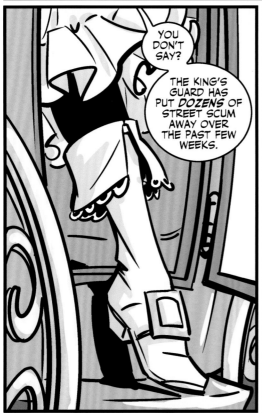

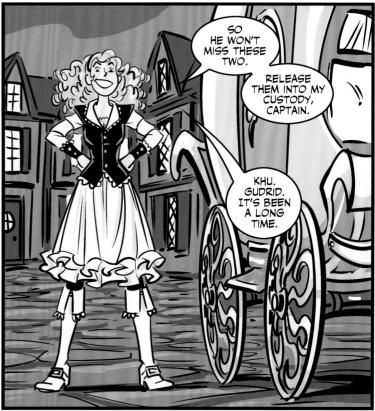

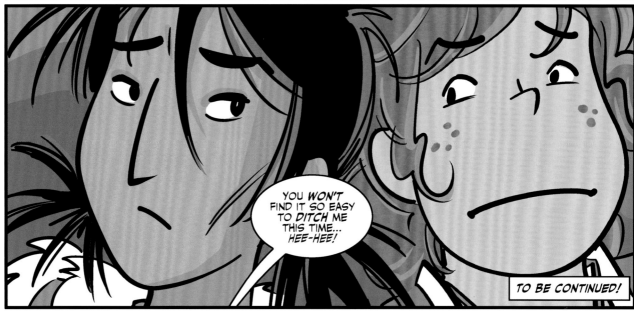

TO BE CONTINUED!

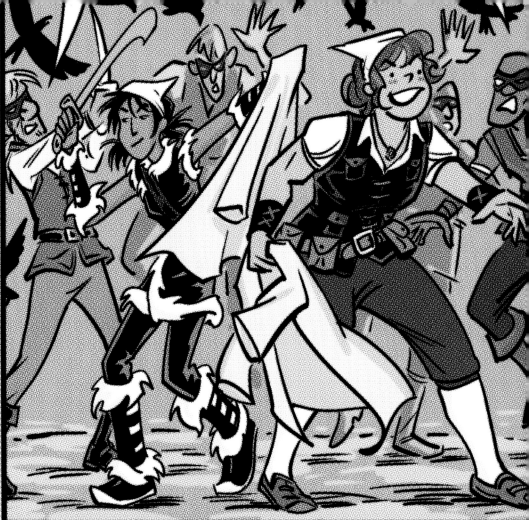
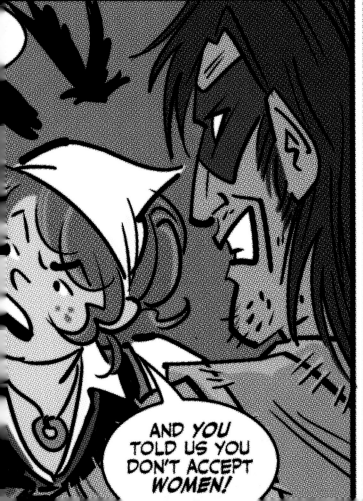

AND *YOU* TOLD US YOU DON'T ACCEPT *WOMEN!*

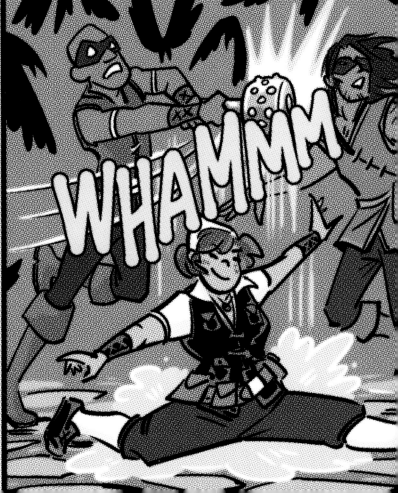

WHAMMM

CHAPTER 4

PITCHING MAKES PERFECT

BEYOND THE "ELEVATOR PITCH"

The unpublished but brilliant young writer blinks in astonishment as the legendary, curmudgeonly, and insanely busy senior editor of *Eagle-Man Monthly* approaches the elevator. The doors begin to open. A moment of silence as the young writer gathers her courage. Then, the writer opens her mouth, and out it comes: *the Elevator Pitch*— that legendary logline that will make the harried editor stop in his tracks, let this elevator go by, and say, "Huh. Maybe you've got something there."

That's the cliché. It never happens like that in reality—first, because editors simply are not permitted for legal reasons to listen to unsolicited pitches in elevators or anywhere else. If you want to pitch your Eagle-Man story to Big-Time Comics Company, you'll generally have to sign an idea submission form in order to protect the company from being accused of stealing your ideas at some later date. So please don't blindly pitch editors at conventions or work your pitches into questions at panels. It's an uncomfortable situation for everyone, and it won't get you work.

But there is a grain of truth to the Elevator Pitch myth. Some companies have public submission policies that allow you to submit pitches. Or someday, when an editor takes notice of your work, you may be invited to pitch a story in person. Or replace the editor at the elevators fable with any creative collaborator you might hope to work with on an independent project and you start to understand why pitching is one of the most important and crucial skills a creator, aspiring or accomplished, can develop.

You might never unleash it by an elevator, but you really *do* need a succinct (one or two sentences . . . three at the most) description of your project that you can dazzle people with at a moment's notice.

A classic example would be how writer Tim Seeley and artist Mike Norton sold what would become their best-selling, multiple-award-nominated horror series *Revival* to Image Comics. Seeley and Norton were already well-established and respected professionals and were chatting with Image publisher Eric Stephenson at New York Comic Con.

"We had already started work on *Revival* and planned on doing it, whether we had a publisher immediately or not," Seeley recalls. "Eric asked what I was working on. I said, 'Well, it's a rural crime thing, but with zombies. Except, not regular zombies. With that guy.' I pointed at Mike.

"We pulled out his iPad and showed Eric the first six or so pages of art. Eric said, 'Whoa. When can we put that out?'

"Yeah, never, ever happened to me before or since."

Writer Tim Seeley and artist Mike Norton didn't have much of an Elevator Pitch for *Revival*, but when you have art like this to show publishers, sometimes you don't need one.

MAKING AN EDITOR A BELIEVER (IN YOU)

When trying to get an editor to take a chance on your pitch, just keep in mind one thing: it is *your* job to make *her* life easier, not the other way around. In fact, it is in the editor's best interest to say no to you every time, even if you're offering her The Greatest Story Ever Told.

Why? Not because editors are bad people, or because they're shirking their duties. Quite the contrary. The average editor gets up before you do, works longer hours than you do, eats lunch at her desk more often than you do, is reading scripts on the train home more often than you have to, and is working on the weekends and late at night when you're asleep or partying. They're not paid enough, they don't have enough staff to help them, and their families are always complaining about how little they see them.

And that's just working on the projects they already *have*.

So why the heck would they add *more* books, *new* ones, to an already overburdened work schedule? Because they love the art of storytelling, that's why, and they love seeing great work get out there in the world to entertain and enlighten as many people as possible.

So treat your editor like an ally and a friend—especially the ones you've never met before—and do something very nice for her: *do not waste her time.*

The bulk of this thoughtfulness on your part will be covered in the succinctness of your pitch. The one-to-three sentence logline, followed by a two-page (maximum) description of the entire project, will be sufficient for the editor to determine whether or not yours is a project she'd like to pursue. And even if it isn't, too bad, because she rarely has time to read more than that anyway. Most of the time, she'll start making up her mind in the first few sentences (which is why your logline has to be on the money).

Furthermore, have some clue of whom you're submitting to before you send anything in. You'd think that would be forehead-slappingly-obvious advice, but we're constantly deluged by people who want us to look at their samples or ideas without bothering to notice that, say, Fred's Evil Twin Comics *only* self-publishes his own work, and, for that matter, *only* graphic nonfiction. So please, please, please: Do not send your gore- and sex-filled demon-killing horror comic to a young adult publisher. Do not send your cutesy eight-and-under talking animal comic to a publisher whose primary demographic is death-loving metalheads who only want to read about topless coeds killing demons. Sure, people are often on the lookout for completely new things. But keep it within reason.

When told that if he found an artist Image Comics would publish the series based on a verbal pitch alone, *Chew* writer John Layman recruited Rob Guillory, who provides art for the best-selling, multiple-award-winning series.

That said, the corollary to this prohibition is also true: If you have something that is particularly appropriate for a publisher—possibly because it is similar to things they publish that you are already a fan of—seek out those companies as places to submit your project to. In fact, if you are a big fan of projects the editor has spearheaded before, definitely tell her that's why you sought her out. Just as none of us are immune to flattery, editors also like to know they are dealing with like-minded people. And who doesn't like to feel appreciated?

It's not technically brownnosing if it's true.

At least that's what we think, and we're sticking by it.

VIRAL: SOMETHING YOU *WANT* TO CATCH

Don't make the cynical mistake of thinking you're "dumbing the idea down" to put one over on the masses. You need a one-line description that sparks interest—"the hook," in common entertainment industry parlance—because it has to be simple enough for people who aren't you to use it.

This next rule is so important we're going to use boldface *and* italics: *A pitch by its very nature* **has** *to be viral*.

Let's say you're working with an editor on a possible project. Eventually, your editor will have to take your pitch/logline/hook to others—very frequently an entire room full of other editors and executives in his company or division—and persuade them to approve it for publication.

After your project is green-lit, the sales and marketing team will use the pitch to try to hook retailers and booksellers into buying your book. The public relations people will give it to the media to spark questions for interviews and the lead paragraphs of press releases. It will become the basis for the solicitation copy that serves to sell your book to retailers in Diamond Comics Distribution's *Previews* catalogue and/or your book's Amazon page. It will be forwarded to the art director, designers, and artists who are working on your cover art and the logo and credits design known as "trade dress." It will probably wind up in one form or another on your trade paperback's back cover copy.

And, most important of all, it will allow your fans and readers to tell their friends and readers of their blogs, online reviews, and tweets what your book is about so they can encourage other people to read it. Word of mouth is crucial in our hypercompetitive media environment, and it is frequently only 140 characters long.

Therefore, it's not really hyperbole to say that if you don't have a pitch, you don't really have anything at all. So what goes into this terrifyingly important little paragraph, anyway?

Here's a fun exercise: try to match these loglines—as they're called in the film biz—with the popular comics and graphic novels they describe:

- An alien raised by Earthlings in the heartland moves to the big city to use his unfathomable powers to help underdogs wherever he finds them.
- A nuclear accident unleashes a repressed scientist's indestructible, rage-powered id; can his alter ego be a force for good as well as destruction?
- After a long period of imprisonment, the Lord of Dreams must battle a multitude of threats from mankind's past, real and imagined, to regain his rightful throne.
- One part *Lord of the Rings*, one part *Unforgiven*, [title] tells the tale of six cursed pistols that turn an innocent farmer's daughter into the deadliest gunfighter in the Old West.
- Food-oriented police-procedural drama, set post-Avian flu pandemic, following a young FDA agent, who has extrasensory powers based on what he ingests, as he solves particularly heinous (usually food-centric) crimes and eventually uncovers the conspiracy that led to the epidemic.
- Ghostbusters, Indiana Jones, Buckaroo Banzai, and the Rocketeer crammed into a robot.

If you're a big comics reader, you probably only had to think for a second before matching those first three one-sentence descriptions to *Superman*, *Hulk*, and *The Sandman*. Those next three are a trio of loglines for a few of today's hottest independent comics—*The Sixth Gun*, *Chew*, and *Atomic Robo*—provided to us by their writers themselves! At one point these series' creators had to convince other people or companies to take a chance on their ideas.

And—here's that word again—*quickly*. When he was first shopping *Chew*, writer John Layman created a multipage pitch document but wasn't getting anywhere with it. "It got rejected and rejected and rejected," he recalls, "and finally I decided to fund it myself. I had a budget and I called [Image Comics editor-in-chief Eric] Stephenson, hoping to get set up with an artist. And I told Stephenson about it (not intending to pitch it), and he said, 'We don't find artists for people, but I like the concept. Get a good artist and Image will publish it.' Voilà! Approved!" The *New York Times* best-selling and Eisner Award–winning series was sold on a brief verbal concept alone—which itself proved viral.

We've generally found it's a lot easier to synopsize a project after it's completed—a lot simpler to describe what you've already done instead of what you're about to do. That's why the pitching section of this book is in the fourth chapter and not the first. Though you'll have strong ideas about your project from the outset, these will very likely change in the process of bringing it to life. Ernest

As writer Cullen Bunn's conception of the *Sixth Gun* story evolved to flesh out a more complex mythology (as demonstrated here), his pitch evolved with it. (Art by Brian Hurtt.)

Hemingway famously said that "all first drafts are shit," which doesn't refer to the quality of the writing. A lot of the time, it will take actually executing a story for you to figure out what it's really about. Characters will take you in surprising directions. Midway through Act Two, you'll discover a better plot point than you had before. You should always remain open to these opportunities, and be nimble enough to capitalize on them. Also, just naturally through the process, you'll describe the project to friends and family—and with each retelling, you'll refine your "pitch" a little bit more. If you're lucky, when you sit down to write your logline you'll already have one at your fingertips.

"*The Sixth Gun* had a strange evolution," recalls writer Cullen Bunn. "The story you read now is vastly different than the one that was originally pitched." Bunn told us he dug up his original proposal when we contacted him for *Make Comics Like the Pros* "and realized I didn't even use a traditional logline. This is what I used: The year is 1887. Thirty years ago, the Devil gifted a band of ruthless killers with six pistols. Each pistol possessed its own special power, making the man or woman who wielded it almost unstoppable. One of the gang members killed all of the others in an effort to steal all the guns for himself. But the sixth gun was lost and presumed destroyed. Now, the killer finds that the gun still exists . . . and it is in the possession of children."

Bunn had to later change that pitch into a version closer to what you see on page 97 because of what you'd call one of those *good* problems: "Oni [Press] was interested in the book from the initial pitch. The initial story, though, was definitely a six-issue series without any real room for continuation. The publisher saw potential beyond that, though, and asked for a take on the concept that would allow for a longer story (slated now for fifty issues) and the world-building that I really love to do." It was only in later discussions that "I started using a cheesy Hollywood logline."

Of course, you don't always have the luxury of having a well-thought-out property that's already gone through multiple revisions prior to making a sale. We've been approached by numerous publishers to "pitch" on a particular property (oftentimes competing with other writers), and in that instance, you have to come up with a synopsis of a story that doesn't exist yet.

The ability to do this consistently separates the pros from the wannabes; and here's what we've learned about pitches from years of other people buying our ideas based on short descriptions alone.

COMMANDMENTS FOR PITCHING

1. Avoid empty superlatives . . . Yes, we're sure you think your graphic novel is brilliant or heartwarming or hilarious, but you shouldn't literally say that, just as you don't get a job recommendation from your mom: of course *she* thinks you're perfect, but she's too biased to be trusted. Subject-verb-object construction, correctly arranged, will sell the awesomeness of your comic without you actually needing to use the word *awesome*.

2. . . . but embrace active words. Consistently employ energetic verbs like *battles*, *struggles*, *confronts*, and *searches* to make your pitches dynamic and exciting— don't just say, "My story is dynamic and exciting."

3. Give a reason to root for your protagonist—yes, even in the *span of a single sentence*. Can you embed what he wants, like we did in *The Sandman* pitch, or what he's trying to stop, as in the *Chew* example?

4. See if you can you end your logline in a question. It's an old rule of hack journalism that the answer to almost any question in a headline is "No." (As in, Did the president *really* call the prime minister a buffoon? Or, Can Brussels sprouts give you cancer?) But hey, it gets people's attention: Can he save the world and earn back his daughter's trust at the same time? Particularly with ongoing comics series, an open-ended question can hint at a wealth of stories that could potentially be told for years.

5. Sketch out the big plot points and character arc, not beat-by-beat details of scenes. In the written pitch, after your basic logline, you'll need to lay out the basic story line in a page or two. We're writers, so we're always tempted to dive into the beautiful, subtle details of individual scenes. But in the initial meeting, editors are trying to figure out if you have a story to tell. Describe the big plot points as simply as possible, and be explicit about the character development that you're envisioning.

6. A short brief about your vision of the character and theme can be a great thing. When Greg pitched for *Action Comics*, he wrote a short paragraph about the fact that he sees Superman first and foremost as Clark Kent, a young man from Kansas who's struggling

Code Monkey Save World **cover, drawn by Takeshi Miyazawa with color by Jessica Kholinne. For more on this cover see pages 100–101.**

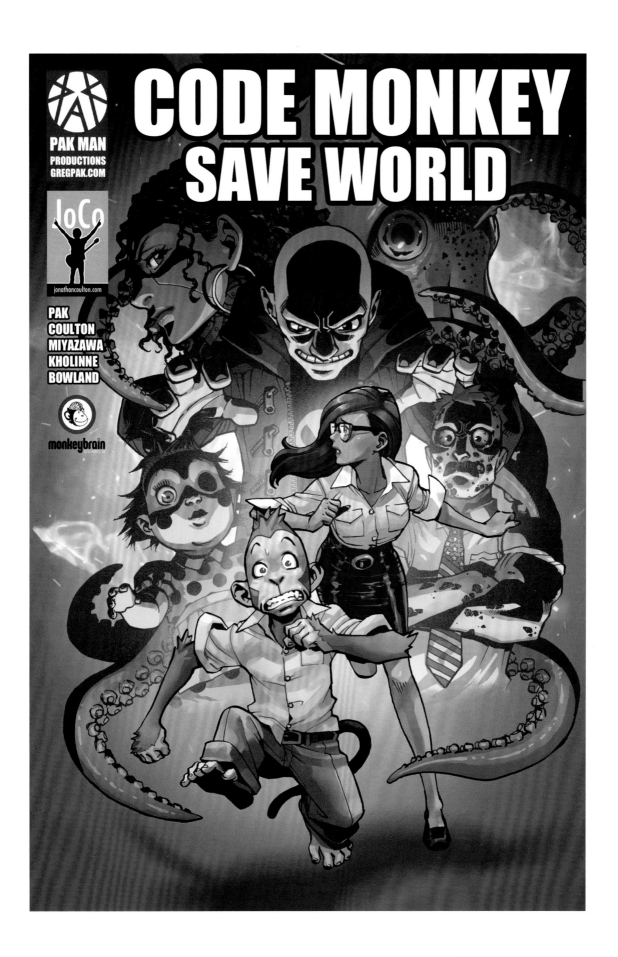

every day to come to terms with his insane powers and responsibilities. A few words like that can go a long way toward helping editors understand the point of the stories you'd like to tell and your long-term plans for the characters.

7. Be prepared to talk for fifteen seconds, for two minutes, or for ten minutes. You'll need different versions of your pitch for different situations. If your audience likes the logline, you may get the chance to talk for a couple of minutes about what happens next in the story. If your audience likes that, you might have ten minutes to lay out the whole first story arc. Your job is to know your characters and story so well that you can talk at any length about them. Also worth remembering: It's usually just fine if you don't have all the answers about every detail of the story. Being open about what you still need to figure out can actually reassure an editor that you're someone who's ready to collaborate.

8. Have another pitch ready if the first one falls flat. This is ridiculously important. Very often, you'll be invited to a meeting to talk about one project. You'll deliver your brilliant werewolf pitch and they'll tell you, "Oh, we're already doing a werewolf thing. Do you have anything else?" You definitely want to have something else. You're in the door, and they're listening—be prepared with at least two or three ideas.

CREATOR-OWNED VS. WORK FOR HIRE

This chapter has focused largely on books set up at the comics publishers that handle creator-generated and -owned properties. As of this writing, those publishers include Image, Oni, Boom, Dark Horse, and DC's Vertigo imprint, among others.

That said, this information is equally applicable to getting work as a writer or artist or letterer or colorist in the much larger world of licensed comics. Most comic book publishers can be subdivided by the licenses they control: As of this writing, Dark Horse has *Conan*; IDW has *GI Joe* and *Godzilla*; Boom has *Adventure Time* and *Regular Show*. Even Marvel and DC can be considered licensing companies, though they own their own properties, like *Spider-Man*, *X-Men*, *Avengers*, *Superman*, *Batman*, and *Justice League*.

These companies traffic in what is known as "works made for hire" under copyright law and colloquially within the industry as "work-for-hire." What that means practically is that your scripts or artwork or colors aren't just owned by the company who hired you; under the law, they *created* them, and you were merely the instrument of that creation. Though some have made a moral judgment of this in the past, we are not doing so here. That is literally how the copyright law is phrased.

As we said in the introduction, also keep in mind that, these days, the best way to write the adventures of the Hulk or Green Lantern is to create your *own* comics *first*! This is how editors hire talent these days, inviting the people who create the independent comics they enjoy to come work for them. They don't read pitches or sample scripts. (Artists have a much easier time of it, as there is always a dearth of capable, available artists at any given moment in the publishing schedule.)

So from now on, when someone asks how to break in at Marvel and DC (as they invariably do), we'll just hand them this book and say, "*This* way."

COVERS AND PROMO ART: THE PITCH MADE FLESH

An entire book could—and probably should—be written about covers, particularly in the digital age. As a general rule, the cover is *a visual version of the pitch for that issue*. A cover has a job, and that job is to make the person who has never heard of your project before say, "I want to buy *that*."

As any book designer will tell you, there are as many ways to go about doing that as stories to be told. The job of a cover is to *stand out*, either popping from the racks across the room or being attractive even as a small thumbnail shrunk down on an iPad screen or distributor catalogue solicit. Your logo, or your title incorporated into a distinctive emblem or wordmark that matches the tone of your story will be a big help in this. See Emma Rios's eerie hand-drawn logo for Pretty Deadly to the right and the LOLCATS hat-tipping use of the Impact font in the *Code Monkey Save World* cover on the previous page. Too busy is bad, because the image will become unreadable at certain sizes; too static can come across as boring. Like Goldilocks, you're looking for porridge that's just right.

We don't necessarily want to recommend any one method; all are effective from time to time. A very abstract cover, using a lot of negative space, conveys a simple beauty and sophistication. A "movie poster" style cover, like the one from *Code Monkey Saves World*, suggests an entire world teeming with adventure and colorful characters.

Writer Kelly Sue DeConnick hooked people into supporting her acclaimed *Pretty Deadly* comic book series with the tagline "spaghetti western meets pinky violence." But she says she had to bluff her way through a more detailed conversation. "I pitched that book before I had the story," says DeConnick. "I told them about what I

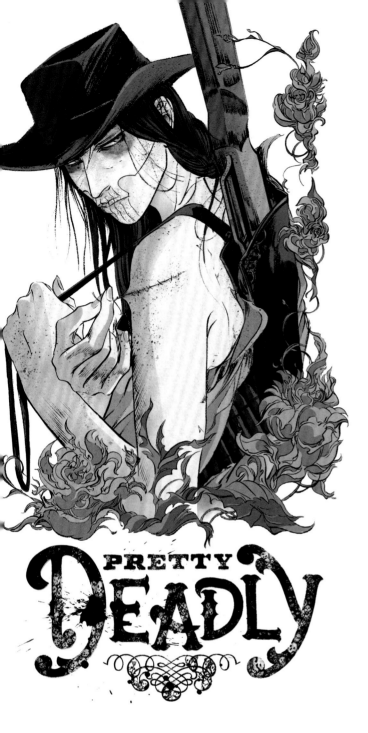

Emma Rios's evocative art and logo
for *Pretty Deadly*, written by Kelly Sue
DeConnick.

genuinely thought it was going to be about—a lady sharp-shooter in the Old West. Not the story we ended up with at all. In retrospect, I was pitching tone, I suspect."

DeConnick says what really sold the book in the end was "the teaser image that Emma [Rios, series artist] did with the woman with the skull tattoo sewing up her own arm."

DeConnick's tagline sold tone. Emma Rios's eerie, creepy, evocative image and logo made that tone tactile.

For the cover of *Code Monkey Save World*, a graphic novel based on the songs of Jonathan Coulton, Greg sent artist Takeshi Miyazawa the following description:

> *Code Monkey and Matilde running toward us—away from a horde of monsters/villains! Code Monkey in the foreground, bounding toward us, holding Matilde's hand, kind of dragging her along. The monsters include Laura the Robo Queen, a few office worker zombies (from Jonathan's song "Re: Your Brains"), the Creepy Doll (which I see as a rag doll with buttons for eyes, almost like a voodoo doll), the Giant Squid (from "I Crush Everything"), and Skullcrusher flanked by giant, Lord-of-the-Ringsy, warg-like wolves. Nice room at the top for a big "CODE MONKEY SAVE WORLD" logo. Code Monkey is probably terrified. Matilde is probably determined, jaw set.*

The hope with a cover like this is to show big, fun action and an interesting world. There's also some character-based humor with a big *Code Monkey Save World* title over an image of the titular hero running from danger.

The challenge with a cover like this is making all of these many elements work together and serve one effect. Miyazawa solved the problem in part by making the villains larger than life in a stylized way, which allows them to be very threatening and distinguishes them from our heroes. He also left out the wolves Greg recommended, which Greg never missed. (Note: Great collaborators sometimes know when to simply ignore stuff that doesn't work.) Jessica Kholinne's colors complete the effect by rendering the villains in just a few shades while keeping our heroes in full color. The slight glow behind our heroes also makes them pop and separates the different elements of the page in just the right way.

SWORDMAIDS COVER

When it comes to *Swordmaids*, a very character-heavy piece, we spoke with Colleen Coover about getting a piece that establishes, in a single image, the dynamic between our three heroines. Here's the text we sent her for inspiration:

A graphic representation of the characters' relationship—Sophie standing in between Khu and Gudrid, grinning like a maniac, gripping a weapon, while Khu and Gudrid stare down on her from either side, like "Oh, God."

Or, for an action version:

Khu and Gudrid right up in our faces, swords flashing, parrying a bunch of swords and spears that frame the image (we're seeing this from the POV of the attackers). Our heroines are tough, intense, grimy, and sweaty—and KICKASS. And then Sophie is smaller, behind them, grinning and waving her weapon, having a great old time.

And here's what she came up with!

Swordmaids
The Pitch Document

With *Swordmaids*, we have a comic (albeit only an 8-page one) but now we've got to go shopping it around out there, to the Images, Onis, and Archaias of the world. And so even though we have lovely sample pages and character designs, a potential publisher is going to want to know (a) what our story's hook is, and (b) where our story, ultimately, is going.

And that's where our one-sentence synopsis and two-page outline come in. Based on some of the principles discussed in this chapter, this is what we came up with. See if you can do better! Even if you're self-publishing, this is a good exercise for you to do anyway on your own project. In stories, as in life, it's very hard to get where you're going if you don't know what your destination is. (Wandering can be its own reward, but more often than not it's just . . . wandering.)

LOGLINE

In this madcap buddy-adventure comedy set in a high fantasy world, two roguish best friends are recruited by a spoiled princess to take her on one last big adventure before she gets married—but little do our heroines know this adventure is far more dangerous and harrowing than they bargained for!

THEME

Nothing is more dangerous (or annoying) to a rogue than discovering she has the secret heart of a hero.

OUTLINE

KHU and GUDRID are two orphans who grew up in the backwater hamlet of Muntz in a far-off fantasy realm. They had to fill their bellies and keep one step ahead of the local Keep Guard with their wits—and, when all else failed, their sword-arms. Khu was always lithe and fast, Gudrid heavy but clever.

They grew up with SOPHIE, a local noblewoman's daughter who was a few years younger than them and was sent from the capital to live with a wet-nurse in the country, as was the custom in those days. Spoiled rotten and possessed of a strong wild streak, Sophie tagged along on Khu and Gudrid's "heists," invariably getting them in trouble. Finally, when Sophie accidentally blows their attempt to steal pies cooling on the kitchen shelf of the Keep, the guard is summoned and the two rogues have to flee their hometown forever.

Fast-forward ten years. Khu and Gudrid are professional swordsmen—er, sword*maids*, warriors-for-hire who work for themselves as often as not. They target the THIEVES' GUILD in the kingdom's teeming capital of EVERWHERE for refusing to admit women among

its ranks. After a brilliant heist, they're fleeing with their ill-gotten gains (or re-ill-gotten, since they stole them from thieves) when they're captured by the King's Guard.

Imprisoned in the dungeon, the jig seems up for our hapless rogues until who reenters their lives but Sophie, now princess, since her father ascended to the throne, and heir to the entire kingdom! Sophie will spare her childhood "friends" from the executioner's axe, but only if they agree to her demands: to solidify relations with the nearby kingdom of the elves she has been betrothed to their prince. She has never had a real adventure before, and she's going to hire these swordmaids to take her on one before her freedom is lost to marriage forever. Our heroines want to save their necks and earn some coin—not to mention they genuinely feel bad for the girl—so they agree to this cockamamie plan.

Sophie, of course, doesn't bother to tell her sword-maids that she's going to bust them out of the dungeon in a psychotically dangerous jailbreak! Their patroness is an adrenaline junkie, and everything she does is with the dial cranked up to eleven. She has a treasure map she wants them to follow—to the ruins of the ancient Wizard's College of ARCANIUM. The journey will be rife with monsters, traps, and assorted dangers, but Sophie says that whatever loot her adventuresses-for-hire find, they can keep: she just wants a specific artifact, an amulet of vast power originating from the hostile underlands of Drow, or subterranean elves, running beneath both human and elvish kingdoms.

Sophie leaves behind a note for her parents that the king and queen, panicking upon finding her miss-ing, misinterpret as saying she has been kidnapped by Khu and Gudrid. They hire the notorious swordsman LAZARQ, THE GIRL-HUNTER (who, as he keeps saying, is fully licensed and bonded by the state). His primary weapons are the girls he keeps in a cage on his back, whom he throws at his foes as weapons (each girl wields specific weapons themselves!).

As expected, the Arcanium ruins are rife with magi-cal traps and lurking beasts. Unbeknownst to her (as an orphan, she does not know anything about her past), Khu's family members were the keepers of the magic academy, and her ancestor, the BONEQUEEN, former headmistress of the school, still haunts the ruins as a dangerous lich (undead sorceress)—and, unfortu-nately, the Drow amulet hangs around her neck!

After a desperate battle, the girls manage to defeat the undead sorceress, and Sophie gets her paws on the amulet. Unfortunately, at that moment Lazarq catches up to them and attacks! The Girl-Hunter mistakes Gudrid for Sophie and carries her back to Everwhere, thinking the swordmaids have been buried beneath the ruins.

Khu demands they go after Lazarq, but Sophie guilt-ily says she can't. She didn't tell her hired swords the full truth—she wanted the amulet not for herself but for her girlfriend, THENA, princess of the Drow, who in their secret correspondence has been furious with her for being married off to the elf prince. Her next stop has to be the Underlands themselves. Khu denounces Sophie for being a spoiled brat who doesn't know a thing about real friendship—just like when they were kids. Khu takes off after Lazarq and Gudrid, Sophie descends into the nearest tunnel to the Underlands to meet with her love . . .

. . . and is instantly captured! It turns out Sophie was duped by nefarious elements within the Drow. GAR-NOTH, the Vizier of the Underlands, has tricked her with phony messages from her girlfriend, hoping to lure her in a trap. He plans to extort massive concessions from both the human and elvish kingdoms using Sophie as his hostage.

Meanwhile, Khu pursues Lazarq and Gudrid using some of the natural magical abilities that are her birthright and were reawakened during her adventure in her family's Arcanium. But she is unable to stop the Girl-Hunter before he returns to the Everwhere palace with her prize. The mix-up is quickly discovered, but in the process, Gudrid meets RELION, the elvish prince, who rushed to the human capital upon learning of his betrothed's "kidnapping." Gudrid falls for him—hard.

Once the Drow demands come in, Relion hires the girls for a new mission—to venture into the Drow Underland and free Sophie from the Vizier's clutches!

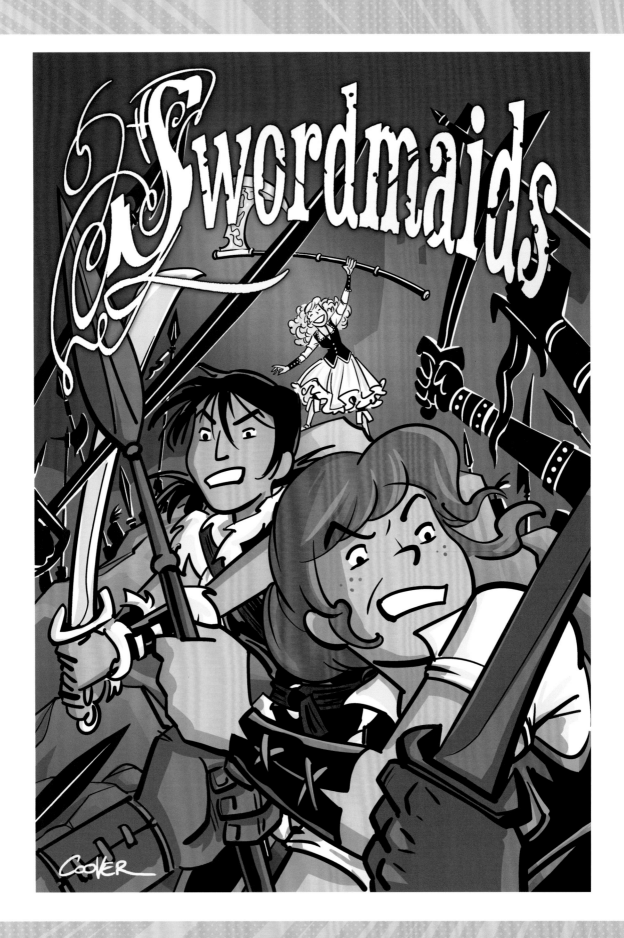

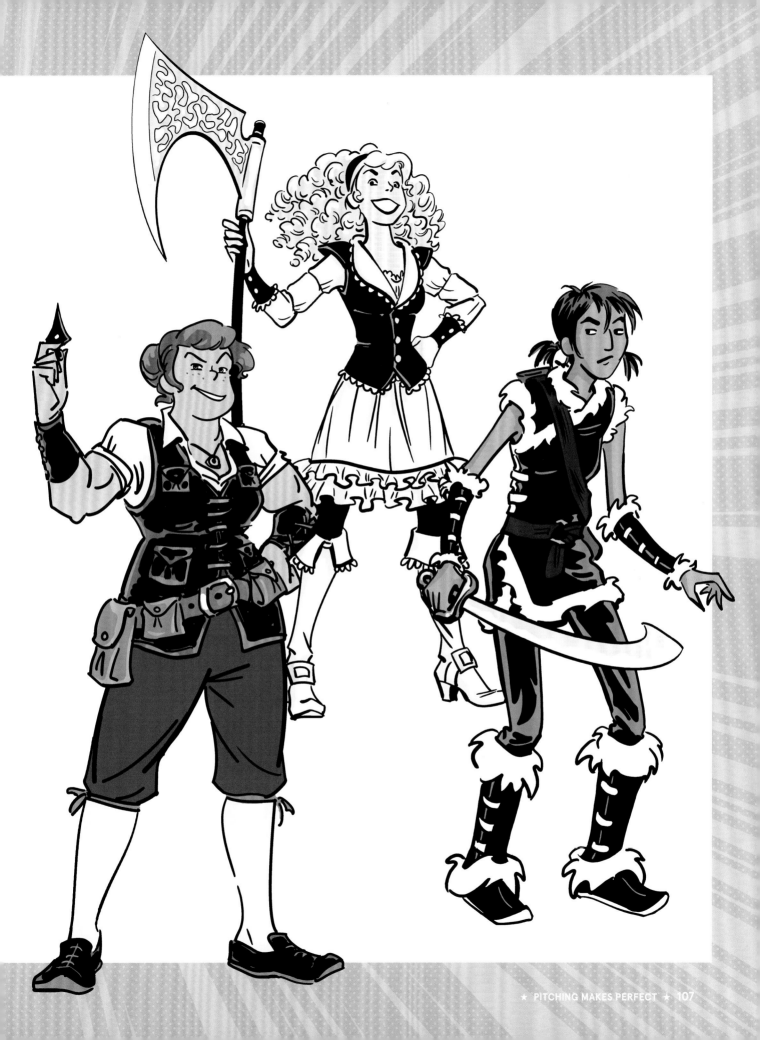

THERE THEY ARE! GET 'EM!

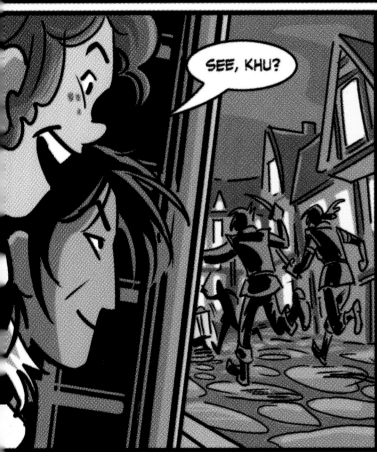

SEE, KHU?

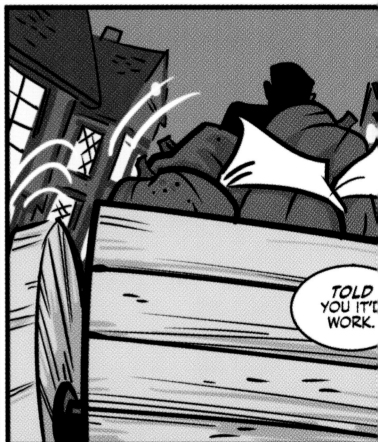

TOLD YOU IT'D WORK.

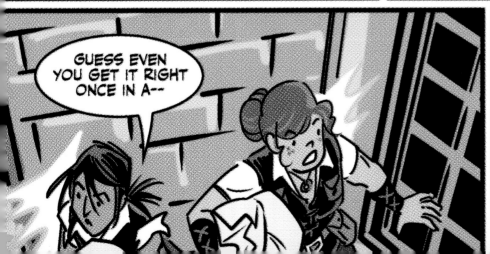

GUESS EVEN YOU GET IT RIGHT ONCE IN A--

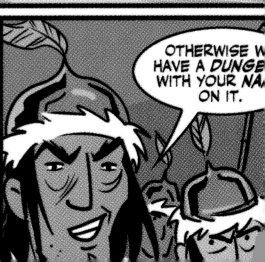

OTHERWISE W HAVE A DUNGE WITH YOUR NA ON IT.

D.I.Y. IN PRINT AND ONLINE

OLD SCHOOL: PRINTERS, DISTRIBUTORS, AND RETAILERS

Comics used to be cheap in America. Like, a dime per copy. And that isn't like some you-could-buy-a-house-for-ten-bucks-in-the-old-days thing, that was cheap even by Great Depression standards. And there's a good reason for that. When they first started out, when the editor of *Action Comics* didn't want to put Superman on the cover because he thought the idea of a man in a cape picking up a car was ludicrous (true story), comics were a unique artifact in America: they were one of the first products marketed directly *to* children.

Before, you would market to the parents to buy your product for kids, but comics (which were initially just reprints of daily strips, essentially the newspaper with every other section but the funnies taken out) were priced so that kids could buy them with whatever loose change happened to be jangling around their pockets at the time. They were supposed to be an impulse buy at a newsstand or in a drugstore, next to similarly priced chocolate bars and hard candies. With their colorful, bombastic covers, they were a sugar rush for the eyes.

With a cover price that low, the only way publishers could turn a profit was to sell comics in bulk. And for most of the twentieth century, that's exactly how they were sold: by the bushel. It sounds astounding to us today, but in the old days, comics were treated like any other commodity regardless of title or contents. News dealers got a bundle, often of random issues, and fans had no idea whether or not their stores would have latest issue of *The Aeronautic Eagle-Man* or if they'd have to go from block to block until stumbling across a magazine rack that carried one.

Ultimately, in the 1970s a new system arose so that fans could be assured of getting every issue of comics titles they loved—their own market through which comics publishers could circumvent the newsstand distribution system and sell "funny books" directly to the people who liked them the most. Today this system is known as the *direct market*, and if you want to be a comics creator, you need to have at least a passing familiarity with it. If you're publishing yourself, you need to know it like the back of your hand.

Fred's *Comic Book History of Comics* goes into how things got this way (plug, plug), but basically, there is one major distributor of comic books and related items in North America and, indeed, the entire English-speaking world: Diamond Comic Distributors of Baltimore, Maryland. Every month Diamond publishes a catalogue called *Previews* that's shipped out to every account (mostly comic book specialty retailers). It's a small-town-phone-book-sized listing of all the comics, graphic novels, posters, toys, games, statues, mugs, tin signs, and related merchandising that will be available two months down the line. For example, the June issue of *Previews* lists all the available stock for August. It is only a small exaggeration that if it's not in *Previews*, it doesn't really exist in print comics in the English language.

Assuming you're a brand-new publisher, you will need to follow whatever Diamond's current submissions process is; go to vendor.diamondcomics.com/public/ to learn what the current policy is on becoming a vendor (or "publisher," in more common parlance). Usually, this means having an entire comic book completed. That's the hard part: you cannot submit your comic unless it is finished.

Mail in your submission at least half a year before you want your first issue to come out to get it in on time. As of this writing, Diamond policy is that a product must generate at least $2,500 in revenue in order to be carried in the catalogue; depending on your cover price, that could be a whole lot or a whole little. Hopefully, once Diamond has had a chance to review your work and your marketing plan (yeah, you need one of those too—see next chapter), you'll get the thumbs up and be carried in the catalogue.

Every month, a store owner or manager sits down with the *Previews* order form and marks how many of which comics she wants to order. Because it is the one monthly periodical all retailers see—really, *have* to see—before making their purchasing decisions, *Previews* is incredibly powerful, and the advertisement rates are not cheap: full-size and color ads cost several thousand dollars a page. Big publishers have to distribute their limited marketing and publicity dollars wisely to give featured products big, splashy promotions. The *biggest* publishers, like DC, get their own special section at the front of the catalogue.

Omnipresent in the retailer's ordering deliberations is the knowledge that Diamond's product—like all comics products since the birth of the direct market—is *nonreturnable*. What does that mean? In the old days of newsstand distribution, if a dealer didn't sell every comic he bought, he could rip off the cover and send it back to the distributor (to save on return shipping costs) to earn a full or partial refund. This encouraged retailers to order as much as possible but was risky for the publishers, who always had to keep a certain amount of money in reserve to pay back returns. Modern-day book distribution works the same way, and 30 percent of monies owed to publishers are kept in reserve for a financial quarter or so in case returns come in. It makes managing cash flow as a publisher a bit tricky, because you're never entirely certain how long it will take for you to see a full profit from a particular title.

The early direct-market comic book distributors, as part of their bargain with skeptical 1970s publishers, did away with "returnability": whatever comics retailers bought, they had to sell. They couldn't send ripped covers back; they were just stuck with them. In the old days, this didn't seem like a bad deal to the retailers, because any new comics that weren't sold within a week or two of release could be bagged and put in the back-issue bins to be bought later down the line by collectors. But in our time, digital comics, torrents, and trade paperback editions have done a real number on the back-issue market. Now, any retailer who doesn't sell 80 to 90 percent of what he orders is operating at a loss. And retailers have to pay for employees, rent, electricity . . . any loss is bad.

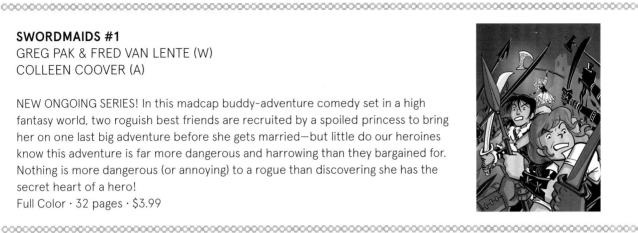

SWORDMAIDS #1
GREG PAK & FRED VAN LENTE (W)
COLLEEN COOVER (A)

NEW ONGOING SERIES! In this madcap buddy-adventure comedy set in a high fantasy world, two roguish best friends are recruited by a spoiled princess to bring her on one last big adventure before she gets married—but little do our heroines know this adventure is far more dangerous and harrowing than they bargained for. Nothing is more dangerous (or annoying) to a rogue than discovering she has the secret heart of a hero!
Full Color · 32 pages · $3.99

Cover + Logline = Catalogue Solicitation. This little box may be the first (and only) time a retailer sees that your comic exists, so make it count.

So every time they sit down with *Previews*, retailers are trying to order *exactly* how much they can sell! Comic book retailers have to be a combination of Nostradamus and Jimmy the Greek, always playing the odds.

The best retailers know their customer base, their likes and dislikes. Almost all keep careful track of their inventory, adjusting orders for an ongoing upward if, say, a new creative team has been announced or some other event is happening that might gain it some extra traction. More commonly, alas, they order a little bit less of each subsequent issue. The second law of thermodynamics manifests itself in comics with almost every title shedding a few of its readers every month, either because they've given up on it or the last issue wasn't memorable enough to pick up the next one or they just had a new baby and can't get to the store or they joined the Peace Corps. Those readers aren't necessarily gone forever, but it's part of the natural order of things that your numbers will drift downward from issue to issue no matter how popular you are. *That's why you want those first issue sales to be as high as possible!* If you start from the highest peak, you have quite a ways to fall before you hit bottom. When ordering #1s of a series no one has ever seen before, retailers have to bring all of their Nostradamus powers to bear. They will try to latch on to anything—a popular creative team, a really cool premise, a subject they're really interested in—to inform order quantities. It's the same old paradox: people won't order you if you don't hit big, but how can you hit big if no one orders you? Here's where variant covers—collectible covers that are rarer, and therefore more sought-after by some collectors—become important, especially covers by famous artists. This is why doing outreach to retailers before *Previews* hits is

key (and you need to do this even if you're being published by someone else—see our next chapter). This is why you need to time your announcements and online press to coincide with the arrival of *Previews*, so it's fresh in the minds of retailers when they sit down to order that month.

And that's why *preordering* is so important. Most comic book stores offer "pullboxes" to customers—the customer fills out a form, a "pull list"—to let the shop know she wants every issue of that title as it comes out, along with its associated merchandise. If you get as many of your friends, Twitter followers, relatives, and total strangers to go to their local comics shops (LCS) and preorder your book, you might pique that shop owner's attention and make her realize there's a market for this heretofore-unheard-of property, and tick up orders accordingly.

Equally as important as all these things you're doing to set yourself up to succeed outside *Previews* is what you're doing inside *Previews* itself. Unless you have a lot of money to spend on advertising (and we should point out from personal experience that it's very hard to tell whether spending on advertising gives you any bang for your buck at all) or you have a supportive publisher, what the retailer is going to see is your *solicitation*: a brief description of the book, its creative team, cover price, whether it's in color or black and white, and a smallish thumbnail of the cover. We've reproduced a faux solicitation for *Swordmaids* above.

(Incidentally, note that description? That's the *solicitation copy*, and it's almost word for word the *logline* we developed in the last chapter. See why it's so important? *This is why you need to pay attention to the things we tell you.* Ahem.)

(continued on page 114)

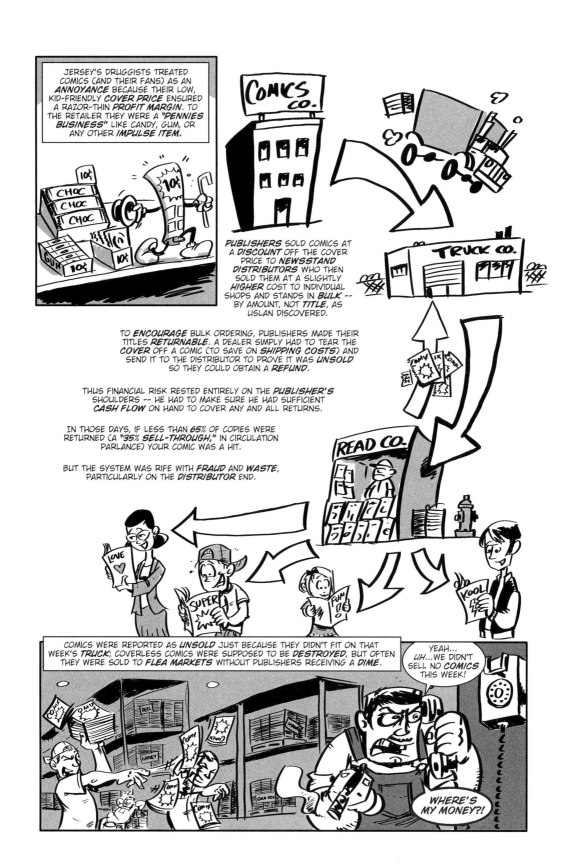

JERSEY'S DRUGGISTS TREATED COMICS (AND THEIR FANS) AS AN *ANNOYANCE* BECAUSE THEIR LOW, KID-FRIENDLY *COVER PRICE* ENSURED A RAZOR-THIN *PROFIT MARGIN*. TO THE RETAILER THEY WERE A *"PENNIES BUSINESS"* LIKE CANDY, GUM, OR ANY OTHER *IMPULSE ITEM*.

PUBLISHERS SOLD COMICS AT A *DISCOUNT* OFF THE COVER PRICE TO *NEWSSTAND DISTRIBUTORS* WHO THEN SOLD THEM AT A SLIGHTLY *HIGHER* COST TO INDIVIDUAL SHOPS AND STANDS IN *BULK* -- BY AMOUNT, NOT *TITLE*, AS USLAN DISCOVERED.

TO *ENCOURAGE* BULK ORDERING, PUBLISHERS MADE THEIR TITLES *RETURNABLE*. A DEALER SIMPLY HAD TO TEAR THE *COVER* OFF A COMIC (TO SAVE ON *SHIPPING COSTS*) AND SEND IT TO THE DISTRIBUTOR TO PROVE IT WAS *UNSOLD* SO THEY COULD OBTAIN A *REFUND*.

THUS FINANCIAL RISK RESTED ENTIRELY ON THE *PUBLISHER'S* SHOULDERS -- HE HAD TO MAKE SURE HE HAD SUFFICIENT *CASH FLOW* ON HAND TO COVER ANY AND ALL RETURNS.

IN THOSE DAYS, IF LESS THAN *65%* OF COPIES WERE RETURNED (A *"35% SELL-THROUGH,"* IN CIRCULATION PARLANCE) YOUR COMIC WAS A HIT.

BUT THE SYSTEM WAS RIFE WITH *FRAUD* AND *WASTE*, PARTICULARLY ON THE *DISTRIBUTOR* END.

COMICS WERE REPORTED AS *UNSOLD* JUST BECAUSE THEY DIDN'T FIT ON THAT WEEK'S *TRUCK*; COVERLESS COMICS WERE SUPPOSED TO BE *DESTROYED*, BUT OFTEN THEY WERE SOLD TO *FLEA MARKETS* WITHOUT PUBLISHERS RECEIVING A *DIME*.

YEAH... UH...WE DIDN'T SELL NO *COMICS* THIS WEEK!

WHERE'S MY MONEY?!

The evolution of comics distribution in America, as described in *The Comic Book History of Comics*. (Script by Fred Van Lente, art by Ryan Dunlavey.)

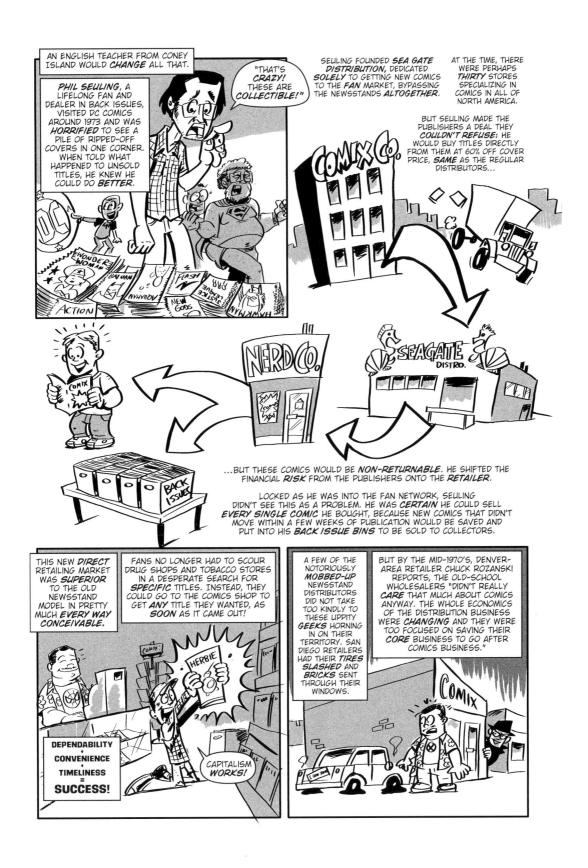

AN ENGLISH TEACHER FROM CONEY ISLAND WOULD **CHANGE** ALL THAT.

PHIL SEULING, A LIFELONG FAN AND DEALER IN BACK ISSUES, VISITED DC COMICS AROUND 1973 AND WAS **HORRIFIED** TO SEE A PILE OF RIPPED-OFF COVERS IN ONE CORNER. WHEN TOLD WHAT HAPPENED TO UNSOLD TITLES, HE KNEW HE COULD DO **BETTER**.

"THAT'S **CRAZY!** THESE ARE **COLLECTIBLE!**"

SEULING FOUNDED **SEA GATE DISTRIBUTION**, DEDICATED **SOLELY** TO GETTING NEW COMICS TO THE **FAN** MARKET, BYPASSING THE NEWSSTANDS **ALTOGETHER**.

AT THE TIME, THERE WERE PERHAPS **THIRTY** STORES SPECIALIZING IN COMICS IN ALL OF NORTH AMERICA.

BUT SEULING MADE THE PUBLISHERS A DEAL THEY **COULDN'T REFUSE:** HE WOULD BUY TITLES DIRECTLY FROM THEM AT 60% OFF COVER PRICE, **SAME** AS THE REGULAR DISTRIBUTORS...

...BUT THESE COMICS WOULD BE **NON-RETURNABLE.** HE SHIFTED THE FINANCIAL **RISK** FROM THE PUBLISHERS ONTO THE **RETAILER.**

LOCKED AS HE WAS INTO THE FAN NETWORK, SEULING DIDN'T SEE THIS AS A PROBLEM. HE WAS **CERTAIN** HE COULD SELL **EVERY SINGLE COMIC** HE BOUGHT, BECAUSE NEW COMICS THAT DIDN'T MOVE WITHIN A FEW WEEKS OF PUBLICATION WOULD BE SAVED AND PUT INTO HIS **BACK ISSUE BINS** TO BE SOLD TO COLLECTORS.

THIS NEW **DIRECT** RETAILING MARKET WAS **SUPERIOR** TO THE OLD NEWSSTAND MODEL IN PRETTY MUCH **EVERY WAY** CONCEIVABLE.

FANS NO LONGER HAD TO SCOUR DRUG SHOPS AND TOBACCO STORES IN A DESPERATE SEARCH FOR **SPECIFIC** TITLES. INSTEAD, THEY COULD GO TO THE COMICS SHOP TO GET **ANY** TITLE THEY WANTED, AS **SOON** AS IT CAME OUT!

DEPENDABILITY + CONVENIENCE + TIMELINESS = SUCCESS!

CAPITALISM **WORKS!**

A FEW OF THE NOTORIOUSLY **MOBBED-UP** NEWSSTAND DISTRIBUTORS DID NOT TAKE TOO KINDLY TO THESE UPPITY **GEEKS** HORNING IN ON THEIR TERRITORY. SAN DIEGO RETAILERS HAD THEIR **TIRES SLASHED** AND **BRICKS** SENT THROUGH THEIR WINDOWS.

BUT BY THE MID-1970'S, DENVER-AREA RETAILER CHUCK ROZANSKI REPORTS, THE OLD-SCHOOL WHOLESALERS "DIDN'T REALLY **CARE** THAT MUCH ABOUT COMICS ANYWAY. THE WHOLE ECONOMICS OF THE DISTRIBUTION BUSINESS WERE **CHANGING** AND THEY WERE TOO FOCUSED ON SAVING THEIR **CORE** BUSINESS TO GO AFTER COMICS BUSINESS."

For the publisher, the comics retailer is the primary customer. Co-owner Alex Cox helps one of his customers in Brooklyn's Rocketship.

Now you may be wondering why we've spent so much of a chapter about self-publishing on thinking like a retailer. There's a simple reason: though a creator may think the end point of the comics financial transaction is the reader, from the publisher's point of view the *retailer* is your actual *customer*. You help yourself by helping retailers sell your books and, more important but much more tricky, by providing them with products they can actually sell. It is retailers who pay the distributor, who then pays you. The reader is an important participant in the process, *but on the retailer end*. Motivated retailers—recommending your book to customers, shelving it in a prominent location in the store, reordering it frequently—are your best sales tool. Use all legal means to keep them happy.

The way the pay chain works is that the customer pays the retailer, who pays the distributor, who pays you. You are third in the food chain, which means you get a little less than the people before you. Diamond buys your comic for 60 percent off cover price, then sells it to the retailer for 50 percent, who then sells it to a customer for 100 percent (not counting any store discount). The amount of dough we're expecting to make from a regular-size floppy of *Swordmaids* #1 is on page 126.

Once all the retailers in the United States, Canada, Great Britain, and beyond have told Diamond how many copies of your book they want, Diamond will then tell you, and we hope your mind melts with happiness. One of the most advantageous aspects of the direct market's "nonreturnability" from a publisher's point of view is that you get to print to order—that is to say, go into the manufacturing process holding in your hand a piece of paper that tells you how many comics you've already sold.

We'd recommend only printing your Diamond orders, with maybe 10 to 20 percent extra to sell on your website or at conventions, or to distribute for free to the press and Mom. Don't get too excited and do a 100 percent over-print, as one older (but not wiser) creator told Fred when he was first starting out. There's nothing more depressing than having boxes upon boxes of unsold comics staring at you like fly-speckled orphans from your garage or closet.

And besides, if you underprint and sell out, you can just do a second, third, or fourth printing with a slightly different cover and a flurry of press releases proclaiming your awesomeness to the universe, just like the Big Boys do! Yaaaaaaayyy!

Choosing a printer and preparing your comic for prepress is a specific technical skill somewhat beyond the scope of this book—though that doesn't mean it's all that difficult. Each printer should provide you with its specs, which you must follow to the letter or you will get an angry phone call from the shop floor from a foreman who does not give a crap about your artistic integrity. Fortunately, Adobe InDesign, the industry standard, has an excellent intuitive interface that will let you input that information easily. And you'll need to get an FTP program like Fetch to upload the final files—which will be enormous—onto the printer's site, from which the printing plates for your book will be made.

Many comic books in North America are printed outside Montreal by a company called Lebonfon. The exchange rate and Canada's abundance of trees (and therefore paper) made this the industry standard some time in the 1990s. So many comics are printed there that Diamond actually picks up Marvel's and DC's and plenty of

(continued on page 116)

DISTRIBUTION LIFE CYCLE

MONTH ONE: Diamond will collect all solicitations and cover images from you (or your publisher) for next month's catalogue.

MONTH TWO: The *Previews* catalogue with your product in it ships. Very important you do a lot of press and promotions here to maximize orders.

MONTH THREE: Diamond collates the orders it receives on the product, and you use that figure to set your print run.

MONTH FOUR: Ship your product to Diamond. If you work with a printer that gets a pickup from Diamond, you should leave at least two weeks for this to have your product manufactured on time.

MONTH FIVE: Diamond ships your comics to stores around six weeks after you receive your orders. Do a lot of promotions this month, too!

MONTH SIX: You get paid. (Diamond has a net-30 payment policy.)

DISTRIBUTION LIFE CYCLE TABLE

SOLICITATIONS DUE	CATALOGUE SHIPS	ORDERS IN	PRODUCT READY	IN STORES	PAYMENT
September	October	November	December	January	February
October	November	December	January	February	March
November	December	January	February	March	April
December	January	February	March	April	May
January	February	March	April	May	June
February	March	April	May	June	July
March	April	May	June	July	August
April	May	June	July	August	September
May	June	July	August	September	October
June	July	August	September	October	November
July	August	September	October	November	December
August	September	October	November	December	January

independent publishers' stock there every week. (Though as the exchange rate between the United States and Canada has evened up somewhat, we've printed in the United States and then shipped to one of Diamond's six or so warehouses around the country without headache and at minimal additional cost.)

Printers in Asia have become an increasingly cost-effective option for color printing in recent years, particularly high-end hardback, original graphic novels. But because that stock is shipped across the Pacific on container ships, you need to give yourself a lot more lead time to get your product on the road to stores.

Unless, of course, to paraphrase the immortal words of Doc Brown, you go to a place where you don't *need* roads.

NEW SCHOOL: TUMBLRS, PDFS, AND KICKSTARTERS

Of course, all of that advice is to transform the comic you've created into a physical item existing in the world. But we don't need to tell you that physical objects are not necessarily required in today's world. Those same digital files you'd upload to a printer's FTP site could be converted into webcomics or PDFs, or distributed via other digital vendors like the current industry giant Comixology.

The dream began at the turn of the millennium when webcomics like Brian Clevinger's *8-Bit Theater* developed massive followings. Clevinger originally put his comics online to accommodate a friend who wasn't able to receive them via email. He was completely surprised when he started to get a thousand page views a day, "then 10,000; 20,000; 100,000." And then he began to realize he could make some money from this crazy thing.

"Around the 10,000 mark or so, it's pretty easy to just set up an Etsy thing or whatever," says Clevinger. "So you have a few merchandized items you sell. In any given month, about 1 percent of the audience would buy something. So it's really just a numbers game of getting enough people so that 1 percent means something."

Clevinger's webcomic eventually generated so much revenue through merchandizing that it actually became his day job.

Sadly, the best advice Clevinger can give to new webcomics aspirants is to start in 1999. "That's step number 1," he says. "Because back then so few people were doing it, anyone who made a webcomic got noticed. That's why *Penny Arcade*'s still huge. When you're first out the gate, it does help."

Today, countless webcomics vie for readers' attention. But dozens of new creators break out online every year, using the Internet to reach a more diverse audience that will support a wider variety of genres than are generally available through monthly print comics. And, of course, going the webcomics route simply makes certain projects financially possible, since much of the infrastructure is available for free. Things shift so rapidly in the Internet landscape that we hesitate to give too much specific advice, but cartoonists have used image-sharing and blogging sites like Tumblr, LiveJournal, and WordPress to post their updates. On the other hand, creators like Mike Norton, with his award-winning *Battlepug*, and Jeff Parker and Erika Moen, with their hipster murder mystery *Bucko*, have websites designed specifically to display their strips. Designing effective webcomics sites is an entirely different book—one we hope someone writes soon—but an examination of these and many other webcomics strips online should help you find a style you like, should you choose this route.

But that's just one model—you don't *have* to give your digital comic away for free! The great company Comixology, aka "The iTunes of Comics," pioneered offering comics within its own free app, available for computers, tablets, and smartphones. Anyone can submit their comics to Comixology via the guidelines at support.comixology.com/customer/portal/topics/350423-comixology-submit. Assuming your comic is accepted, Comixology converts your book to its proprietary file format, which allows readers to use their neat Guided View technology to move the browser "camera" from panel to panel as opposed to turning page by page . . . particularly useful when you're reading a funny book on a smartphone screen. Comixology offers your title for sale on its app and site, splitting the profits with you (and with Apple, if the reader buys via an iOS device, but that's another whole conversation).

Additionally, with a proper conversion service, like Graphicly (graphicly.com), you can offer e-book versions of your comics on your site and through e-book services/devices like Amazon's Kindle and Barnes & Noble's Nook.

Some complain that Comixology and Kindle use a form of Digital Rights Management—commonly referred to as DRM—that is meant to disrupt or discourage piracy but that also means consumers can only read their comic within the vendors' proprietary apps. Alternately, creators themselves have offered downloadable comics for a dollar or two on their own websites in the form of DRM-free

Colleen and Fred produced this humorous short for the pioneering *ACT-I-VATE* online collective. As you can see, webcomics can be indistinguishable from print ones . . .

INFLICTED ON YOUR SENSES BY FRED "ALPHA MALE" VAN LENTE (STORY) & COLLEEN "ALPHAER FEMALE" COOVER (ART)

♪ FOOTBALL NEEDS A BLIMP! HOOKER NEEDS A PIMP! "PULP FICTION" NEEDS A GIMP! WHAT DO **WE** NEED? ♫

UNDERCOVER CHIMP!

TROOP-X! THE TOP-SECRET AGENCY DEDICATED TO THE PROTECTION OF ALL CHIMP-KIND...

YOU WILL FIND THIS **NEXT** UNDERCOVER ASSIGNMENT THE MOST CHALLENGING **YET**, AGENT PAN.

ORDINARY CHIMPANZEE HABITAT!

NOTHING TO SEE HERE!

AGENT PAN HALL OF FAME

OPERATION RINGLING

OPERATION FLINGING

AS LONG AS I DON'T HAVE TO WEAR **CHAPS** AGAIN I'M HAPPY, ALPHA.

Heh. Honolulu Zoo. Got that guy right between the eyes...

DON'T GET **COCKY**, PAN! YOU'RE IMPERSONATING A **BONOBO** – OUR SMALLER COUSINS.

UNLIKE WE "COMMON" CHIMPS, BONOBOS ARE **MATRIARCHAL**, MORE CASUALLY **SEXUAL**, AND LESS LIKELY TO EAT THEIR **YOUNG**.

PFFF! FREAKS.

THESE BONOBOS ARE TOO GENTLE TO HANDLE THE SUDDEN INFLUX OF **HUMAN POACHERS** INTO THEIR AREA. I NEED YOU TO DISCOVER WHO CONTROLS THE LOCAL TRADE IN **BUSH MEAT**–

AWW YEAH! MY **FAVORITE** DISH. I **LOVES** TO PLEASE THE **LADIES**, YOU KNOW WHAT I'M SAYIN'?

IT...DOESN'T MEAN WHAT YOU THINK IT DOES.

IT **DOES** IF YOU **DO** IT RIGHT!

HEYYOOOHH!! UP HIGH!

PDFs. Check out Brian K. Vaughan's, Marcos Martin's, and Muntsa Vicente's *Private Eye* at PanelSyndicate.com for one example. Once the file is downloaded, it is the consumer's forever, to do with and dispose of as he sees fit. Creators who do this must depend on the honor system to make sure readers don't simply forward the files on for free to their friends, thus depriving them of sales. But given the proliferation of sites offering illegally pirated print comics for free, it's hard not to argue that most readers are on the honor system already anyway.

THE NOW SCHOOL: REJECT THE ZERO SUM FALLACY

As of this writing, in certain online corners of comic-dom, the print-versus-digital "controversy" continues to rage. Retailers are nervous about the possibility of digital comics cutting into their own profit margins, and justifiably so—just ask Blockbuster and Tower Records. (Oh, wait. You can't. They're dead.) Many readers spurn digital issues as well, preferring the feel of paper in the hands over the glare of the screen on their eyes, not to mention being

ICE QUEEN

KATERINA POPOVICH
QUEENS COUNTY
COLD HEARTED HOTTIE

. . . or they can be completely different. Reilly Brown's *Power Play* comic was digital-native and used guided-view technology to provide a unique experience for the reader—difficult to demonstrate in print, but imagine the right image suddenly replacing the left one when the on-screen comic is swiped with your finger. (Script by Kurt Christenson, art by Reilly Brown.)

iTunes プレビュー

マンガで英語:プラトン | ハジける哲学者!

By eigoTown.com Ltd.

Open iTunes to buy and download apps.

View More By This Developer

iTunes で見る

¥170

Category: Education
Released: Mar 01, 2013
Version: 1.0
Size: 157 MB
Language: English
Seller: eigoTown.com Ltd.
© eigotown.com
Rated 9+ for the following:
Infrequent/Mild Profanity or
Crude Humor

Requirements: Compatible with
iPad. Requires iOS 5.0 or later.

Customer Ratings

Current Version:
★ ★ ★ ★ ★ 7 Ratings

**More iPad Apps by
eigoTown.com Ltd.**

Description

英語をマンガで学びましょう！ これは、アメリカン・コミックを誰でも簡単に楽しめるよう、辞書機能や朗読、解説までつけたアプリです。マンガの主人公はなんと、かの有名な哲学者プラトン！ でも、これは教科書のような小難しいアプリではありません。例えばプラトンが、実は元々プロレスラーだったなんて知ってました？（本当なんです。）そんなプラトンの世

マンガで英語:プラトン | ハジける哲学者! Support ▶

...More

iPad Screenshots

Left: Fred Van Lente and Ryan Dunlavey originally received the funds to self-publish *Action Philosophers* from Teenage Mutant Ninja Turtles cocreator Peter Laird's Xeric Foundation, which sadly no longer provides such grants. The $2,800 seed money paid for the first two issues, and to their surprise, they were such a success that the series funded itself for the remainder!

Let's try that same comic again, but digitally: in 2013 eigoTown.com of Tokyo brought out *Action Philosophers* #1 as an iOS app in both English and Japanese.

○ ○ ○ Evil Twin Comics News & Fun: In honor of #CreatorOwnedDay, here's a lettered...

◀ ▶ ⬆ 🌐 eviltwincomics.tumblr.com/post/44632543795/in-honor-of-creatorownedday-heres-a-lettered ⟳ Reader

👓 📖 ▦ Twitter MLB

Evil Twin Comics News & Fun

 + Follow eviltwincomics tumblr.

>>go back to Evil Twin Comics website >> Ask us anything

Fred and Ryan Dunlavey raised funds for the first installment of their project, *Action Presidents*, via a successful Kickstarter campaign in conjunction with the Reading with Pictures nonprofit. They previewed it on the Tumblr page of their company, Evil Twin Comics, and released it digitally via Comixology. Welcome to the twenty-first century.

forever in love with longboxes, mylar bags, and backing boards. That's fine too: they're the customers, and someone once told us they're always right.

Conversely, many herald the advance of digital comics as the messiah that will rescue funny books from the iron-clad grip of the superheroes that have had a four-color stranglehold on the medium in America since approximately 1959. Online retailers like Comixology will be the new "spinner rack" that will welcome all sorts of readers of all ages. Several vocal creators have proclaimed the aesthetic superiority of digital to dead trees, arguing that clicking from panel to panel and using simple animation to layer-in word balloons and narration captions, sound effects, and sudden surprise reveals will revolutionize the medium in a way Winsor McCay and Jack Kirby could have only dreamed of.

This all makes for very interesting debate (or not), but for the publisher—particularly the self-publisher—this alleged controversy is mostly immaterial. The answer to the question "Print or digital?" *has* to be "Yes!"

Businesspeople live in the concrete realm of the marketplace. And the marketplace itself is not a zero-sum game: while some people only buy digital and others buy only print, many people (ourselves included) buy both. Digital and print need to be exploited simultaneously. Spurning one to focus on the other is simply leaving money on the table. You have to be able to transmit your work in any—and we do mean *any*—medium in which a significant number of people are willing to buy it.

Really, the "print or digital" question boils down to *"Which do I do first?"* Do you bring out a print comic that's also offered online via Comixology or another online retailer, or a DRM-free PDF on your own site, or both, either at a reasonable time after your print edition or simultaneously (a practice somewhat redundantly called "day-and-date" due to the old practice of releasing items worldwide over the International Dateline, where Hong Kong and Australia would actually be on a different date on the same simultaneous day as Europe and the US)? We would very much recommend releasing your digital version day-and-date—there's no evidence it cuts into print sales. We're inclined to offer a slight cover price discount on digital editions from their print counterparts after a few months or so—or to offer material in the print version unavailable digitally, as writer Ed Brubaker has long done with his creator-owned series *Criminal* and *Fatale*.

Alternately, you can post your comic online, via Tumblr or some other site of your own, or for-pay at Comixology. Mark Waid and friends have conducted an interesting experiment with for-free digital comics at Thrillbent.com. But we would make a strong recommendation to at least plan in the back of your mind a way to format the book on paper eventually, as an original graphic novel (OGN) or as single issues. Monetizing online content initially offered for free is the single biggest comics challenge of the early twenty-first century, and it's just smart economics to start thinking about this stuff as early as possible.

The moral of this story is *be everywhere*. Collected here in one place are all the versions of *The Comic Book History of Comics*: tablet, smartphone, online, trade paperback, and the complete serialized series (when it was called *Comic Book Comics*). (Art and design by Ryan Dunlavey.)

Swordmaids
The P&L

Just why you got into comics, right? Number crunching! S-e-x-y.

Well, tough. If basic business skills were taught in art school (and basic art skills were taught in business school, not that suits would listen to any of it), we'd all be a lot better off.

An estimate of profit and loss, or P&L, is Economics 101 when approaching any new product in our fine, capitalist society. (Until the revolution comes: Then your product will be assigned to you by the Central Proletariat Planning Committee for Funny Books. And you'll *like* it!) Most publishers will do some version of this before deciding whether or not to accept your submission, and there's nothing wrong with you, as a self-publisher, doing it on your work: the editors will send proposals they want to do to their sales and/or marketing departments, which will run the numbers on them; in most companies the accountants have the power to veto editorial, so hope the P&L turns up in your favor.

As a creative person, you shouldn't necessarily decide what projects to create based on the numbers, but it's always helpful to know how much money you're going to lose on fulfilling your hopes and dreams. If you beat your projections, then you'll be pleasantly thrilled! It's win-win.

STEP 1: *GUESSTIMATE SALES.*
Compare your product to other, similar ones (though we all know you are a special snowflake) to guess how many copies you're going to move. Though Diamond Distribution does not provide exact sales figures to the press—as a privately held company, it doesn't have to—it does provide enough information that news sites like

iCV2, The Beat, Newsarama, Comic Book Resources (CBR), and others can estimate them. Google the most recent sales for comics or graphic novels and compare your book to other, similar titles on the chart. Keep in mind those charts are monthly, and so you're looking at sales for a title's first few days on the shelves. Ideally, you'll make more sales after that, but keep in mind that most books make most of their money during this initial period.

As this is a thought exercise and not a genuine P&L, we are ignoring a few things to keep the demonstration simple:

- We are ignoring the fact that we and Colleen have our own built-in audiences who buy our work because they've seen it in the past and they like it. This is an advantage, though it's not always guaranteed to translate to sales—that varies widely from project to project.

- We are ignoring the fact that an all-ages, female-dominated, high-fantasy series like *Swordmaids* does not have a lot of direct-market, sales-friendly factors going for it. This is frequently, but not always, a disadvantage to sales, as we are not an action-/male-dominated, adult-skewing genre series. It may not be politically correct to say so, but it's true. We're doing *Swordmaids* because we want to, and we think other people will like it, too, not because it's a surefire moneymaker. We hope to be pleasantly surprised. God knows we didn't think *Action Philosophers* would be a moneymaker until it was! The market is always surprising you.

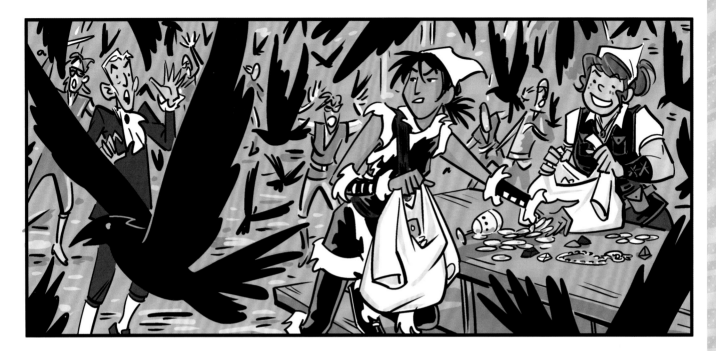

You need to spend money to make money, ladies.

- We are pretending, for ease of explanation, that *Swordmaids* will come out in a serialized format, in 22-page direct-market-friendly issues. For the reasons in the previous bullet point, that might just be a *terrible* idea for this project. An original graphic novel (OGN) gives you a higher price point and the chance for bookstore distribution, thus increasing your potential audience beyond the direct market and giving you a better sales chance to survive. In the charts in this section, boldface lines indicate percentages that will not change, regardless of your page count or price point, or whether you are serialized or an OGN.

- These sales figures do not take into account online revenue from sites like Comixology (or your own website), bookstore distribution, direct sales to retailers and to fans at conventions, and so on. This is pure direct-market stuff. *But, all the basic calculations remain the same, regardless of your various markets.*

Copies printed	3,000
Gross copies sold (95%)	**2,715**
Price of book	$3.95
Discount (Diamond's)	**60%**
Revenue per copy after discount	$1.58
Total revenue	$4,289

STEP 2: *BUDGET THAT INDIVIDUAL ISSUE.*

Basically, budget everything you'll need to get that book to comics shops. Your printer will provide you a basic sell sheet that will have most of the figures you'll need. As twenty-first-century printing presses are huge, unwieldy machines that need to be laboriously calibrated for every new job, a low print run will cost more per-unit than a high run. *Color* comics tend to be *three times as expensive* as black and white, though in general they sell better. (*The Walking Dead* being a glaring exception to this principle.)

The common business term on this (you'll also need to know it for tax purposes) is *cost of goods sold* (COGS).

Per unit printing cost	$0.80
Copies printed	3,000
Freight (2%)	**$0.02 (rounded up)**
Total per issue	$0.82
Total COGS	$2,460

STEP 3: *SUBTRACT LINE 2 FROM LINE 1.*

This will get you your gross profit (or loss). Put down that calculator, we'll just tell you: $1, 829!

That's, uh . . . that's not very much money at all, is it? And keep in mind what we left off that budget: payment for you and your creative team, any advertising or marketing expenses, the cost of replacing damaged goods, and any overhead expenses, like renting an office space and keeping the lights on in that space.

Also! That sales figure is for *Swordmaids* #1 only. Your sales, in most (but not all) scenarios, will dip by at least 30 percent by #2 and, oftentimes, 1 to 5 percent for every issue after that due to perfectly normal attrition until you do something (a new arc, a new artist, kill your main character off) to get new eyeballs on the title. In other words, it's quite possible that the $1,829 profit could dip down to the cusp of four digits within six months. You may, in fact, not see any real profit until you've produced enough issues to come out with a trade paperback—or two or three trades!

Grim stuff, huh? Just as they say about politics, publishing ain't beanbag.

But put away those razor blades! There is light at the end of that tunnel, and it's not an oncoming train! Because there's one final step we haven't done yet.

STEP 4: *REPEAT STEPS 1 THROUGH 3 UNTIL YOU DISCOVER THE PUBLISHING SCENARIO THAT WORKS BEST FOR YOU.*

The world of comics is bigger than the direct market, and it is bigger than the serialized monthly comic. Not too long ago that was not true, but it certainly is today. Who says you need to do a monthly comic? Why not ask the printer for prices for a longer graphic novel (80 to 120 pages in length) with a higher price point, which means a higher potential return?

Or why not try to get people to pay for the book before you even *produce* it?

THE CODE MONKEY EXAMPLE

When faced with all these questions in early 2013, Greg and Internet musician Jonathan Coulton launched a Kickstarter to presell the *Code Monkey Save World* graphic novel in both digital and print form direct to readers. The individual issues of the story came out digitally starting in October 2013 on Comixology (distributed by the great folks at MonkeyBrain Comics, who also distribute Colleen's *Bandette*). Then the final printed book was sent to backers in February 2014.

So why this plan—and why no physical "floppies"?

Greg and Jonathan Coulton had a story that required about four traditional comic books to tell. They could have printed four "floppy" comics and released them in a physical form on a monthly basis. But they'd quickly run into the same challenges we've outlined above for a presumably low-circulating project like *Swordmaids*. Furthermore, for a Kickstarter project, printing individual floppies would have been a disaster, requiring the team to send four separate packages to every backer who chose physical books as a reward. That's a financial black hole when you factor in fulfillment and shipping costs. A traditional publisher can work through Diamond and send books in bulk to stores. But a Kickstarter project like *Code Monkey Save World* has to ship to hundreds or thousands of separate addresses.

Given the need to ship a single physical package, Greg and Jonathan decided to release individual issues digitally and then print a collected physical paperback. They considered hardcovers, which wouldn't have cost that much more to print, but shipping costs to individual addresses more than doubled.

In the end, they secured an $8,400 estimate from a printer for 6,000 copies of an 84-page paperback. At first blush, that seems ridiculously cheap—just $1.40 for a book that could retail for $15 or $20! But when you factor in the page rates for everyone who worked on the book (and it was critical to Jonathan and Greg that everyone get paid a reasonable page rate), as well as shipping and fulfillment costs, the budget quickly got into the tens of thousands. Greg and Jonathan's initial Kickstarter goal was to raise $39,000 in Kickstarter preorders to produce an 80-page graphic novel. In the end, they raised $340,000 from over eight thousand backers—and were able to expand the page count to 104 pages.

Those numbers are a bit skewed—they include costs for producing and shipping other rewards like T-shirts and coffee mugs to Kickstarter backers. But it's proof of an alternate mode of publishing; if you can raise money directly from readers via crowdfunding, self-publishing digitally and in trade paperback form becomes an eminently viable choice. Brian Clevinger says unequivocally that he "definitely would have gone Kickstarter" with his *Atomic Robo* book if such an option had been available at the time.

But it's worth noting that this route is generally best used by people who have some kind of track record and following already, which takes us back to our earlier discussion of webcomics. As Clevinger notes, he and *Atomic Robo* artist Scott Wegener are constantly asked, "How do you break in?" But Clevinger says, "I don't think there is a breaking in anymore. You just put it online." By building an audience step by step over years, Clevinger has opened the door to a variety of different publishing choices. In August 2013, his first *Atomic Robo*–related Kickstarter surpassed $135,000.

So that's one way to go.

Or, you could sneakily incorporate your project as a proof of concept in another book . . . say, a comics how-to book. Then, you get a big book publisher to pay *you* to do it!

Aw, what are we thinking?

That's crazy talk.

Brian Clevinger and Scott Wegener's *Atomic Robo* is an extremely successful print comics series, digital comics series, and Kickstarter campaign. When it comes to "Be everywhere," they reign supreme.

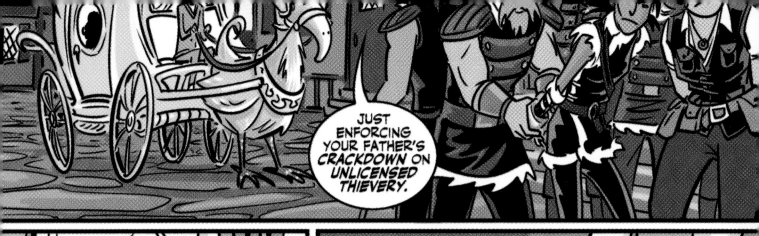

JUST ENFORCING YOUR FATHER'S *CRACKDOWN* ON UNLICENSED THIEVERY.

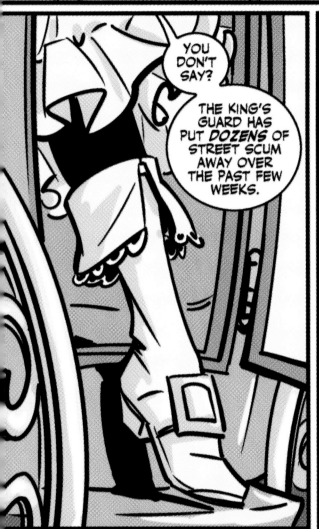

YOU DON'T *SAY?*

THE KING'S GUARD HAS PUT *DOZENS* OF STREET SCUM AWAY OVER THE PAST FEW WEEKS.

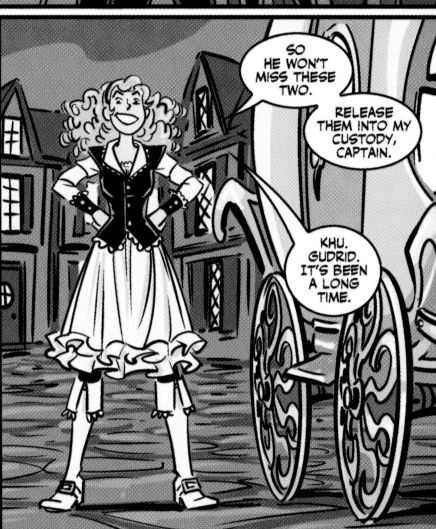

SO HE WON'T MISS THESE TWO.

RELEASE THEM INTO MY CUSTODY, CAPTAIN.

KHU. GUDRID. IT'S BEEN A LONG TIME.

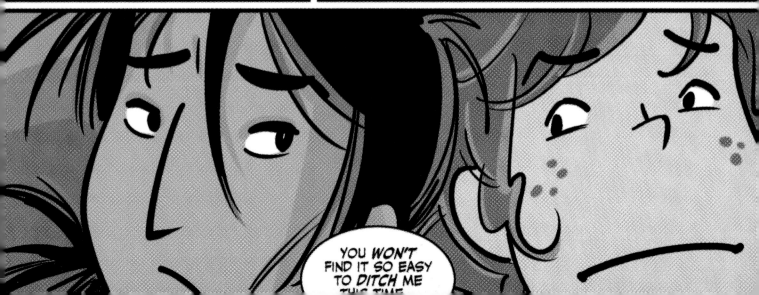

YOU *WON'T* FIND IT SO EASY TO *DITCH* ME THIS TIME.

FINDING YOUR AUDIENCE—

AND KEEPING IT!

PUBLICIZE OR PERISH!

We've worked on huge, iconic, company-owned characters with decades of history and hundreds of thousands of fans. And we've worked on entirely new, creator-owned properties that no one but us and our significant others have heard of. But regardless of a project's pedigree, when it comes to publicity and promotion, we treat them all the same way: as desperately endangered creatures that need massive and regular infusions of attention in order to survive.

Fred Van Lente
>> writer at large

Fred's website aims for simplicity, showing a simple menu with links to a bio, a list of work, email, and Twitter. Below that is an embedded window showing his latest tweets. And below that are very brief posts that include links to the latest news and press about all things Van Lente.

Opposite: Greg's website includes essentially the same information, but with more images and icons. And Greg generally provides more text in each post, including excerpts from articles and occasionally expanded thoughts of his own.

Comics are made for vastly less money than movies or television programs, which means the industry can survive if thousands rather than millions of people pony up their dollars each month. But that still means that, as of this writing, a monthly comic book from DC or Marvel needs to sell somewhere around twenty thousand issues in order to avoid cancellation. Books from smaller publishers can survive with a bit less circulation, partly because the creators are generally all paid a bit less. But, of course, it's that much harder to get attention for an independent book that doesn't star a legacy character.

The best way to ensure that your book thrives, of course, is to produce a magnificent piece of art and entertainment. For advice on how to do that, please reread the previous five chapters of this book, and work on your craft and skills for ten years.

But if you spend any time talking with comics fans, you'll soon hear repeated laments about beloved, award-winning, fan-favorite books that have been canceled because of falling sales. The reality is that even great work needs promotion in order to claim the ongoing attention of consumers who are bombarded every minute of the day with a thousand different voices and images

touting countless other, much more expensively produced cultural products.

In this chapter, we'll run through a few strategies for getting the word out about comic books. We'll start with a special emphasis on how to promote your most valuable, ongoing product: yourself.

SELF-PROMOTION

Well, this is a bit of an icky topic, isn't it?

No.

We love self-promotion. And we'll never apologize—because establishing your public identity and presence is a critical part of your survival as a working creative person.

Think of it this way: your fantastic skills may get you a work-for-hire gig drawing *Eagle-Man*. And that's a wonderful dream come true and may provide you a solid income for years. But inevitably, someday that gig will end. And you don't want to vanish into the ether when the job does.

So your task is to turn all the *Eagle-Man* fans who love your work into *You* fans. Here's a plan of action in six easy steps.

Step 1. Do great work. We're repeating ourselves a bit, but this is important. Social media and self-promotion strategies only work if what you're pushing is genuinely awesome. Sure, people may follow you on Twitter just because you're funny or provocative or helpful. But the big surges in social media followers will come when you put work out into the world that people love. Work hard all the time, and get better all the time. That's the foundation for everything else.

Step 2. Set up your own website. Back in the Dark Ages of the Internet, Greg and Fred both registered their domain names and set up their websites. These days, new artists might not see the point. It's a pain to set up and maintain a personal website, and sites like Twitter and Tumblr provide automated image handling and link creating that make updating incredibly fast and easy.

But we still believe a personal website with an easy-to-remember URL (ideally your own name) is essential. Social media sites have their own life cycles. They change their formatting and terms of service, get bought out, lose members, and even shut their doors. So if your web identity is entirely tied up in membership with a social

media site you don't control, you could lose that identity when that social media site changes.

Your own website, on the other hand, is the permanent place where you can present your best face to the public. Update it as often as you can. Provide information about your work and links to places people can buy it. Link to all of your chosen social media sites.

Ideally, when someone hears about you and searches for your name, the first result that comes up is your personal website. And you completely control the very first images, words, and links that pop up when someone clicks on that link. That's the best way to ensure that the information you want to push the most is front and center.

So, what do you want people to see when they encounter you in the virtual world? On a purely practical level, you should tell people what you do, where they can buy what you're selling, and how they can contact you and follow you on social media.

Step 3. Join Twitter (and whatever other social media sites work for you). For years, comic book creators have been building followings on Twitter, Tumblr, Facebook, Google+, Instagram, and every other social media site that

pops up. We've spent a ton of time posting art, teasing new projects, and cracking jokes, and we've told ourselves that this has all been critical work to build our audience. And for years, we've been kind of kidding ourselves. We've mostly just been having fun and joking around the virtual watercooler, which is what Twitter has become for the comics industry.

But joking around the watercooler is one way coworkers bond and build the relationships to get things done in the flesh-and-blood world. In the same way, our silly, informal use of Twitter has been critical for us in building or maintaining relationships with colleagues and potential collaborators—even in launching some of the most important projects of our careers.

Greg's *Code Monkey Save World* Kickstarter began when Greg tweeted, "Occurs to me that you could field a pretty awesome supervillain team with characters from @jonathancoulton songs." And Jonathan tweeted back, "DO IT." Greg and Jonathan had known each other for years in the nonvirtual world, but without the immediacy of Twitter, Greg might never have proposed the idea and Jonathan might not have jumped on it in quite the same way.

The success of the *Code Monkey Save World* Kickstarter also depended hugely on Greg and Jonathan's social media presences. Jonathan has over 100,000 followers on Twitter, and every time Jonathan tweeted about the campaign, Greg immediately saw a surge in Kickstarter backers.

In short, Twitter and other social media sites have actually proved their concrete, monetary value in the new world of crowdfunding.

So get on that.

Step 4. Develop your public voice. When we were schoolkids back in the Dark Ages, we were taught to use the third person and avoid slang in formal essays. That's probably still pretty good advice for college papers and TPS reports. But in the world of blogs and social media, people have found great success with a wide range of writing styles. How you choose to express yourself—and what you choose to write about in these venues—is entirely up to you and should reflect your personality and comfort levels. But be aware that post by post and tweet by tweet, you're creating a public voice that could be associated with your work forever. Here's how we've chosen to handle the challenge.

We both generally write informally on our websites and Twitter accounts, more like the way we might talk in a conversation than the way we might write a newspaper op-ed. On our personal websites, we generally focus on the projects we're working on. But on Twitter, we might talk about all kinds of things—even commenting from time to time on politics or current events. Greg has an unfortunate obsession with centaurs that surfaces from time to time. Fred likes the Mets and beer.

From a strictly mercenary point of view, the effect of the informal writing style and the off-topic discussions can be to make the writer more human and accessible to the reader. The Internet thrives on immediacy, intimacy, and personal interaction. People are naturally drawn to what feels authentic. And if people feel like they're hearing a real person's voice, they might be that much more interested in buying whatever that real person is selling.

At the same time, we counsel setting limits for yourself based on your own comfort levels. If you want to keep your private life private, don't talk about it online. And absolutely do not feel compelled to post or tweet all the time if that's not your style. Some creators get special attention for their posts precisely because they post so infrequently.

Additionally, we have a few general recommendations for everyone regarding online behavior:

Don't feed the trolls. The haters will eventually find you on the Internet. The best thing to do is block them and forget them. When you're tempted to respond, Google "Duty calls" instead, and look at the *XKCD* cartoon that pops up. That always helps us.

Don't slag off other creators or companies. We'll cheerfully mock dumb politicians on Twitter, but we try to never slam another creator's work or make fun of another company's projects or initiatives. First, because life's too short. We'd rather use that time to celebrate the fantastic work of colleagues and friends. Second, because it's a small world, and people have long memories. A few snarky words today can ruin a chance for an incredibly rewarding creative partnership tomorrow.

Don't tweet drunk or angry. Yes, you might gain more followers when you rant. But many of those followers are *train wreck* fans, not *You* fans. Also, tweeting angry can lead to grousing about your actual work or coworkers online. They might deserve it. But going public in a passive-aggressive way will almost certainly just make things worse.

This topically irreverent online ad for *Archer & Armstrong* stirred up lots of buzz—good and bad—for the series. (Art by Clayton Henry.)

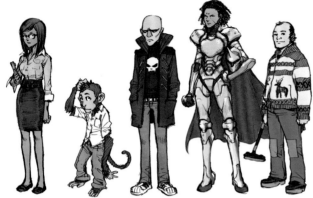

CODE MONKEY SAVE WORLD

PAK · COULTON · MIYAZAWA · KHOLINNE · BOWLAND · WWW.CODEMONKEYCOMIX.COM

Left: Character designs are "safe" promotional art to gin up excitement about a project, as they rarely contain story spoilers. (Art by Takeshi Miyazawa.)

Right: Don't discount the power of multiple promotional images based on a single theme. You can use mysterious releases of the images to count down to a big announcement and give the public multiple exposures to your work. Valiant Entertainment used these images to build up the successful "Sect Civil War" storyline in *Archer & Armstrong*, and they also doubled as the covers for the individual issues. (Art and design by Michael Walsh.)

THE CIRCLE OF (COMICS) LIFE: HOW TO LAUNCH A BOOK

So you've set up your website and your various social media accounts. And most important, you've got a book in the works! What's the process for actually telling people about this thing?

In a typical promotions/publicity cycle, four to six months before the actual publication of the book, a publisher will announce the creative team and provide the basic pitch for the book. The point of this announcement is to get potential readers excited about the book—and prime retailers for preordering the book in high quantities. Refer to the distribution chart in the last chapter (page 115) to peg the best times to do various kinds of promotions.

Often, this initial announcement will take place at a big comic book convention like the New York Comic Con or the San Diego Comic-Con. But sometimes the timing doesn't coincide with a convention, and sometimes conventions feel too crowded for maximum impact anyway. The announcement of Greg's *Batman/Superman* took place outside of a convention and was able to get great press from all the major comics venues, which might have been overwhelmed with ten other great stories on the same day if the book had been announced at a big convention. The final outcome didn't seem to suffer at all—the book debuted as the second-highest-selling book of July 2013.

The announcement typically takes the form of a press release sent out to the world, but much more important are key advance interviews with select venues appearing on the same day.

When DC announced *Batman/Superman*, advance interviews appeared with *USA Today*, *Newsarama*, and *Comic Book Resources*. Other interviews followed over the

course of the week. One of the coups was getting written up by the AP, which resulted in a few articles appearing in print in newspapers around the country. For a mainstream comic book project, this qualified as a strong opening, presswise.

Even if you don't have the two most successful characters in comic book history backing you up, the mainstream media can also be courted if you're not above stooping to a little bit of controversy. As Valiant Entertainment was rolling out Fred's relaunch of *Archer & Armstrong*, the head of marketing, Hunter Gorison, hit on the brilliant idea of doing an ad featuring the first arc's nominal villains, the devil-worshipping Wall Street cabal The One Percent. Hunter thought the topical nature of the characters would elicit interest from news outlets beyond the usual comics sites, and he was right: the Associated Press picked up the story, and it ran on dozens of sites all around the world (Fred encountered readers in Mexico who had seen it) and "boosted the signal" of a small, indie title considerably.

Of course, not all of the attention was positive: a lot of people of a certain political persuasion were not too amused at the tongue-in-cheek presentation of The One Percent. One of the few hundreds upon hundreds of Internet comments the story generated that we can actually print here appeared in Fred's hometown *Cleveland Plain Dealer*, which denounced him as a "limousine liberal." Not only can some people not take a joke, they are also grossly misinformed as to how much comic book writers make. But there is no such thing as bad publicity—particularly when you're fighting for every eyeball and entertainment dollar that you can (which is always).

Do your best to identify which unique outlets would be most interested in your project, increasing the potential for broader press. When Greg and Jonathan Coulton

SECT CIVIL WAR **PART ONE**

SECT CIVIL WAR **PART TWO**

SECT CIVIL WAR **PART THREE**

SECT CIVIL WAR **PART FOUR**

launched the *Code Monkey Save World* graphic novel Kickstarter, they were able to get amazing coverage from nerd-friendly websites like *BoingBoing.net*, *Techhive*, and *Wired*. Greg and Jonathan each had separately established relationships with the writers from those venues over the years. But those writers would have been unlikely to lavish the same kind of attention on another album of Jonathan's or another comic book of Greg's. The very specific story of Jonathan and Greg coming together to do this amazingly nerd-friendly project as a Kickstarter was what made the story work.

As you plan your own launch, make a list of all the different audiences your project might appeal to, and then seek out the media that serves those audiences. And don't forget your hometown press or any other communities that you might be part of. Greg grew up in Texas and still gets amazing support from Dallas-area papers. Ditto for Fred and the aforementioned *Plain Dealer*.

These early announcements will often take place far enough before the launch of the actual book that there's little or no original art to show off. But it's critical to have at least one or two nice pieces of art to tease. Think carefully about the images you release for this initial announcement. These images will be used by everyone; you'll see them again and again and again. So err on the side of a few fantastic images rather than a ton of images that include some less-than-fantastic drawings. If you don't want to see an image everywhere, don't release it.

Similarly, if you have a shot at getting a tremendous image, wait for it. For the *Code Monkey Save World* Kickstarter launch, Greg and Jonathan had commissioned character designs from Takeshi Miyazawa, which were

brilliant and funny and evocative. Greg and Jonathan were prepared to launch the campaign with just those designs. But the launch got held up a week for technical reasons as they waited for Amazon to confirm various bits of information. Greg was gnashing his teeth with impatience during that week. But that week gave Tak time to finish inking a cover and Jessica Kholinne time to color it. So when the project launched, every interview and article featured this gorgeous, finished, and expensive-looking piece of comics art. The success of a Kickstarter project depends a lot on people deciding in an instant that this looks like something awesome and real. That piece of art no doubt had a huge impact in getting people to click that "Back This Project" button.

Q: HOW DO YOU ANSWER INTERVIEWS? A: LIKE THIS:

Answering interview questions for your first big comics project can be an intimidating experience. If you're working for one of the established comic book companies, you can run your answers by the publisher's publicity people and your editors. But especially if you're the writer of the book, the responsibility will ultimately rest with you to figure out how to talk about your story and characters.

One dirty secret of mainstream comics is that sometimes the initial announcement of a book will take place before you've worked out all the details of the story. But you'll have been talking with your editors and collaborators about the characters and the story for weeks or even months, so you should know your basic hook. You pitched to get the job, after all—now you're just adapting that pitch to a mass audience.

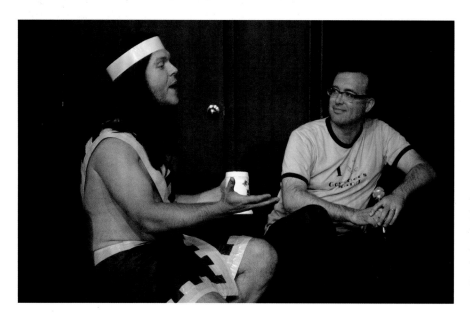

You probably won't ever be interviewed by your own characters, as Fred was by Hercules (Taylor Moore) in a comedy show at New York's Upright Citizens Brigade Theater. But it never hurts to be prepared.

COMMANDMENTS FOR HANDLING INTERVIEWS

1. Email is fine. When you're launching a new project, it can be smart to do the first few interviews via email. Some journalists prefer phone interviews, which makes sense, because when you get on the phone, you have a better chance of a genuine back-and-forth conversation. But we've never had a comics journalist say no to a request for an email interview—it's incredibly common, and it saves them transcription time.

 The advantage of an email interview is that it allows you to take the time to think through the questions and craft fully formed, thoughtful answers. You can also run the text by the folks on your creative team or the publicity department of your publisher. That can help you avoid releasing anything to the world that your employers might not like, which is usually a big bonus for you. And when you're first starting a project, it gives you the time to figure out just what the heck you really want to say about it.

 The drawback with email interviews is that they can be much more time-consuming than phone interviews. Since you can take the time to refine all of your answers, you probably will. And if you're doing a half dozen or more of these interviews, you can lose a whole work day to them. Often, we'll do the first couple of interviews via email, but once we get comfortable with our answers, we're happy to do subsequent interviews on the phone.

2. Handle tricky questions with care. Most of the comics journalists you'll be dealing with at this stage in the game are writing for excited fans and just want to get some cool details about your awesome new project. But inevitably, you'll get questions you won't quite know how to answer. Your interviewer may ask you to comment on someone else's controversial use of the character you're writing. Or you might be asked about some bit of the character's past that you aren't familiar with. And on occasion you might be blindsided by a question about the business practices of your employer or some other wider scandal that's unrelated to the book you're here to plug.

 Doing the first few interviews via email gives you the chance to take a little time to formulate your answers to these kinds of questions. You also have the option in an email of deleting a question and just not answering it. We try to answer all of the questions that directly relate to the book we're talking about, although Greg will frequently and shamelessly say, "All in the fullness of time," to avoid making definitive statements about future events. You're under no obligation to spoil your own book!

 One thing we will never do is bad-mouth another creator or company in an interview. So any questions that seem to be trolling for those kinds of comments get deleted or dodged.

3. Respond quickly, and do as many interviews as you can handle. It's a cliché, but it's true: a huge part of success in life is about showing up. If you respond promptly to every press request you get, you'll get more press than everyone else.

 Doing press isn't easy. It's time-consuming, and it can be stressful, particularly if you're the shy or reticent type. But if you don't talk about your book, you're not giving it its best chance for success. And all that hard work everyone on your creative team is doing could go to waste.

 Of course, there's no guarantee that doing all the press in the world will put your book over the top. But if you don't show up, you'll never know.

4. Remember why you're doing the interview. The goal of all this press is to get retailers to order your book. This means getting readers to preorder the book with retailers. So don't be shy about explicitly encouraging readers to preorder the book. We'll often point them to www.comicshoplocator.com to find their local retailer.

 This also means that you should feel free to find a place in the interview to pitch your story the way you want, regardless of what questions you're asked. Let's say you're the new writer of *Eagle-Man*, and the interviewer's first question is about how it feels following up on Fred Van Lente's definitive *Eagle-Man* run. Feel free to answer with a few words about something you loved from Fred's *Eagle-Man*—and then talk about how what you're doing provides interesting contrast to or resonance with that.

 It's also a good idea to get to the point as early as possible. Ninety percent of the time, interviewers will print your answers exactly the way you write them, in the order you write them. Of course, most people reading articles online never get to the end. So get your hook in early in the answer to the first or second question in the interview.

 So that's how you can try to control the interview, but it's also important to relax enough to have fun. You're not just selling the book; you're also giving readers a little glimpse into you as a person. And if you're

Left: Fred and main series letterer Simon Bowland sign *Incredible Hercules* at Gosh Comics in London.

Opposite, left: Writers Fred Van Lente and Jim McCann and penciller Steve Kurth field questions from fans at the Florida Supercon in Miami.

Opposite, right: Vertical thinking in practice: Fred and Ryan Dunlavey (left) with their *Action Philosophers* and *Comic Book Comics* banners at FanExpo Canada in Toronto.

having fun, people will be more likely to want to take this ride with you.

Similarly, being true to yourself and the project is generally the best way to sell it. When you speak from your heart about why you love *Eagle-Man*, *Eagle-Man* fans will get excited right along with you.

5. Always ask the interviewer to include a link to your website and Twitter page. You're not just promoting this book; you're promoting yourself!

6. Build an ongoing relationship with your interviewer. If a publisher hooks you up with an interview, take the opportunity to get to know the interviewer a bit—and snag the interviewer's contact information. Make a good impression so that when you have a project of your own, you can come back to that interviewer for more press.

7. Plug your creative team and thank the readers and retailers. Always say please and thank you, particularly in print.

NO SUBSTITUTE FOR THE REAL WORLD

In the world of social media, it's easy to get obsessed with the number of followers a person has. Businesses have even sprung up through which people can actually buy followers. But a million fake followers will buy a thousand fewer books than a thousand real fans. For comics creators, the lesson here is that turning off your computer or smartphone and heading out into the real world to make in-person appearances whenever you can is probably the

single best way to promote your work and build your audience. The good news is that the comics industry provides dozens of venues through which you can do exactly that in the form of comic book conventions.

The biggest US conventions are the now-infamous Comic-Con International in San Diego and the New York Comic Con. These events regularly get national press and have become critical marketing platforms for movies, video games, and television shows. But there are dozens of other conventions around the country—and the world—where hundreds of creators mingle with thousands of fans almost every weekend of the year.

As established creators, we're often given complimentary tables in the "Artists' Alley" of various conventions. We can set up camp there to sell and sign books. And we participate in any signings and panels that our publishers or colleagues invite us to. At busy conventions, we might speak on panels before several hundred to a thousand people and exchange words and smiles with hundreds of people while signing comic books. Some creators do a dozen conventions a year, year after year. That can translate into tens of thousands of people who have shared a direct, personal moment with you. And if you made that a positive moment, that's tens of thousands of people who are more likely to buy your books in the future.

The minus is that conventions can be expensive—even if we're lucky enough to get a free table. Hotel rooms for the San Diego Comic-Con in particular are notoriously pricey. To maximize your earning power, follow these very simple rules:

1. Bring something new to sell every year. This is especially true if you attend the same show annually. Typically, the same people show up to the same shows year after year. So always provide something your preexisting fans will want to pick up and walk away with, signed or unsigned, that they couldn't get anywhere else.

2. Think vertically. Comics conventions tend to be very crowded places, with thousands of people milling about, long lines of people queuing up for the guy who played X-Wing Pilot #4 in Episode XII, and cosplayers constantly posing for and taking pictures. The attention of attendees is pulled in every direction, so make sure you get in their field of vision by having a freestanding banner behind you (easily orderable from a dozen different online vendors or a print shop near you, usually for $200 or less), and as piddling as it sounds, build vertically on your own table: stack books on top of one another, have an easel to lean artwork or books on, and so on. Make sure you are seen.

3. Don't be desperate, be happy. Sorry if you think this is beneath you, but in Artists' Alley, you are working retail. And what's worse than working retail? Working retail for free! Don't scare away potential sales by being a sweaty, needy jerk. Smile when people pass by the table. Say hello when they stop. Use your logline as your sales pitch, and answer everyone's questions courteously.

4. Have the right attitude. Don't get too down if despite all your self-evident talent and forced cheerfulness, people walk away without buying. You should treat conventions as opportunities to build readerships, which doesn't always directly translate into dollars right then and there. It's an old marketing truism that consumers need to see products up to seven times before finally making a purchase. And maybe that just was the first time some of those people saw you. By being out there and present, you'll make sure it's not the last.

Even during years when we're not traveling as much, we regularly do signings and special events with local comics shops and arts organizations. Any chance to show your face is a chance to turn a casual reader into a fan. And retailers really appreciate it when you show up to meet their customers. A motivated retailer hand-selling your work to their customer base is the best friend a comics creator can have. And you can get creative at store events, with raffles and costume contests, creating your own mini-convention. Collector's Corner in Baltimore hosted Fred at a release party for *Archer & Armstrong*—complete with free cake in the shape of the comic's cover! Who doesn't love free cake?

Swordmaids
Online Presence

 Swordmaids-Khu @Swordmaids-Gudrid Are you sure this is going to work?

So let's apply what we've discussed to *Swordmaids*. We already have our own personal websites and social media accounts, but is there something more we could do for this specific project?

You bet!

First, we can and should create a website dedicated to *Swordmaids*. Depending on how much time and energy we want to spend, we could create an entirely separate website, like Greg did for his *Vision Machine* graphic novel. Or we could just direct people to a web page that's part of Greg's site, the way he does with most of his other projects. Either way, a home base that provides the basic information about what the project is about and how to buy it is critical.

Second, there's another whole level of social media creativity that can be used to support projects like this. The cool kids call it *transmedia* or *multiplatform storytelling*. We'll just call it creating Twitter accounts that our characters run. We've tried this a few times with different characters, and it's honestly a pretty difficult undertaking. It worked best with the Amadeus Cho character, who ended up with about a thousand followers on Twitter and still tweets from time to time. Amadeus was a bit of a special case; as a young, contemporary tech freak with an irreverent attitude, he's tailor-made for social media. His voice made perfect sense coming through in tweets.

That's a bit trickier needle to thread with Gudrid and Khu, who live in a preindustrial world, after all. But for a scrappy independent project, anything that provides a possible hook to reach new audiences is worth trying. Below is a first stab at what Gudrid and Khu tweeting might look like.

 Swordmaids-Khu @Swordmaids-Gudrid Stealing pies at 6 don't tell Sophie

 Swordmaids-Gudrid @Swordmaids-Khu Um was that sppsd to be a DM that wasn't a DM

 Swordmaids-Khu @Swordmaids-Khu aw crap

 SophieAwesomePrincess @Swordmaids-Khu @Swordmaids-Gudrid Hi guys! See you at 6!

 Swordmaids-Khu @SophieAwesomePrincess @Swordmaids-Gudrid Uhhhh! Why are you even following us?

 SophieAwesomePrincess @Swordmaids-Gudrid @Swordmaids-Khu Actually my dad's NSA* monitors everyone's Magic Wireless Media accounts!

 SophieAwesomePrincess @Swordmaids-Gudrid @Swordmaids-Khu * NSA = Knights' Surveillance Agency (the "k" is silent)

 Swordmaids-Khu @Swordmaids-Gudrid Shut up. Look, we'll trick her and meet at 5, okay?

 SophieAwesomePrincess @Swordmaids-Gudrid @Swordmaids-Khu k, see you then!

 Swordmaids-Khu @SophieAwesomePrincess @Swordmaids-Gudrid aw crap

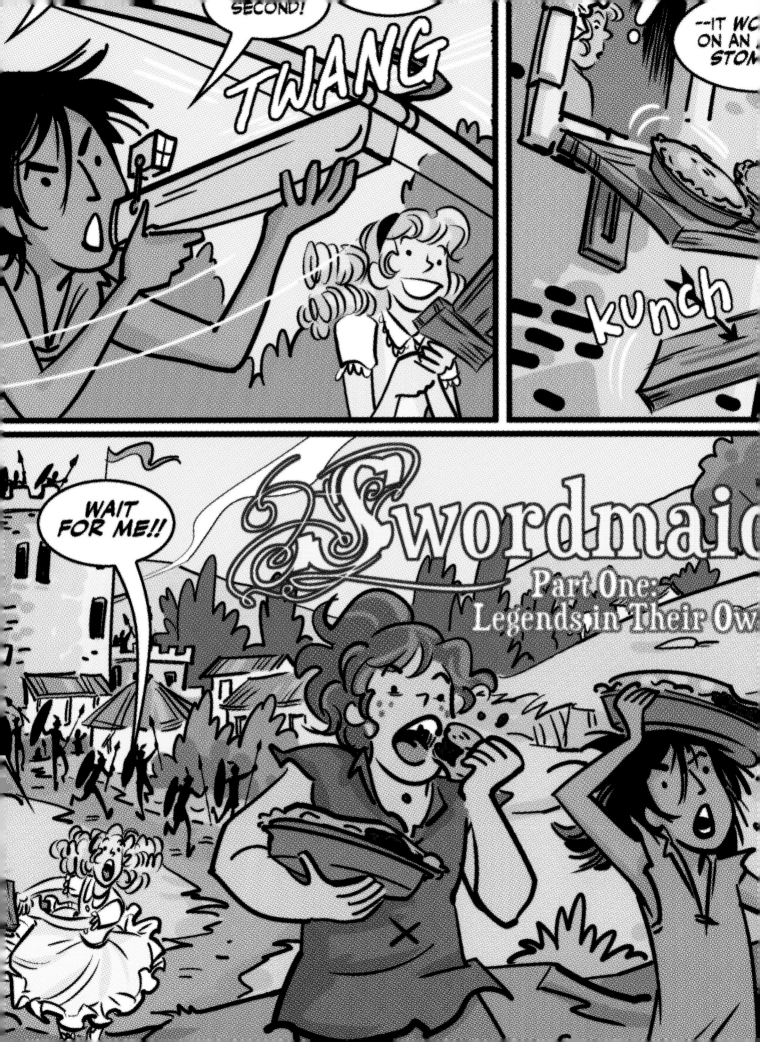

AFTERWORD:
THE PROBLEM WITH BREAKING IN . . .

Congratulations! You got your comic out the door, and it is, we are sure, a huge hit. If it bombs, don't blame us. Clearly, you weren't reading this book closely enough.

Ha! Kidding. Everybody—and we do mean everybody—makes some mistakes and suffers some failure on the way to success. Multiple failures, in fact: Fred's first mainstream comic was *Prime* for Malibu Comics in 1996—and his second was *Amazing Fantasy* from Marvel in 2005! That was a long and often difficult nine years in between, but he kept writing, kept publishing indy books and stories and articles, and kept making friends with like-minded creative people.

The good news is that the comics field is small enough and informal enough that once you have made a comic, you have achieved your dreams: you have broken into the comics industry.

The problem with breaking in, though, is that *staying in is harder*. Remember Fred's involuntary nine-year sabbatical between paying gigs? That's more common than you might think. As we leave you, we'll share some tips that will hopefully make remaining in the industry a little bit easier after you make your first, big (or little, even) splash.

PACE YOURSELF

We once heard Marvel executive editor Tom Brevoort say that he didn't know of any freelancer who didn't take on more than he could handle. It's a curse of the freelancer life that it's incredibly hard to say no to work. We might have a completely full schedule right this instant, but we may also know we have nothing lined up for six months from now, so if someone comes calling with an ongoing gig, it can be incredibly hard to say no.

But if we overcommit and start missing deadlines or turning in substandard work, we'll undermine our hard-earned reputations and endanger our long-term future.

We know. We can't stop ourselves. We know we can't stop you. When the offers come that are too good to say no to, you won't say no.

But be prepared to make the hard decisions when the time comes—or to accept the consequences of missing deadlines. Maybe you'll have to give up a book. Maybe you'll get bumped from a book. Maybe you'll be forced to take on a cowriter or to let someone else pencil half the book. If you end up coming face-to-face with one of these worst-case scenarios, if you've thought it through, at least you may be prepared to help your editors make the best of the situation.

DON'T BURN BRIDGES UNNECESSARILY

There's a lot of good-natured and not-so-good-natured ribbing that goes on between various comics publishers, often in public. We recommend staying away from too much of that. You may be working exclusively for one company for many years. But after some time, you may want to make a change. And if you've been gleefully slagging off the other side all this time, you may have limited your options. Play nice and keep your options open.

BE A PRO, NOT A FAN

Almost everyone working in mainstream comics started off as a starry-eyed kid reading and loving comics. We're all fans, and that's great. But when we start working on company-owned comics professionally, we have to think like storytellers instead of fans.

Editors aren't looking to hire the *biggest fans* of the characters. They're looking to hire the *best creators* with the best ideas. Sometimes those things may go hand in hand. Sometimes they don't.

One of the constants in mainstream comics is that, every five to ten years, beloved characters get overhauled and reimagined. The Hulk was gray, then green. Dumb, then smart, then dumb again. Then Banner in the Hulk's body. Then a conquering emperor. In time, characters tend to return to a certain baseline. But when it's time for them to move to a new and different place, editors will often look for new and different writers. We know that the fact that we *weren't* dyed-in-the-wool fans was a mark in our favor when we were chosen for certain gigs.

SHOW YOUR FACE

Your mother was right: first impressions really matter. So when you have the chance to meet potential collaborators face-to-face, be friendly, open, enthusiastic, and yourself. All of those things may not perfectly jibe, of course, in which case we recommend just being yourself. The ultimate goal, after all, is to find simpatico collaborators who understand you and want to work with you specifically because of your perspective and quirks.

As New Yorkers, we had a certain advantage when we started working in publishing, as the Big Apple is still the nerve center of the industry; but if you don't live in the same city as your potential publishers, don't fret. Most creators don't. But the comics industry has a thriving convention scene that provides multiple opportunities throughout the year for professionals to meet, bond, and scheme.

OPEN YOURSELF TO MANY POSSIBILITIES

Some creators spend their whole careers dreaming of working on one particular character or story. Maybe for you that's Eagle-Man, or maybe it's your creator-owned dream project. In either case, we understand. But we also advise you to open yourself to other possibilities along the way.

Every creator has to follow her own heart. Sometimes a dream can't be deferred and it's time to fight like crazy for that one big story. On the other hand, we're just talking comics. There will always be more Eagle-Man stories. And as long as you can keep working, there's always another chance you might be able to pitch your Eagle-World epic to a more receptive audience later on down the line.

More important, in this fantasy scenario, you're in the door. They invited you to come talk to them. So they're potentially interested in working with you in some capacity. If you ask some questions and hear what they have going on, you might find out about an entirely different project that may actually be an even better fit for you. And let's face it, we all have room to grow and improve. So the more experience you get before you finally tackle that dream project, the better that dream project might eventually be.

STAY IN TOUCH

Some creators and editors seem so bound to certain companies that it's almost impossible to imagine them working anywhere else. But every year, creators and editors move from company to company. So it's an excellent idea to stay in touch with the editors and creators with whom you've had a particularly good working relationship.

Both Fred and Greg have recently been hired by Warren Simons, a former Marvel editor who's now the executive editor of Valiant Comics. One of Greg's greatest Marvel experiences was working on the *Magneto Testament* miniseries with Warren. The two kept in touch and when Warren eventually called, Greg was ready. It's worth noting that Greg would have worked on any character Warren wanted to discuss. Great editors should be aware of their power: if you've done right by creators as an editor, creators will come running when you call.

We hope we've been helpful getting your ideas out of your head . . . and into the comics.

BEYOND COMICS?

We're in the comics business because we love making comics. But we both went to film school. And we've both written screenplays and done work on video games for hire. Greg is now working on a couple of children's books and has even explored the transmedia world, turning his *Vision Machine* graphic novel into an interactive iPad app with a full voice soundtrack and limited animation. Fred has written two nonfiction books in addition to the tome you're holding right now. In short, we're storytellers, and we're likely to jump on any opportunity in any medium to tell interesting stories.

Particularly in an age when creator-owned comics have been turned into wildly successful movies and television shows, we highly recommend that comic book writers diversify and seek out experience in writing for other venues.

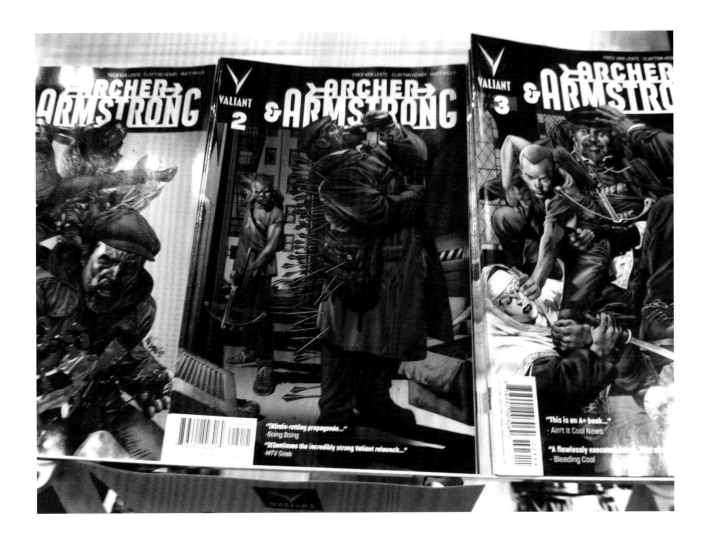

CHOOSING THE RIGHT PROJECTS

At certain points in your career, you may be offered a gig that you might desperately need for financial reasons but that you suspect from the beginning could turn into a disaster. Every creator has to make his own decision about these kinds of projects. We'll just say that we've been there. And when we needed work, we bit the bullet. And sometimes that bullet went off right between our teeth. But we can't regret it.

We both have a few books on our résumés that we worked incredibly hard on but that, at most, we generously give a C-plus. But if we had to do it all over again, we absolutely would take the same jobs. We learned. We got better. We bonded with creative partners on those projects. And we got more work.

The other reality is that there will always be people out there who absolutely love the project you're the most embarrassed by. So be happy, be proud, and thank them for reading.

On the other hand, there will come a time when you have options. And you will be approached to work on a stinker. And you will feel great when you are smart enough to say no. You will also panic, because nothing is more terrifying to a freelancer than saying no to paid work. But trust your gut. If you don't want the gig and you don't need the gig, don't take the gig.

ALWAYS BE GROWING

We leave you with just one final thought, our inspirational riff on the cynical "Always be closing" line from *Glengarry Glen Ross*:

We have collectively clocked about four decades in the storytelling business. We're old pros. As a matter of fact, we're so ridiculously confident in our abilities that we just wrote a book about it.

And yet every day we're learning something new and striving to get better. There are still territories left uncharted . . . like the big Hollywood versions of our creator-owned properties like *Swordmaids*.

So our last piece of advice to you is to constantly put yourself into situations that force you to learn and get better at what you do. Take the jobs that scare you because they're dealing with subject matter or genres you haven't yet embraced. Seek out collaborators who are better than you so that you can steal all their secrets. Read books, see plays, play games, and go to movies and museums that push you out of your comfort zone. Talk about process with fellow creators. Show your work to smart people, and listen to what they say.

Most of all, listen to your true self.

In Billy Wilder's classic film *Double Indemnity*, Edward G. Robinson gives an amazing speech about the "Little Man" inside of him.

"Every time one of these phonies comes along, he ties knots in my stomach," he says. "I can't eat!"

Robinson is playing an insurance investigator, and when he talks about "phonies," he's referring to grifters' false claims. But for us creators, our Little Man tells us when our work is phony. He knows when we're cheating, or faking it, or taking shortcuts, or avoiding some fundamental truth or beauty or ugliness that can truly make our stories sing.

In other words, we already know what we need to do and where we need to go. We just have to embrace that tough truth and do the hard work to keep on growing.

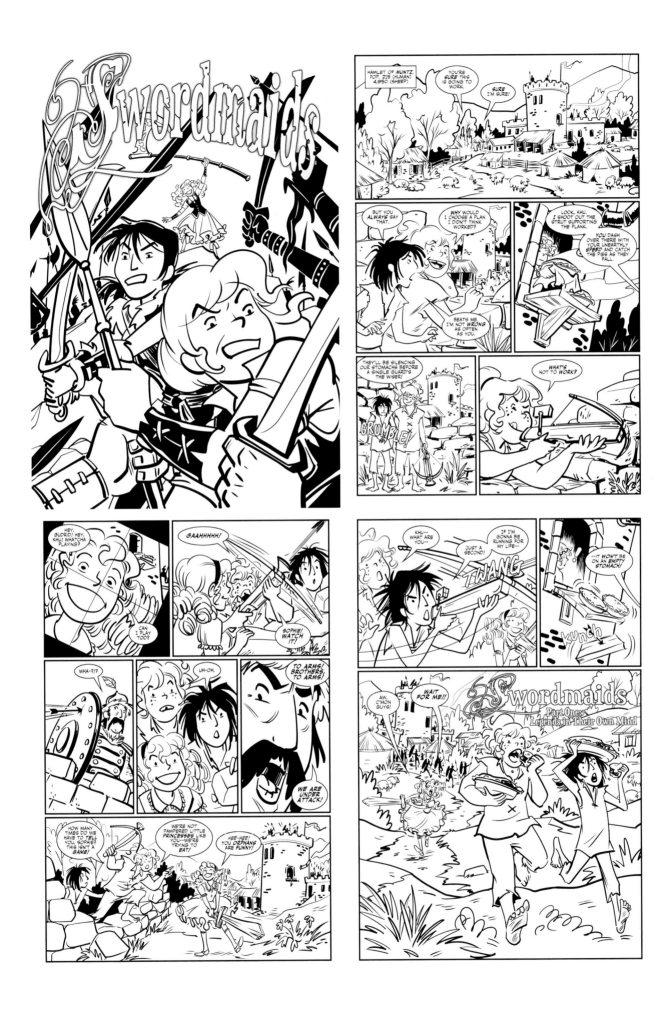

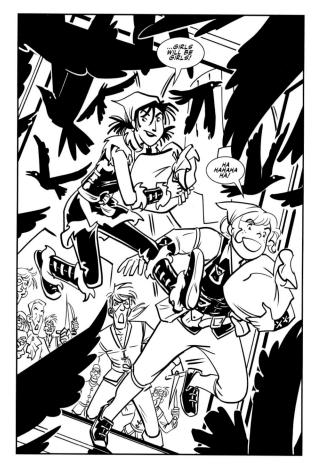

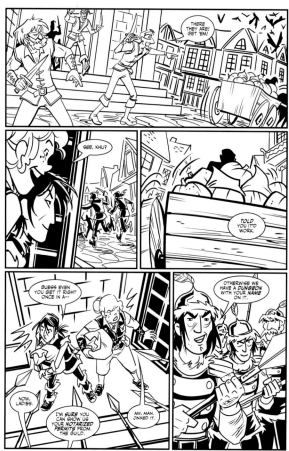

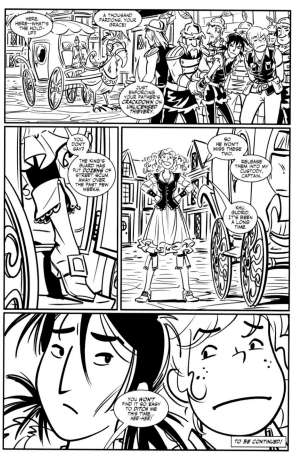

TO BE CONTINUED!

INDEX

A

Action
 left-to-right progression of, 46, 47
 sequences, 47
Action Comics, 98, 109
Action Philosophers, 2, 53, 54,
 121, 138
Action Presidents, 122
ACT-I-VATE online collective, 116
Adlard, Charlie, 5
Adobe InDesign, 114
Adventure Time, 100
Aerial shots, 51
Agents of Atlas, 43
Amazing Fantasy, 5, 143
Amazon, 116, 136
Angle down shots, 51
Angle up shots, 50
Announcements, 134, 136
Archer & Armstrong, 22–25, 63, 77,
 82, 132, 134
Aspen Comics, 27
Atlas Comics, 28
Atomic Robo, 97, 127
Awesome, 80

B

Bandette, 8, 9, 126
Barnes & Noble, 116
Baron, David, 25, 77
Barry, Lynda, 53
Batman/Superman, 53, 134

Battlepug, 116
Bellaire, Jordie, 48, 64, 66, 68, 70, 72
Bellegarde, Nate, 70
Bird's eye shots, 51
Blogging, 116, 132
Boom, 100
Bowland, Simon, 14, 25, 72, 73, 77, 138
Boy Commandoes, 46
Bradbury, Ray, 2
Brain Boy, 16, 73, 75
Breaking in, 8–9, 100, 127, 143
Brevoort, Tom, 143
Brown, Reilly, 29, 30, 48, 68, 119
Brubaker, Ed, 123
Bucko, 116
Budgeting, 125–26
Bunn, Cullen, 97, 98

C

Cancellations, 130
Captain America Comics, 46
Chasing Amy, 62
Chew, 96, 97
Christenson, Kurt, 119
Clevinger, Brian, 116, 127
Cliffhangers, 19
Close-ups
 extreme, 49
 importance of, 46
 use of, 49
Code Monkey Save World, 14, 16, 98,
 100, 101, 126, 132, 134, 136

Collaboration
 golden rules for, 82
 importance of, 1, 61
 nature of true, 1–2, 6, 10
 as personal relationship, 82, 144
Collector's Corner, 139
Coloring, commandments for, 72
Colorists
 guidelines for, 72
 importance of, 66
 role of, 64, 66, 68, 72
*The Comic Book History of Comics
 (Comic Book Comics),* 110,
 112–13, 123, 138
Comic-Con International, 138
Comics
 collaboration and, 1–2, 6, 61, 82
 color vs. black-and-white, 125
 creator-owned vs. work for hire,
 100
 distribution of, 110–14, 115
 history of, 109–10, 112–13
 movies vs., 43, 45
 printing, 114, 116
 print vs. digital, 123
 storytelling in, 45
Comixology, 116, 122, 123, 125, 126
Conan, 100
Conner, Amanda, 53
Conventions, 138–39
Coover, Colleen, 1, 6, 7, 10, 11, 32, 47,
 55, 83, 111, 116, 124, 126

Cosby, Nate, 5, 78, 81
Cost of goods sold (COGS), 126
Coulton, Jonathan, 101, 126, 132, 134
Covers, 100–103
Cow Boy, 78
Cowboys & Aliens, 2, 5, 24
Cox, Alex, 114
Credit, sharing, 82
Criminal, 123

D
Daredevil, 24
Dark Horse, 98
Dark Horse Presents, 68
Dark Knight Returns, 62
DC Comics
 breaking in at, 8–9, 100
 as licensing company, 100
 sales at, 130
 Vertigo imprint, 98
Deadlines, 63, 72, 81, 144
Dead Man's Run, 27
Deadpool, 64
DeConnick, Kelly Sue, 100–101
Defenders, 24
Detail shots, 49
Diamond Comic Distributors, 96, 110,
 114, 115, 116, 124, 125, 126
Digital Rights Management (DRM), 116
Direct market, 110
Distribution, 110–14, 115
Ditko, Steve, 28
Dr. Strange: Season One, 64
Double Indemnity, 146
Double-page splashes, 46, 48
Drawing style, 45–46, 53, 63
Dunlavey, Ryan, 2, 53, 54, 80, 112,
 121, 122, 123, 138

E
E-books, 116
Editing, commandments for, 81
Editors
 coloring and, 72
 guidelines for, 81
 inking and, 62
 lettering and, 73
 maintaining relationships with,
 144–45
 pitching to, 93, 95–98, 100

role of, 78, 81
 writers and, 78, 81
Egri, Lajos, 13, 16
8-Bit Theater, 116
EigoTown.com, 121
Elevator pitch, 93, 95
Eliopoulos, Chris, 78
Ellipsis points, 33
Ellis, Steve, 2, 5
Ellison, Harlan, 8
Email interviews, 137
Emotion, conveying, 16, 62
Empathy, importance of, 45
Ending, knowing your, 15–16
Establishing shots, 50
Evil Twin Comics, 122

F
Fantastic Four, 28
Fatale, 123
Fetch, 114
Field, Syd, 16
Final Draft, formatting in, 27
First impressions, importance of, 144
Fischer, Harry Otto, 9
Flatting, 64
Font size, 73
Full scripts, 28

G
Gaiman, Neil, 8
Gerber, Steve, 21
GI Joe, 100
Gingerbread Girl, 8
Godzilla, 100
Golden Rule of Comic Creation, 8
Gorison, Hunter, 134
Graphicly, 116
Growth, importance of, 146
Guardians of the Galaxy, 24
Guillory, Rob, 96

H
Halo effect, 68
Hama, Larry, 46
Hardman, Gabriel, 43–46
Heathentown, 43
Hemingway, Ernest, 98
Henry, Clayton, 82, 132
Hernandez, Gilbert, 53

Hesitation, ellipsis points
 indicating, 33
Hooks, building, 19
Howard the Duck, 21
The Hulk, 43, 97
Hulk: Season One, 64
Hurd, Gale Anne, 27
Hurtt, Brian, 97

I
Ideas, sources of, 8, 9
IDW, 100
Image Comics, 96, 97, 98
Incredible Hercules, 6, 8, 15–16, 29,
 72, 78, 138
Incredible Hulk, 5
Inkers
 choosing, 62
 coloring and, 72
 guidelines for, 63
 lettering and, 73
 role of, 62
Inking, commandments for, 62–63
Inner voice, 16
Inserts, 49
Interviews, 136–38

J
Janson, Klaus, 62, 63
Johns, Josh, 25

K
Kholinne, Jessica, 14, 64, 65, 98,
 101, 136
Kickstarter, 122, 126–27, 132, 136
Kim, Ian, 15
Kindle, 116
Kinski, 43, 44
Kirby, Jack, 28, 46, 53, 82
Kurth, Steve, 53, 138

L
Laird, Peter, 121
Land, Greg, 5
Layman, John, 96, 97
Layouts, 55
Lebonfon, 114
Lee, Jae, 53
Lee, Jason, 62
Lee, Jim, 53

Lee, Stan, 28
Leiber, Fritz, 9
Lettering, 72–73
Little Nemo in Slumberland, 46
LiveJournal, 116
Locators, 32, 33
Loglines. *See* Pitching
Long shots, 50
Lopresti, Aaron, 78
"Los Robos," 64, 65
Lupacchino, Emanuela, 63, 82

M

Magneto Testament, 78, 145
Malibu Comics, 143
The Manhattan Projects, 64
Man-Thing, 24
Martin, Marcos, 119
Marvel
 breaking in at, 8–9, 100
 as licensing company, 100
 popularity of, 28
 sales at, 130
Marvel Adventures Iron Man, 5
Marvel Method, 28, 29–30
The Massive, 64
McCann, Jim, 138
McCay, Winsor, 46
McCloud, Scott, 16
Medium shots, 49
Microsoft Word, formatting in, 21,
 24–25, 27
Miller, Frank, 62
Mistakes, 72, 82, 143
Miyazawa, Takeshi, 14, 64, 65, 98,
 101, 134, 136
MODOK's 11, 5
Moen, Erika, 116
MonkeyBrain Comics, 126
Moore, Alan, 21
Moore, Taylor, 136
Movies vs. comics, 43, 45

N

Narration, 16
New York Comic Con, 138
Nook, 116
Nordling, Lee, 24
Norton, Mike, 95, 116
Nowhere Men, 64, 70

O

Octane, 53
OGN (original graphic novels),
 123, 125
Oni Press, 98
Ortego, Guillermo, 63
Outlaw Territory, 15

P

Pagulayan, Carlo, 78
Panels, size of, 46
PanelSyndicate.com, 119
Paniccia, Mark, 5, 78
Parentheticals, 32–33
Parker, Jeff, 116
Parker, Tony, 27
PDFs, 116, 119
Pencillers
 coloring and, 72
 commandments for, 45–46
 empathy and, 45
 importance of, 45
 inking and, 62, 63
 lettering and, 73
 role of, 45
 writers and, 21, 28–29
Penny Arcade, 116
Perez, Pere, 25, 77
Photoshop, 64, 68
Piekos, Nate, 16, 73, 75
Pirated comics, 119
Pitching, 93, 95–98, 100–101, 104–5
"Planet Hulk," 5, 14, 78
Planet of the Apes, 43
Platinum Studios, 2, 24
Point-of-view (POV) shots, 50, 51
Possibilities, being open to, 144
Power Pack, 8
Power Play, 119
Premise
 definition of, 13
 knowing your, 13–15
Preordering, 111
Pretty Deadly, 100, 101
Previews catalogue, 96, 110, 111, 115
Prime, 143
Printing, 114, 116
Pritchett, Charles, 72, 74
Profit and loss (P&L), 124–27
Projects, choosing right, 146

Promo art, 100–101, 134, 136
Promotion
 conventions, 138–39
 importance of, 129, 130
 interviews, 136–38
 self-, 130–32
 store events, 139
 timing, 134

Q

Quesada, Joe, 78

R

Reaction shots, 49
Reading with Pictures, 122
Reed, Josh, 27
Regular Show, 100
Retailers
 appearances at, 139
 as primary customers, 114
Reverse shots, 51
Revival, 95
Rios, Emma, 100, 101
Robinson, Edward G., 146
Robot Stories, 5
Ross, Alex, 53
Roughs, 55

S

Saint George, 29–31, 48
Sales
 to avoid cancellation, 130
 estimating, 124–25, 126
The Sandman, 97
Script format
 conventions for, 32–33
 in Final Draft, 27
 full vs. Marvel Method, 28
 in Microsoft Word, 21, 24–25, 27
 succinctness in, 21
Secret Avengers, 43
Secret Invasion, 6
Seeley, Tim, 95
Self-promotion, 130–32
Setting
 color as, 70
 determining, 9, 10
Shot types, 46, 48–51
Showing vs. telling, 16
The Silencers, 2, 5

Silva, RB, 19, 74, 75
Simon, Joe, 46
Simons, Warren, 78, 145
The Sixth Gun, 97, 98
Small Favors, 8
Smith, Kevin, 62
Social media, 131–32, 140
Solicitations, 111, 114, 115
Sound effects, 33
Spatial relationships, 46, 47
Splash pages, 46, 48
Steigerwald, Peter, 27
Stephenson, Eric, 70, 95, 97
Storyboards, 44, 45
Storytelling
 in comics vs. movies, 45
 didactic, 16
 dramatic, 16
 guidelines for, 46
 multiplatform, 140
Stuperpowers!, 2
Style, 45–46, 53, 63
Superman, 97
Swordmaids
 characters of, 9–11
 cover for, 102–3
 finished pages for, 83–91
 idea for, 8–11
 online presence for, 140–41
 outline for, 10
 P&L for, 124–26
 pitch document for, 104–5
 roughs for, 55–59
 script for, 32–41
 setting for, 9, 10
 solicitation for, 111
Swords, 9

T
Thrillbent.com, 123
Thumbnails, 55
Time of day, indicating, 68, 72
Tobin, Paul, 8
Tranquility, 2, 5
Transmedia, 140
Tumblr, 116, 122, 123, 131
Twitter, 131–32, 140
Two shots, 49

U
Urasawa, Naoki, 53

V
Valiant Entertainment, 24, 72,
 134, 145
Vaughan, Brian K., 119
Vicente, Muntsa, 119
Vision Machine, 19, 72, 74, 140, 145
Voice
 inner, 16
 public, 132

W
Waid, Mark, 123
The Walking Dead, 125
Walsh, Michael, 134
Warlock, 5
Watchmen, 21
Watterson, Bill, 53
Webcomics, 116, 123
Websites, personal, 130, 131, 132, 140
Wegener, Scott, 127
Wide shots, 50
Wilder, Billy, 146
Williams, Freddie, III, 16

Wolverine: First Class, 5
Wood, Wally, 46
WordPress, 116
Work for hire, 100
World War Hulk, 5, 62
Worm's eye shots, 50
Writers
 artists and, 21, 28–29
 coloring and, 72
 editors and, 78, 81
 inking and, 62, 63
 lettering and, 73

X
Xeric Foundation, 121
X-Men First Class, 8
X-Men: Phoenix—Endsong, 5

Y
Young, Kito, 53